Nature at Your Doorstep

A WARDLAW BOOK

WATER-LILY PYRALID

Nature at Your Doorstep

A NATURE TRAILS BOOK

John Tveten & Gloria Tveten

Illustrations by John Tveten

TEXAS A&M UNIVERSITY PRESS COLLEGE STATION

This paper meets the requirements of
ANSI/NISO z39.48-1992 (Permanence of Paper).
Binding materials have been chosen for durability.

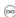

Earlier versions of these essays appeared in the *Houston Chronicle.*

LIBRARY OF CONGRESS CATALOGING-IN-PUBLICATION DATA

Tveten, John L.

Nature at your doorstep : a nature trails book / John Tveten
and Gloria Tveten ; illustrations by John Tveten. — 1st ed.

p. cm. — (A Wardlaw book)

ISBN-13: 978-1-60344-036-3 (cloth : alk. paper)

ISBN-10: 1-60344-036-4 (cloth : alk. paper)

1. Wildlife watching. 2. Nature study. I. Tveten, Gloria A., 1938–
II. Title.

QL60.T85 2008

508—dc22

2007048112

To Michael, Lisa, Brett & Amanda

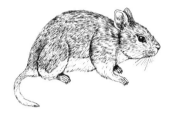

NORTHERN GRASSHOPPER MOUSE

We also dedicate this book
to our friend and editor,
Shannon Davies,
who encouraged us
to compile our columns in book form
and remained patient and understanding
through all three volumes.

KIT FOX

Contents

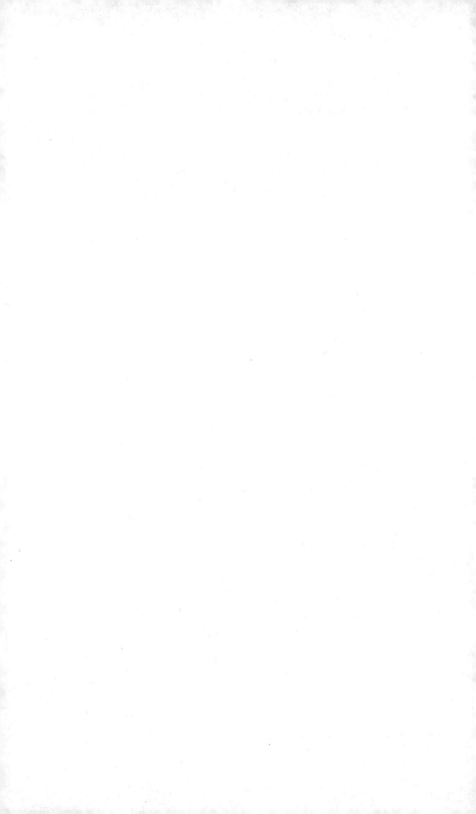

Acknowledgments

We are indebted to many people who played a part in these investigations through the years, who helped make it possible to visit new places and guided us to new experiences. In particular, we want to thank members of the many nature clubs and institutions from whom we learned along the way: Houston Outdoor Nature Club and its Ornithology Group, Houston Audubon Society, Piney Woods Wildlife Society, Armand Bayou Nature Center, Robert A. Vines Environmental Science Center, Houston Museum of Natural Science, Mercer Arboretum and Botanic Gardens, Jesse H. Jones Park and Nature Center, Houston Arboretum and Nature Center, Nature Discovery Center, Texas Ornithological Society, and the numerous nature festivals that have invited us to participate as speakers and field-trip leaders. We joined some of these organizations more than four decades ago and learned by attending meetings, participating in field trips, and listening to the wisdom of some of the best naturalists from the Houston area and across the state. We cannot begin to thank them enough for their patience and their knowledge.

We want to thank our editors at the *Houston Chronicle,* of whom there were many in the twenty-four years we wrote for that newspaper. In particular, Jack Loftis first allowed us space to write about our love of nature and helped steer us in the right direction, while Jane Marshall, our last *Chronicle* editor, provided us with kind encouragement and expert guidance.

We owe a special debt of gratitude to Texas A&M University

Press and its staff for helping to smooth out rough edges in our manuscripts and assemble them into this and previous volumes that we hope will serve to interest and inform those who share our love of natural history.

Keith Arnold reviewed the manuscript and offered helpful suggestions, while our copyeditor, Cynthia Lindlof, always seemed to understand what we were trying to say and cheerfully guided us through the intricacies of literary style.

Introduction

Nature at Your Doorstep is the third volume in a series based on newspaper columns that appeared weekly in the *Houston Chronicle* under the title "Nature Trails" for more than twenty-four years, from February 15, 1975, through March 26, 1999. The first, *Our Life with Birds*, dealt entirely with the avian world, including various aspects of bird biology and habits as well as the joys of birding. In the second volume, *Adventures Afar*, we selected columns that transported the reader to some of the most beautiful and fascinating locations in the Western Hemisphere.

Now, in *Nature at Your Doorstep*, we offer a selection of columns about the plants and animals found closer to home. Any family vacation, or even a simple walk in the backyard, can prove to be an informative wildlife safari. We hope this volume will serve as inspiration and guide for some of those experiences.

While these selections may seem at first to treat a disparate collection of flora and fauna, they have been combined here to give a wide overview of the natural world. This, in a sense, reflects the very nature of a weekly newspaper column. Except when we wrote a series on a particular destination, each column was designed to stand by itself, the subject dictated by a particular experience or a timely event, and the subject matter varied widely to appeal to all tastes and interests. It is a format shared by numerous books of collected essays and newspaper columns.

In choosing the articles to be included in each chapter of this volume, we selected those we thought would have the widest appeal. Also a consideration, however, was the length of the column as it was originally printed. During some periods, our space in the newspaper was more limited, and we were unable to treat the subject with the depth we thought it required. In other cases, we used several illustrations for a group of related organisms and wrote little accompanying text. We did not feel those columns were appropriate for this purpose. Thus, we include here such varied subjects as plants, insects, mammals, reptiles and amphibians, and marine organisms, each essay standing alone but collected into chapters following a particular theme.

For the first few years, "Nature Trails" appeared under the sole credit John L. Tveten. Having just left a job as an industrial research organic chemist to start a new career as a freelance nature writer and photographer, John had the audacity to approach Jack Loftis, then feature editor of the *Chronicle,* with the idea for a weekly column. Later, Gloria took early retirement from teaching college mathematics and shared the byline. Virtually all of these adventures were shared experiences, however, and we have rewritten most of the early columns to reflect that fact.

Freed from the strict space constraints of a daily newspaper, we have also expanded some of the material slightly where we felt it was warranted. In a few cases, we have included more than one column in a series; in others, we have combined portions of two or more columns published over a period of years, rewriting them as one.

Finally, we have added for this book parenthetic comments in italics that help explain the context or content of each chapter or column or that reflect changes in wildlife taxonomy or status. Hopefully, these will clarify notations that at first may seem confusing or outdated.

As noted in the first two volumes of this series, rules of nomenclature put forward by the American Ornithologists' Union and adhered to in most bird-oriented literature call for the capitalization of bird names. Most popular writing follows a more literary style in

which the names are not capitalized. This includes newspaper and magazine articles, as well as many books intended for the general public. The columns included here were originally published in the latter style. We have chosen to continue that style, in part because no similar rules requiring capitalization of the names come into play for other groups of plants and animals.

As noted in the first volume, we authored more than 1,250 weekly columns during the tenure of "Nature Trails" in the *Chronicle*. Although the length and format of the columns varied from time to time according to the whims of various editors and editorial policies, we estimate that we wrote more than 1.25 million words for our allotted space. Not all of those words, perhaps, were good literary choices, but we hope that the ones we have chosen for this book will prove informative and entertaining.

Nature at Your Doorstep

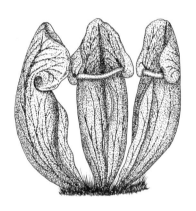

RED PITCHER-PLANT

1

Enjoying Nature

Through the years, we have traveled widely across North, South, and Central America and the West Indies in search of wildlife. Accounts of some of our more exotic trips were included in volume 2 of these collected "Nature Trails" columns, a book entitled Adventures Afar.

It is not necessary, however, to venture far from your doorstep to find rewarding adventures in nature. We spend most of our time at home, or at the most traveling in Texas or other regions of the United States. Even then, we never lack for new and fascinating plants and animals to study and enjoy. The columns in this chapter reflect backyard experiences or those that an entire family could enjoy on any short vacation trip.

Nature at Your Doorstep: 1998

The song cascades down from the treetops in a cheerful medley of chippering, bubbling notes that continue almost unbroken from sunrise to sunset. Our backyard is filled with the delightful avian music, and the chorus can be heard throughout much of the neighborhood. These are not the clear, whistled notes of the resident cardinals nor the insistent, repeated phrases of the mockingbirds. Indeed, this is a song we seldom hear. It comes from a large flock of goldfinches that has remained in our yard much later in the year

than normal, and the birds have now assumed their full courtship plumage and voice.

In most years, these small finches appear at our feeders through the winter and leave again by early March. During these months, the males are cloaked in olive drab, with little hint of the dazzling finery they will soon adopt. For the last few weeks, however, we have watched them slowly change to their trademark shining golden plumage, complete with jet black skullcap, wings, and tail.

Their songs have changed, too, becoming louder and more insistent, until the charming birds now sing continuously throughout the day. Spring is here, they seem to say, and avian hormones are raging. Soon these goldfinches will move farther north to build their nests and raise their young, deserting us until returning late next fall.

The transformation of these loveliest of our feeder birds is not the only sign of spring in our backyard. Several indigo buntings have paused on their northward migration to favor us with their iridescent beauty. As we sit on our patio to watch on this warm, sunny April afternoon, the buntings cling to the stems of blooming spiderworts to nibble delicately at the seeds of weed grasses that have sprung up among the flowers. Adult male buntings are bright, electric blue, while females wear a drabber brown and buff. Young males show the mottled brown-and-blue pattern of their first spring as they slowly molt from juvenile, femalelike plumage to their first formal dress.

The spiderworts on which they perch cover large patches of our yard, the progeny of a single small clump we transplanted from a friend's flower bed more than thirty years ago. Now they have virtually taken over our lawn, but we rejoice in the delicate bluish purple flowers during this season of the year.

Spring does not come all at once here along the Texas coast. We have followed it for many weeks on our daily walks through the neighborhood. It started, perhaps, with the blooming of the redbuds and yellow jessamine, the greening of the first willow oaks and ash trees. It has now progressed to the stage where even the pecans, the last cautious holdouts, have put on new leaves and pendent blossoms.

A host of wildflowers has emerged in lawns and along the streets

and sidewalks, forming a patch-work quilt of rainbow hues. In late March, we counted thirty-two different flower species on one morning walk; yesterday we added seventeen more. Most people would call these "weeds" as they spring up along the borders of their lawns, but some are inordinately lovely in both their form and color. We count the

AMERICAN GOLDFINCH

magenta henbit, the sky blue herbertia and stemless spiderwort, and the waxy yellow buttercups among the most beautiful.

To many city-bound observers, spring is represented by banks of large and colorful azaleas or by the other cultivars that ornament most yards and gardens. To us, however, spring arrives with the pageant of the native wildflowers—some tiny and seldom seen, some larger and more colorful—that creeps across the landscape.

Spring has come, too, to the mulberry trees in our backyard. The fruit of the red mulberry is not quite ripe enough even for the birds, but that of the white mulberry is unusually sweet and succulent. We help ourselves to the bounty hanging from the lower branches, while our avian visitors dine above. We sit watching as a pair of summer tanagers and a Swainson's thrush help themselves to the juicy fruits. Resident red-bellied woodpeckers, mockingbirds, and blue jays also eat their fill, as does a migrating catbird that stops to rest and feed.

Few birds can resist ripe mulberries in the spring, and even the seed-eating cardinal stops to pluck a tasty morsel as it makes its rounds. We had never seen rose-breasted grosbeaks in our yard until the mulberry trees reached fruiting age, and the visiting grosbeaks are now joined by several species of tanagers, orioles, buntings, and thrushes.

A male ruby-throated hummingbird zips in to sample the nectar of red salvias nearby, and a Carolina wren perches atop a potted fern to serenade us with its surprisingly loud, repeated *teakettle, teakettle,*

teakettle song. The hummingbird will undoubtedly continue on northward to nest, but the wren is busy building in a flowerpot in the corner of the yard.

A large green Carolina anole crawls slowly down from the trunk of a cedar elm and pauses beside us on the patio. Puffing out its throat, it expands its bright pink dewlap like a fan and performs several vigorous "push-ups," proclaiming at least temporary ownership of this small patch of ground. Two other male anoles engage in a contest on the back fence. Standing nose to nose, they flare their dewlaps and strike fearsome lizard poses, only occasionally resorting to short chases along the fence boards to establish their superiority.

Overhead, a fox squirrel and a mockingbird vie for territory. The squirrel is stretched out on a limb with its tail curled forward over its back, while the mockingbird dances before it, wings flashing and tail spread. Finally, the squirrel gives up and finds a more rewarding pursuit; it chases another fox squirrel around and around the tree.

As we sit and watch the pageant around us, we revel in the delights of another spring. Every year brings new and rewarding surprises, perhaps a new flower that springs unbidden in a corner of the yard or a new warbler gleaning caterpillars and other insects from the leaves of the mulberries. This year, certainly, the highlight has been the incomparable beauty and song of the goldfinches that have lingered into April, northern finches joining ranks with Neotropical migrants just returning from the south.

Views from the "Magic Porch": 1994

More than a thousand miles to the west of our home in Baytown, Texas, another backyard offers more of nature's infinite delights. The ecology is very different, with desert sands and gravels replacing the black gumbo soil of the Gulf Coast and less than half the annual rainfall dictating a very different assemblage of plants and animals.

The show begins at dawn with doves and quail and continues until dusk with a varied cast of charming characters. Indeed, it plays right on through the night, as kangaroo rats and pocket mice venture out on their nocturnal rounds. The stage for this wildlife pageant is a backyard in Oro Valley, a sprawling suburb on the northern edge of Tucson, Arizona. Eight-tenths of an acre of native scrub, the lot has no lush green lawn. Instead, the hard-packed desert gravels hold acacias and agaves, mesquite and paloverde trees. Prickly-pear and cholla cactus accent the scene with yellow and magenta blooms.

This is the prevailing landscape throughout the neighborhood. Gone are attempts at planting lawns, at pouring valuable water into thirsty sands. There is little effort to "improve on nature," to introduce alien grasses and broad-leaved plants that are ill equipped to survive the desert's summer heat or prolonged drought. This admirable trend has spread throughout the country. Gardening with native plants makes much more sense. We can enjoy nature on its own terms; we need not conquer or remake it.

On our recent visit to Arizona to visit our son, Michael, and his family in their new home, we enjoy the fruits of this philosophy. We eat meals on what Mike, Lisa, and Brett *(our granddaughter, Amanda, was not yet born when this column was written)* call their "magic porch," overlooking the passing wildlife parade.

Scratch grains spread on the ground nearby attract white-winged, mourning, and Inca doves, all feeding ravenously side by side. Curve-billed thrashers and canyon towhees join in more cautiously. A gilded flicker or cactus wren carefully chooses a seed or two, although both species prefer insects as their staple rations. Colorful cardinals take their turn, sometimes feeding beside their close relatives, the pyrrhuloxias. Smaller than the better-known cardinals, the latter have slender crests and twisted, parrotlike yellow bills.

BANNER-TAILED KANGAROO RAT

PYRRHULOXIA

Ubiquitous house finches and house sparrows troop to the handouts, accompanied by fledgling young that beg food from their parents with quivering wings and plaintive cries. In an acacia nearby, a mockingbird feeds its perpetually hungry chicks that are not yet large enough to leave the nest.

Our personal favorites are the Gambel's quail that wander through the neighborhood, sampling various offerings. Always in pairs, they walk slowly along, dapper head plumes bobbing up and down. Several of the quail pairs have young in tow, varying in size from tiny balls of fluff to strapping, half-grown birds we call "the teenagers." One of the parents keeps a wary eye for danger as each family feeds; an alarm call uttered at any unusual sound or movement sends every chick scurrying for cover without hesitation.

The birds are not the only patrons of this bounty. Desert cottontails of all ages consume seeds as well as bits of fruit and greens. Round-tailed ground squirrels scamper back and forth to their burrows, cheeks packed with seeds, while Yuma antelope squirrels venture out from cover much more cautiously. A pair of enormous desert spiny lizards and an occasional whiptail lizard scurry by. Primarily insectivores, the spiny lizards nevertheless steal a bit of lettuce and retreat to the safety of the prickly-pear to nibble delicately.

We find at least half a dozen mourning dove nests in the yard. One in a cholla near the porch shelters two young almost ready to fledge. A watchful dove sits on eggs atop a pillar at the front door, while another incubates patiently on a clump of mistletoe in a sheltering acacia tree. Their plaintive cooing can be heard throughout the day.

Roadrunners, ravens, lesser nighthawks, phainopeplas, and black-tailed gnatcatchers all wander through the yard, and an oc-

casional Harris's hawk causes momentary panic among the other patrons as it flies past and swoops low to survey the scene. The cast of characters is ever changing in this suburban wildlife refuge, and we never tire of the view from the backyard "magic porch."

For most people, a long day's drive across the country is an invitation to utter boredom, a necessary evil to be endured in order to reach a more rewarding goal. Such is not the case for us. Ordinarily, we revel in the journey itself, not just the ultimate destination. Whether traversing forested hillsides, rolling prairie grasslands, or seemingly barren stretches of desert sands and scrub, we find enjoyment in the landscape itself and in the wildlife that calls it home. The following are columns we wrote about traveling the highways of our nation.

Where the West Begins: 1984

It is one of those glowing, golden days of early autumn as we drive northwestward across Texas from the coast. A bank sign on the corner in one small town flashes eighty-five degrees just after noon, but the breeze through our open windows feels much warmer. We have come nearly three hundred miles, past Brenham and Temple, following Highway 36 through Gatesville, Jonesboro, and Hamilton.

Feeling a twinge of after-dinner drowsiness, we turn the radio to a country-and-western station and sing along with Willie Nelson and then the Oak Ridge Boys. With our voices, we can do that only when we drive alone. The next town down the road is Comanche, and just ahead lie Rising Star and Cross Plains. We have accomplished something now; we are really getting somewhere. We are now in the real West.

Biologically speaking, the dividing line between the eastern and western portions of Texas runs roughly along the Balcones Fault Zone, where the prairie rises abruptly into the limestone hills. Once we also heard a botanist assert that the West begins where the rainfall drops below twenty inches a year.

Geographers and biologists are entitled to their opinions, undoubtedly more scientific than ours; however, we have our own definition of where the West begins. It begins where you find little towns with names like Comanche, Cross Plains, and Rising Star. We love the sound. In our minds, and with our best Texas drawls, we imagine ourselves saying, "Howdy. Ah'm from Rising Star, Texas."

There is nothing wrong, we hasten to add, with names like Hamilton and Gatesville. The former honors a governor of South Carolina who contributed money to the Texas army during its revolution; the latter, one of the heroes of the Mexican War. Both towns played an important part in Texas frontier history. But for the pure music of the name, it is hard to beat "Rising Star."

Horses no longer stand idly at hitching posts along the main streets of these towns, swishing their tails and rattling their bits. Instead, there are pickup trucks, the official vehicles of West Texas, parked along the curbs. We hear no jingle of spurs, but the streets still have something of the stark, barren look of frontier towns.

The cattle industry remains a dominant one in the region, but now there is oil production, too. Comanche is famed for growing peanuts, and we see groves of pecans and peaches and vast fields of juicy melons. A few vineyards herald a new cash crop that expands each year. Roadside signs advertise fresh produce at bargain prices.

The soil here looks more fertile than that of the rolling limestone hills over which we have just passed, and the scattered slabs of rock have been hauled from the fields and piled around the corner posts of the fencerows. When dry and bare, the dirt tries desperately to get up and move, but when well watered, it will grow almost any crop imaginable.

Scattered mesquite trees dot the drier hillsides, their foliage a bright lime green in contrast to the darker leaves of the live oaks and post oaks. Some pastures are lush with grasses turning golden in the sun; others appear severely overgrazed and are now filled with clustered mesquites, prickly-pear, and yucca, sure signs of land mismanagement.

Hay fields are newly mown and dotted with the huge rolls that in recent years have replaced smaller rectangular bales. The smell is

delightful. We follow one hay truck for miles, declining to pass, just for the lingering fragrance drifting back from the freshly cut load. A rancher waves from his perch on a tractor, and we grin widely and wave back. This, too, is a sign of the West.

Most of the roadside wildflowers have bloomed earlier in the year, the colorful flowers now replaced by ripening fruits and seeds. Remaining are yellow composites such as sunflowers of several species and the sticky, malodorous gumweed. Their golden brightness is interspersed with the royal purple of liatris and spiny eryngo.

YUCCA

High in the almost cloudless sky, vultures trace huge, lazy spirals, like schoolchildren endlessly practicing penmanship exercises on azure tablets. With no apologies for our anthropomorphism, we wonder what they think as they look down on the human panorama far below.

Countless mourning doves spring up from the roadsides with their jerky, rowing wing beats. Others perch in long lines along barbed-wire fences, their plump silhouettes contrasting with those of the wonderfully graceful scissor-tailed flycatchers that are beginning to gather for their southward migration. A scissortail flies in front of our vehicle to catch an insect in flight and then veers off abruptly with flaring tail. Few other birds delight us more.

We continue to roll on westward, headed for the High Plains, to Abilene and Lubbock and on into New Mexico. To some, it is a long, boring drive, but we enjoy every moment as a time to see and to think. We enjoy the West, especially when we find towns like Comanche, Cross Plains, and Rising Star. Truly, that is where the West begins.

Companions for the Road: 1995

An orange glow in the eastern sky behind us offers promise of a bright, sunny fall day as we head westward across the enormous, sprawling state of Texas. Interstate 10 stretches out before us, a concrete and asphalt ribbon winding from the Louisiana border to El Paso and the New Mexico line beyond.

With the dawn, flocks of birds take wing along our route. Great-tailed and common grackles move from communal roosts into the fields to feed. Cattle egrets fly in loose formations, their white plumage aglow in the first rays of the rising sun. Occasionally, too, a great egret crosses our path, its slower wing beat giving it an unmistakable regal grace.

A flock of red-winged blackbirds swirls out across a fallow field, twisting and turning like a single being. It seems impossible that the group can be so perfectly coordinated, a precision flying team with no apparent guidelines to follow through the trackless sky. An eastern meadowlark serenades the sunrise from a roadside fence post. From nearby thickets, blue jays and mockingbirds fly their initial sorties of the day.

We note each new species as we drive along, adding it to a growing list that will mark our passage across the state. It is a game we play as the miles roll by, a diversion that makes the time pass swiftly and that puts an ecological perspective on the scenic countryside. As young children, we each played other games to pass the time on family trips. We counted livestock in the fields, with special bonus points for all white horses, and raced to complete the alphabet from roadside signs. We listed, too, car license plates from each new state, never quite completing the entire map.

Our I-10 bird list will be similarly incomplete, of course, for there are many species we cannot distinguish at freeway speeds. We do not stop to prowl the woodlands along the way, nor can we flush skulking sparrows from the passing fencerows and grassy fields. As we skirt the cities and towns, we add urban rock doves *(now called*

rock pigeons), starlings, and house sparrows to our list, for these alien species seldom venture far from human habitation.

Reaching San Antonio, we head up onto the Edwards Plateau, gradually climbing through the limestone layers that take us far back in geologic time. Some road cuts have precise, even layers lying just as they were deposited on the floors of ancient seas. Others are twisted and contorted, products of faulting and upheaval through the ages. All may harbor fossils of life-forms long since vanished from the earth.

Here the bird life changes dramatically, as do the corresponding plants. Biologically speaking, East meets West along a broad front running down the middle of Texas—through Dallas and Fort Worth, Waco, Austin, San Antonio, and on to the lower Rio Grande Valley. East of that line, you find birds typical of the eastern states, those adapted to forests, blackland prairies, and the coastal plain. West of the line, the birds are more at home in an arid climate with limestone hills or rugged mountain ranges.

In the Hill Country we add our first scrub-jays to the list, a western species that lacks the crest of the East Texas blue jay. A road-runner dashes along beside us as if trying to keep pace, a quintessential West Texas bird, although it occurs more sparingly in other regions of the state.

The miles roll on, past Kerrville, Junction, Sonora, and Ozona. We have descended from the plateau, and the terrain is flatter and much more arid. Cresote-bush and yucca fill the surrounding desert; mesquite and acacias line the ephemeral stream courses that are now bone dry.

Nearing Fort Stockton, we see Chihuahuan ravens on many of the power poles. Larger than the common crow, and with a massive beak and wedge-shaped tail, these ravens are unique to the desert Southwest. Here, too, western meadowlarks add their more musical melodies to those of their eastern counterparts. At a roadside rest area a curve-billed thrasher serenades us from a picnic table, and a cactus wren scolds loudly from the branches of a desert willow.

We camp overnight at Balmorhea State Park amid black phoebes, Inca doves, and swirling barn swallows. The next morning we are

SWAINSON'S HAWK

back quickly on the interstate. Van Horn and El Paso lie ahead.

As morning temperatures rise and thermals ascend the hillsides, red-tailed hawks trace lazy circles around scattered white clouds, accompanying the turkey vultures that sail on motionless wings for hours on end. Two other large raptors wear dark bibs marking them as adult Swainson's hawks. Unlike the red-tails, which remain throughout the year, Swainson's hawks are Neotropical migrants that will soon leave to spend the winter in South America.

We add many other species on our route across the state: great blue heron, black vulture, American kestrel, loggerhead shrike, savannah sparrow, black-throated sparrow, lark bunting. None is especially unusual; each is a bird we have seen many times before. Yet these old friends prove to be welcome companions and participants in our travel game, helping the miles and the hours roll pleasingly by.

Rocky Mountain Staircase: 1979

The casual traveler can observe nature from our nation's highways and byways with wonderfully rewarding results. As noted in previous columns, wildflowers and birds provide variety and interest along even our busiest interstate highways. However, still more treasures await those who are able to shoulder a small pack and walk less populated nature trails, far from thundering traffic and crowds of people. Such places still exist, although they are becoming harder to find, and the delights they offer more than compensate for the effort. We offer as an example a simple one-day hike in one of our country's most spectacular national parks.

The sun is shining brightly as we shoulder our packs and start off single file across the alpine tundra. Although the calendar says that summer has arrived, snowbanks still line Trail Ridge Road, and there is a chill bite in the clear, crisp air. It could still be considered spring here at this altitude of twelve thousand feet along the top of Colorado's Rocky Mountain National Park.

Just three days earlier we walked in a blizzard that closed the highway with ice and snow as winds measured one hundred miles per hour atop the peaks. Now, however, the warm sun has again laid bare the tundra, and wildflowers are opening to form a multicolored tapestry of blooms. Almost all grow as perennials; buds that formed last year have waited patiently beneath the snow for just this magic moment. The plants must flower quickly and set their seeds, for the season is short in this land above the trees.

Although few of the alpine plants stand more than an inch or two high, their blossoms are amazingly large and colorful. Snow buttercups shine waxy yellow, contrasting with the intense blue of alpine forget-me-nots. The woolly buds of *Rydbergia* have begun to unfurl into large heads of sunflower-like blooms, and a few brilliant magenta flowers dot the matted clumps of fairy primrose. Alpine phlox, alplily, and dwarf clover add their own, more subtle beauty.

Furry little pikas and fat yellow-bellied marmots bask on sun-warmed rocks, while brown-capped rosy-finches and horned larks fly along ahead of us. All are as uniquely adapted to life in this seemingly hostile environment as are their floral counterparts. We search the slopes for ptarmigan, members of the grouse family. Pure white in winter plumage, they will now have molted to match the lichen-covered boulders, the ultimate in camouflage protection. Unfortunately, although we have found these amazingly tame birds here in other years, we cannot spot them now.

In the shelter of rocky Tombstone Ridge, we stop to eat our lunch. In spite of its name, it proves to be a hospitable place. A rocky ledge offers protection from the chill wind, so we remove our jackets to enjoy the surprising warmth of the noontime sun. Then we again pick up our gear and step over the crest of the mountain, descending the steep slope into the forest below.

Maps call the path we follow the Ute Trail, a faint reminder of the Native Americans who first inhabited this majestic place. It is not heavily used, and we meet no other hikers, for the steep, rugged trail drops thirty-three hundred feet in just a portion of the nine-mile segment we plan to hike. Carefully we descend the rough boulders into Windy Gulch, searching ahead for the stone cairns that mark our route.

The first trees we encounter at timberline are twisted and bent by the wind and ice, some growing almost parallel to the ground as they struggle for survival. Here the snow remains in large unmelted drifts, an accumulation blown down by fierce blasts from the tundra above. Slipping and sliding, often breaking through to our knees, we continue downhill. Soon we leave the snow behind, along with the Engelmann spruce, subalpine fir, and beautiful limber pines characteristic of the subalpine zone.

Now we enter the more benign Canadian, or montane, life zone. Here hillsides are dotted with Douglas-fir and lodgepole pine. Patches of chartreuse-leaved aspens contrast with the dark green of the dominant conifers. Small streams fed by the melting snow above tumble through grassy meadows ablaze with wildflowers. The soft earth underfoot offers relief after miles of rocky trail, and we revel in the beauty and solitude surrounding us.

This zone, too, we leave behind, descending into the towering ponderosa pines as we approach our destination in Beaver Meadow. At an elevation of little more than eight thousand feet, we encounter still another series of plants and animals. Mule deer and elk, antlers still in velvet, lie bedded down among the trees or stand unconcerned to watch as we walk slowly past. Deep purple larkspurs carpet open meadows, and along the trail we find the pink calypso, or fairy-slipper orchid, one of the most delicately beautiful of all the park's myriad flowers.

A woodpecker perched high on a pine trunk puzzles us until we see his yellow cap—a northern three-toed woodpecker *(now called the American three-toed woodpecker)*—the first either of us has ever seen. We study it carefully because it differs slightly from the idealized pictures in the field guides we carry, but there can be no

mistake as to its identity. It proves to be the rarest and most exciting bird of the trip.

AMERICAN THREE-TOED
WOODPECKER

We reach the trailhead tired and sore but delighted with the rewarding day. We have seen some of the world's most beautiful scenery, from barren tundra to lush mountain meadow, and thrilled to new plants and animals along the way. Hiking the Ute Trail proves to be a trip down a truly spectacular Rocky Mountain staircase.

Sounds in the Night: 1990

For many, outdoor enjoyment ceases with the sunset; darkness is a time to retreat indoors, as far away as possible from potential prowlers. We, however, enjoy nights in camp almost as much as we enjoy the days spent along our nature trails. They are times of reflection and relaxation amid a fascinating array of nocturnal sights and sounds.

The full moon is rising over a granite ridge behind our camp, and in its silvery light we can see half a dozen deer grazing placidly. A screech-owl flies to a tree limb nearby and calls repeatedly, a wavering song that always fills us with delight. It is another beautiful October night in Inks Lake State Park, one of our favorite stopping places as we wander through our home state of Texas.

We are here on a weekday, and the park has only a few other campers, most of them clustered together in the open trailer sites along the lake. We have selected a campsite farther back in the hills among the junipers and live oaks, a site chosen for its solitude and the lovely lichen-covered granitic outcrops all around us. We share the entire camp loop with only the deer and birds, and the windows

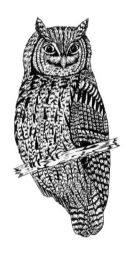

EASTERN SCREECH-OWL

of our small pop-top van are zipped open to the night. The temperature, which registered 101 degrees in Burnet in midafternoon, is dropping quickly. The tiny gnats that plagued us during the heat of the day have vanished with the sun.

We lie in bed watching the moon ascend through a sky filled with an uncountable number of stars. Even in the competing light of the moon, they shine more brightly than those we normally watch through the glow of city lights. We sleep for a short time and wake again to watch the sky. The screech-owl gives its eerie call and then falls silent as the deep bass hoots of a great horned owl echo off the ridge. The latter is one of our favorite melodies of the night, but it strikes terror in the hearts of many wild creatures.

Once there is a rustling sound in the fallen leaves around our van, quite different from the firm footsteps of the deer. It is probably the armadillo that we saw on the road as the sun was setting. In this warm weather, it is much more likely to be nocturnal than during the colder months of the year.

A rattling noise around the picnic table next rouses us, and we peer out to see a wide-eyed raccoon clamber up among our pots and pans. Finding nothing edible, it jumps back down and wanders off. Fortunately, we put our cooler away before we went to bed, for the lid would probably not deter a coon with all its strength and cunning.

In the middle of the night, a poorwill calls in the distance. This little western relative of the nighthawk and whip-poor-will has entertained us in several campgrounds across the western half of Texas, just as have the chuck-will's-widow in East Texas and the pauraque in the Rio Grande Valley. All call their names incessantly through the night, as if in fear of being forgotten as we compile our bird checklist for the trip.

We hear all these sounds against a backdrop of insect music, a

chorus so constant that it becomes white noise, no longer registering on the conscious mind. Unfortunately, although we know most of the insects by sight, we do not know their individual songs, and we make up our minds to learn them more thoroughly. There are so many things to master to help make each day, and night, more interesting.

Morning comes with the first pink glow in the eastern sky, and the screech-owl falls silent once again. It is shift-change time in the woods around Inks Lake. Now we hear the whistle of the cardinal and the mellow, two-note cooing of the Inca doves. A doe and her twin fawns stand only a few feet away, the fawns showing white spots across their flanks, remnants of the camouflage pattern of their early youth. We open the door, and they trot off a few feet, hooves clattering on the rock, then stop and look back curiously at us.

It has been a wonderful night, one filled with as much interest and intrigue as the day. We have lost a little sleep by listening to the nocturnal serenade, but we feel better for it. We wake rested and mentally refreshed, for we enjoy nature around the clock.

What's in a Name?: 1987

Several years ago, we had a friend who did not quite understand our insatiable passion for nature. He could see little point in keeping a list of birds or in trying to learn the names of wildflowers. It was not that he was immune to natural beauty; he simply did not care about placing the things he encountered or admired in neat little taxonomic pigeonholes.

"Why do you care what a bird is called?" he once asked us. "It is just as pretty and sings just as sweetly whether I know its name or not."

He was right, of course, but we believe that most people instinctively want to know what things are called. When we see something especially pretty, or interesting, or even horrifying, our first questions are usually, "What is it? What is its name?" It seems to us as

relevant to wonder at the identity of a beautiful bird song as to inquire about the composer when we hear a haunting, unfamiliar passage by Mozart or Beethoven.

In considering our friend's question through the years, and in attempting to teach natural history to countless classes and tour groups, we have listed three different ways to appreciate nature. We once called them "levels," but we do not like that term. It somehow implies a degree of desirability, and we do not mean to imply any such hierarchy or any increasing degree of sophistication. They are simply different approaches to the world around us.

The first step is simply the visceral reaction, "Gosh that's pretty." Or unusual. Or interesting. It is simply an enthusiastic response to a stimulus, an awareness that something exists and is worthy of notice and consideration. That is the most important element in the enjoyment of nature, for without the awareness and excitement, there can be nothing else. For our friend, it was sufficient. For many of us, it is a vital first step.

The second step is to learn the name of the subject. To us, seeing a number of birds or flowers without knowing their identity is like sitting through a concert without a program, hearing music we like very much but do not know. What is it? Who wrote it? How will we ever encounter it again if we do not know its name?

Sometimes those names reveal other fascinating facts. If carefully chosen, names can reflect origins or familial relationships. They may describe subjects more fully or draw attention to important details. If nothing else, names are the way in which we communicate with each other. They identify objects or concepts as surely as our own names identify us to our friends. Using them is the only practical way to inquire about things or to look them up in reference works. It is the only way to discuss the important why, how, when, or where.

The third step is to learn more about the subject whose name we now know and use. In the case of a plant or animal, for example, we find it interesting to know whether it is common or rare, how it functions, and how it fits into its environment. Familiarity with a creature's habits can help one find it and anticipate its actions.

Our response to our friend's question is that we enjoy seeing a

little yellow-and-black bird even more when we know it is an endangered golden-cheeked warbler. It somehow heightens the beauty of the song when we know it is proclaiming its territory from the top of an Ashe juniper while its mate sits on a nest somewhere in the shrubbery below. True, the bird's appearance and vocal prowess have not changed as we learned

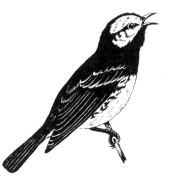

GOLDEN-CHEEKED WARBLER

more about the species, but our perception of them has.

Knowing more about a firefly or a ground squirrel, about what they are and how they live, does not alter the insect's marvelous pyrotechnic dance or the rodent's cheeky begging at our picnic table, but we believe that knowledge makes them more interesting.

No matter how much we learn about nature, however, and there are still endless roads to ramble and subjects to study, we believe it is especially important to not lose that initial enthusiasm. The great Texas naturalist and writer Roy Bedichek phrased it perfectly when he asserted that all too often the professional ornithologist tends to become insensitive to the pleasure of birds or conceals emotional reactions as bad form. "We speak of 'cold' scientific fact," wrote Bedichek, "as if temperature had something to do with verity."

We would like to learn the names and understand the inner secrets of every creature we meet along the nature trails of the world, and we encourage everyone to do the same. However, we hope we never lose the spontaneous enthusiasm of our first steps along those trails. Nature, with its endless variations and surprising strategies, is far too exciting for that.

2

Strategies for Survival

Plants and animals employ myriad strategies for coping with adverse conditions, whether it be the bone-chilling cold of an Arctic winter or the parching heat of a desert summer. Each has its own methods of enduring inclement weather; each has unique techniques for finding food and water and for reproduction in the face of predators and other threats. No single strategy works for all species, and it is this diversity that makes the study of nature so endlessly fascinating.

Coping with Cold: 1976, 1994

Winter is a particularly difficult time for the plants and animals that share our world. During that season they are involved in a struggle for their very survival. Easiest to observe, perhaps, are the adaptations of the various trees and shrubs. Some are evergreen, their tough, leathery leaves or needles protected against freezes and desiccating winds by aromatic resins, waxes, and other chemicals within their tissues. These protective compounds require an enormous investment in energy and raw materials, however, and they are not discarded lightly. Instead, the leaves remain on the tree throughout the winter, ready to function again when spring arrives.

Deciduous trees, on the other hand, adopt a "throwaway economy" rather than make a long-term investment. They synthesize few of the chemicals that protect the leaves of evergreens, instead

channeling their energy and resources into growth and seed production. They can thus afford to shed their foliage each year and grow new soft, tender leaves in spring.

Many perennial plants freeze to the ground, rising anew each year from hardy roots or bulbs buried deep within the soil. Other plants choose the annual approach, their future dependent on tough, hard-coated seeds that survive when other tissues freeze.

In contrast to plants that are rooted in one location and subject to the challenges of that environment, more mobile animals seek shelter from the harshest winter weather. Reptiles and amphibians burrow in the soil or into the soft mud at the bottom of ponds and marshes. Others seek out hollow or rotting logs or find dens among the rocks, curling up to sleep through the season.

Some mammals hibernate through the fiercest blasts of winter. Their body processes slow to almost undetectable levels, while their stored body fat fuels a tiny flame of life. The heart dramatically slows its beat, and respiration is shallow and infrequent. Body temperature may drop to half its normal value, and the high-speed "engine" idles silently, consuming body fat at only a fraction of the normal rate.

One of the most famous hibernators is the woodchuck, or "groundhog." It is also one of the soundest sleepers. Stuffing itself on plant material in early autumn, the roly-poly rodent then burrows below the frost line before winter's icy winds and snow descend on its domain. It gradually sinks deeper and deeper into an unconscious state as its heart rate drops from a normal eighty to ninety beats per minute to less than five. About twelve breaths an hour and a body temperature of forty degrees are barely enough to sustain life, yet they also conserve the stored fat reserves that must last until spring.

WOODCHUCK

Even though February 2 has been officially designated Groundhog Day, few of those animals are awake by then, at least in the northern portion of their range. More intent on surviving another six weeks of

winter than on predicting it, most will sleep until March, losing half their body weight in the four- to five-month nap.

Although not a true hibernator, even the formidable grizzly bear prefers a long winter's sleep to foraging for scanty provisions in the ice and snow. Bears, however, are relatively light sleepers. By some unknown mechanism, they apparently anticipate the first severe winter blizzard and seek out suitable caves, usually beneath the roots of trees. Here they fall asleep, sustained by a heavy layer of recently acquired fat as falling snow covers their tracks and the cave entrance with an insulating blanket. Because their body processes remain active, they may be easily aroused.

Other mammals, instead, dress more warmly for the cold, adopting thicker pelage in winter and shedding it as temperatures rise again in spring. Deer sport winter coats of hollow hairs that provide superb insulation, and the varying hare acquires an immaculate white coat that not only decreases radiation of precious body heat but provides excellent camouflage as well, a trait shared by such diverse creatures as the weasel, Arctic fox, and ptarmigan.

Some creatures simply store supplies away for midwinter consumption when other foods are difficult to find. Chipmunks, for example, spend the summer and autumn months putting up supplies in their burrows or sheltered niches. Acorns, grain and other seeds, dried fruit, and mushrooms are carried in cavernous cheek pouches and stored away. With the advent of cold weather, the chipmunks simply retreat to their pantries and fall asleep atop the food. Respiration and body temperature remain high enough so that they awaken from time to time. Selecting a choice morsel, they have a little snack and then doze off again.

Meanwhile, the beaver stockpiles tender branches at the bottom of its pond. The little pika, which lives among the rocks on high mountain slopes, cuts and stores a crop of hay in underground "barns." Small rodents and shrews make the most of the protective layer of snow by creating elaborate systems of tunnels through which they can roam and forage in comparative comfort and safety.

Cold-blooded *(now more frequently referred to as "poikilothermic")* insects and other invertebrates frequently hibernate during

the coldest portions of the year, their bodies protected by chemicals that act as a natural antifreeze. Some species hibernate as adults; others, only as eggs, partially grown larvae, or pupae. Each has its own distinctive reproductive cycle and slows the process to spend the winter in a suspended state called diapause.

Some butterflies and moths, for example, survive as tough-skinned eggs laid on twigs or bark. Others overwinter as chrysalides in the ground, beneath fallen leaves, or hung in some sheltered niche. Many of the moths encase their pupae in cocoons spun of silken strands. A few of our butterfly species cannot withstand a severe freeze at any stage in their life cycle. The famous monarch migrates southward for the winter and returns again when temperatures rise. Other butterflies not genetically programmed to migrate may simply die with the first frost, to be replaced the following year by southern populations that move northward once again, breeding as they go.

Most mobile of all wildlife populations are the birds. They, too, may migrate southward in autumn, although their movements differ greatly in extent. They migrate not so much to keep warm as to find adequate food supplies. Warblers and flycatchers that nest in temperate zones must venture into the tropics to find the insects they require; their places are taken by seed-eating finches that move down from the north. The Arctic tern forsakes its nesting grounds in the high Arctic to enjoy the longer days at the opposite end of the earth. Its round-trip journey each year means a flight of some twenty thousand miles. Meanwhile, the whooping crane, North America's tallest bird, finds the winter weather and provisions at Texas' Aransas National Wildlife Refuge more benevolent than in its summer home in Wood Buffalo National Park in the Northwest Territories of Canada.

Other birds have the ability to vary their diets with the season. Some that feed on insects during the spring and summer months turn to berries and seeds as the days grow short in autumn. Only if those crops fail will they be compelled to move. Mountain species may merely descend the slopes to find shelter and more abundant food supplies at lower elevations.

Many other creatures migrate to some degree. Fishes seek deeper

COMMON POORWILL

waters less affected by temperature extremes, and even the great whales move to warmer seas when ice chokes their summer range. Gray whales, for example, move southward along our Pacific coast from the Bering Sea to bear their calves in winter in the warmer bays and lagoons of Baja California.

Because they, too, are equipped with wings, bats often follow the example of the birds and migrate to warmer climates. Some, however, choose to stay in their northern breeding ranges, and they must hibernate, for there are few flying insects on which to feed during the dead of winter. In deep hibernation, a state reached more easily by bats than by any other mammal, the heart rate of a bat may fall to no more than three beats per minute.

Until the phenomenon of avian migration was discovered to explain the periodic disappearance of many birds, early humans believed they hibernated in the mud. That theory was then disproved completely—until December 29, 1946. On that chill winter day, Edmund Jaeger made a startling discovery; he found a tiny bundle of feathers nestled in a rock depression in the California desert. It was a common poorwill, a western relative of the whip-poor-will, and it was sound asleep. Jaeger could detect no heartbeat or respiration, and the bird's body temperature was more than forty degrees lower than normal. Then, slowly, one eye opened and closed again. The bird was hibernating. That same bird, marked with a numbered band, returned to the identical spot for four years, proving that at least one bird species shares the secret of sleeping through the worst of winter.

The world around us may seem relatively bare and bleak in winter, but life continues in abundance, often hidden from all but the most inquisitive minds and discerning eyes. Each plant and animal has its own plan to follow; many can survive even the harshest of environments.

Surviving Summer Heat: 1980

West Texas in midsummer does not have the most hospitable of climates, at least at lower elevations. Shrubs wilt in the afternoon sun, and grasses turn brown from the heat and the drought. Few flowers are in bloom. There are, however, many plants throughout the deserts of the world that are adapted for coping with searing sun and almost constant aridity. It proves interesting to discover how these plants endure in their seemingly hostile habitats.

There are two basic strategies for surviving desert droughts. Perennials manage to subsist from season to season, often employing a number of tricks to conserve moisture. Their extensive root systems seek out elusive water in the soil and quickly soak up the little that falls as rain. Other desert plants are more ephemeral, annuals that avoid the drought as seeds, perhaps lying dormant for several seasons until served with enough moisture to germinate. They then spring up quickly, flower and produce new seeds, and just as quickly die, their genes again residing solely within the seed.

Perhaps the best known of the perennials inhabiting the American deserts are the cacti, a family originally restricted to the New World but widely introduced in other regions. They range in size from the giant saguaros that tower fifty feet above the desert floor to tiny, round button cacti no larger than a fingertip. Cacti are equipped with shallow, wide-spreading, fibrous root systems lying very near the surface, for rain seldom penetrates deeply into the desert soil. With this network of roots, the plants can quickly absorb an enormous amount of water that is then stored in the thickened stems reinforced by expandable skeletons of rods or honeycombed networks of fibers.

To avoid giving up its hard-won moisture to the atmosphere, the cactus has forsaken leaves and produces its food in tough, waxy green stems. Those stems, in turn, are protected by thorns, armament developed as a defense against browsing animals. Many arid-country plants—trees, shrubs, and wildflowers alike—are

CREOSOTE-BUSH

thorny, an adaptation that protects the storage vats for most of the desert's water supply. Cactus spines not only provide defense but also function as a latticework to provide at least partial shade to the underlying stem. Especially dense at the tender growing tip of the plant, and often combined with long white hairs, they serve the same purpose as protective screens or lath sheds used by gardeners.

The spreading root systems of desert shrubs, each competing for the small amount of water present in the earth, create a surprisingly uniform spacing of the plants. In addition, some species may employ chemical warfare against their neighbors. Creosote-bush, brittlebush, and guayule of the southwestern deserts are all suspected of secreting toxic compounds that inhibit growth. Thus, a portion of the uniform spacing may be caused by older bushes poisoning the younger and weaker plants as well as by a simple struggle over subsurface moisture.

Some plants, particularly those that grow in streambeds and washes where there is deep-lying water, develop enormous taproots rather than the fibrous system. The mesquite so common in Texas, for example, has roots that may bore down a hundred feet or more into the soil. Young trees are virtually all root, and they do little growing above the ground until they have located an adequate supply of water.

Leaf adaptations vary widely among desert plants, but all are aimed at water conservation. There is little place for broad, fragile leaves that lose by transpiration more water than the roots can absorb. Generally, these adaptations provide for thick, succulent leaves or very tiny ones. Some are covered with a waxy coating or a cloak of velvety hairs. All reduce evaporation and protect the tender tissue within.

Some plants lose their leaves completely during times of drought.

The ocotillo and leather-stem of West Texas stand completely bare, looking absolutely dead until rain stimulates new green growth; upon drying out, the leaves fall again. Paloverde, too, drops its minute leaves under stress. Many such species have green twigs and branches containing chlorophyll to help in the manufacture of food, making up for the lack of leaf surface.

Evidently such devices prove extremely effective, for they are utilized by desert plants throughout the world. Often plants of unrelated families look much alike, employing the same mechanisms for survival. Thus, the cacti of the New World look much like the euphorbias of the Old World, and the yuccas and agaves of the Americas resemble the aloes of Africa.

Life in a world almost devoid of water is difficult indeed, but when it does rain, the desert blooms in wild profusion. Perennials turn green and burst into flower; annuals spring forth almost overnight from dormant seeds. The resulting bounty is a splendid sight, made even more beautiful by its spontaneity.

Facing the same arid, blisteringly hot conditions, animals encounter problems similar to those faced by plants, often to an even greater extent. Few creatures can endure the blazing sun for long; none can exist without water in some form. They, too, have evolved unique mechanisms to meet the challenges they face.

Simplest of the solutions to heat and drought, of course, is to move to a more benign climate. That is what some animals, particularly birds, accomplish by migration. With their great mobility, they are able to spend the winter months in warmer locations and then move with the lengthening days to a cooler climate farther north or at higher elevations in the mountains. Mammals may also follow periodic, seasonal rains, seeking watering places in order to survive. Most desert dwellers, however, are permanent residents of their environment. They have learned to cope with the conditions in a variety of ways.

The smallest creatures are potentially the most vulnerable, for the smaller the size, the larger the ratio of surface area to volume, surface area that is exposed to the heat and the drying effects of the wind.

COUCH'S SPADE-FOOTED TOAD

Many—insects, spiders, scorpions, crustaceans—have tough exoskeletons that are relatively impervious, keeping moisture trapped within and serving as protection against desiccation. These creatures are also able to creep into holes or crevices to avoid the direct sun.

Reptiles, too, are covered with an armor plating of scales that offers some protection. Because lizards, in particular, are seen so often in the desert, it might be assumed they are oblivious to heat. Such is not the case. Being cold-blooded, they have no internal cooling system and take on the temperature of their surroundings. In direct sunlight, the temperature of the desert floor may well rise to 170 degrees, and most reptiles suffer heat prostration and die quickly at 105 to 115 degrees. Thus, they must periodically seek shelter in the shade or disappear underground. Snakes are even more sensitive than lizards because they have no legs to keep their bodies from direct contact with the scorching earth. Most are nocturnal during the hottest seasons. In fact, most of the animal life of the desert prowls by night. Although the blazing sands may seem utterly deserted at noon, they come alive at dusk.

More drastic than simply seeking shelter by day is the strategy of estivation. Similar to hibernation in response to cold, estivation is the state of suspended animation in response to heat and drought. Ground squirrels, so active and visible during cooler seasons, may retreat to their underground burrows and sleep during the long, hot summer.

When ponds begin to dry up, the spade-footed toad employs a tough projection on each hind foot to burrow backward deep into the ground. There it lines its cell with a gelatinous secretion to reduce water loss and goes into a deep sleep that may last for many months. Not until a cloudburst saturates the soil will the toad awaken and emerge. Calling males are quickly joined by females, and the eggs are laid and fertilized almost immediately. Within a day or two

the tadpoles hatch, for there is no time to lose. A week later those developing tadpoles are able to sink into the mud at the bottom of the drying puddle. In less than four weeks, the young toads have reached adulthood and are ready to dig back into the ground.

The eggs of tiny fairy shrimp can lie dormant for decades in the parched, salty soil of the desert, waiting only for rain to provide a temporary pond. Land snails seal the openings of their shells with mucus that hardens and protects them from drying. Each creature has its own strategy for combating the hostile elements of nature; each survives in its own way.

Passing on the Lineage: 1991

Frenetic activity in the world outside our door proclaims that spring has finally arrived, and most of nature's subjects seem to agree with Tennyson: "In the spring a young man's fancy lightly turns to thoughts of love." The butterflies are making their appointed rounds of flowering plants, pollinating the blooms while seeking mates of their own. Cardinals and mockingbirds are singing their courtship songs.

Not all our wild creatures share this vernal enthusiasm, however. In fact, there are some animals that find no need at all for the male of the species. Numerous insects and other small creatures, and even some vertebrates, reproduce by means of unfertilized eggs. Called parthenogenesis, this strategy of reproduction is surprisingly widespread and successful, even if it does seem somewhat less than romantic to the poet or the young at heart. In some species, the males are short-lived and play only a supporting role; in others, there are no males at all.

The queen honey bee is fertilized only once, on an initial mating flight, and sperm is stored in her body. She can then lay either unfertilized, parthenogenetic eggs that hatch into male drones or fertilized eggs that produce female workers or other queens. The males derived from the queen's unfertilized eggs are still able to

mate, although they possess only half the genetic material that would normally be present in a fertilized egg. Subsequent females are all potentially sexual but become reproductive queens only if fed an especially nutritious diet.

In many of the stick-insects, males are nonexistent. The females lay only unfertilized eggs that produce only more females. Each daughter has exactly the same genetic composition as her mother. Biologists long thought that such reproductive traits were confined to invertebrates. However, the Russian zoologist Ilya Darevsky published an astounding paper in 1935 on his study of the Caucasian rock lizard. In collecting five thousand specimens, he found not a single male, and he suggested that these animals were reproducing by eggs that had not been fertilized.

A few years later, several whiptail lizard species in the southwestern United States were also discovered to be exclusively female. It is possible that these arose as hybrids, which would normally be sterile. Instead, the chromosomes in the developing female eggs double an extra time so that the eggs eventually have pairs of chromosomes as do normally fertilized eggs. The young are clones of the parent, and they, in turn, produce other clones. Often there are various geographical populations with similar but slightly different color patterns, each believed to contain descendants of a single individual.

The large number of aphids that feed on our plants in spring and summer reproduce so rapidly because they give birth to live young

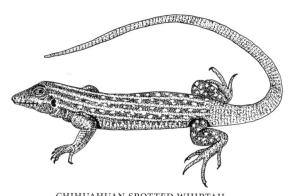

CHIHUAHUAN SPOTTED WHIPTAIL

by parthenogenesis. Most of the females are wingless, but at various intervals winged females hatch and fly off to start new colonies without need of a companion male. Then, in autumn, males appear, and the females mate and lay fertile eggs that lie dormant through the winter. Similarly, a number of gall-forming insects also alternate between sexual and parthenogenetic generations, sometimes in different portions of a plant.

The advantages are many. Only one parthenogenetic aphid, for example, need alight on a plant to give rise to a huge new colony. Without the need to secure a mate, the time between generations can be very short. The entire population can also reproduce, thereby doubling the number of potential young. On the other hand, there is no variation among the clones, and the species has less potential to adapt to changes in the environment or to the onset of disease. It is a useful strategy for some organisms but less suitable for most other creatures, particularly those that are more advanced on the evolutionary scale. Tennyson, to our knowledge, did not address the problem.

In recent years scientists have found parthenogenesis, or "virgin birth," to be even more widespread than previously suspected. Huge Komodo dragons may reproduce without mating, as do assorted other lizard and snake species. A female bonnethead shark, a species of hammerhead, gave birth in a Nebraska aquarium without access to a mate, and examination of the female baby found no contribution from male DNA.

The Eyes Have It: 1985

In response to a constant battle for survival in the natural world, various life-forms have evolved a wonderful array of defenses: camouflage colors and patterns, impenetrable spines, venomous bites and stings, toxins, mimicry, speed, and threat displays, to name but a few. One of the most striking of these defenses is the widespread

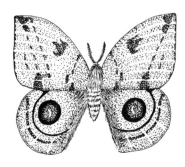

IO MOTH

adornment with false eyespots.

The Io moth found throughout eastern North America, for example, has a large eyelike spot in the scale pattern of each hind wing. Rimmed with black, these blue "eyes" contain gleaming white "pupils" to add to the realistic effect that may well save the insect's life. It would not be difficult to imagine them as part of a much larger face, and they must certainly give pause to an unsuspecting predator.

Other moth species share this defense. Too many, it would seem, to be accidental. The hind wings of the huge polyphemus also bear eyespots, as do many of its silkmoth relatives. Spreading their wings amid the foliage, the moths look not unlike large owls staring out at an intruder.

While at rest, moths normally sit with their front wings covering the hind ones, the eyespots and other bright colors hidden from view. Often cryptically colored, the forewings provide near-perfect camouflage on a tree trunk or leafy branch and make the insect extremely difficult to see. When disturbed, the moth then spreads its forewings quickly and reveals the huge, staring "eyes," a sudden flash that has been shown in laboratory experiments to startle even hungry birds. Should the bird or other potential predator not give ground, it may still hesitate long enough to allow its quarry to escape.

Numerous butterflies, lepidopteran cousins of the moths, also exhibit false eyespots. They attain a similar startle response by resting with wings held together above their bodies and then flipping them open to flash the hidden pattern. The common buckeye is one such species, and it complements the startle mechanism with subsequent darting, elusive flight.

Caterpillars of the moths and butterflies, too, may employ the same eyespot ruse. The green larvae of the spicebush and palamedes swallowtails and some of the sphinx moths have large, surprisingly

lifelike "eyes" on their bodies, well back of their smaller heads and functional eyes. In the latter case, the display becomes even more effective as the harmless caterpillar pulls its anterior body segments together and rears up to sway back and forth in an admirable imitation of a snake.

Equally frightening to the fledgling bird or timid rodent must be the eyed elator, a type of click beetle. The size of a human thumb, it bears two very large eyespots on its thorax. When disturbed, it bends its body sharply backward and then suddenly releases a locking pin to straighten with an audible click, propelling itself vigorously into the air. To a predator already intimidated by the staring "eyes," this probably proves to be the final straw.

Some creatures use false eyespots in a more passive and less threatening way. Tiny hairstreak butterflies, for example, sit with wings closed to display small, scintillating spots on the underside of the hind wings. Slender "tails" project outward and move as the butterflies rub their wings together, adding realistic antennae to the illusion of an insect head. Frequent triangular tears in hairstreak wings indicate that hungry birds often fail to guess which end is which.

Examples of false-eye and startle defenses abound. Coral-reef butterflyfish have large round spots near their tails, perhaps making it difficult for predators to anticipate in which direction they will dart. Frogs have colorful markings on the rear surfaces of their hind legs and flash them suddenly as they leap away. Many of our small animal species, particularly in the tropics, have evolved similar defenses, and these sightless "eyes" undoubtedly play a vital role in their survival.

Instinct Rules: 1984

Animals exhibit a virtually endless variety of instinctive adaptations essential for their survival. Lacking a high degree of "intelligence" as we understand and measure it, they are genetically programmed

to follow a pattern of behavior characteristic of their species. Some of those instincts appear amazingly intricate and complex, seemingly far beyond the capability of creatures with limited mental capacity.

Moth caterpillars, for example, may spin cocoons characteristic of that species alone, quite different in shape and construction from those of their near relatives. The promethea caterpillar builds its hibernaculum in a rolled leaf attached firmly to a twig with silk; luna and Io moth larvae descend to the ground to spin among the fallen leaves. None has learned the prescribed technique from its parents, which it never knew, nor did it take Cocoon Weaving 101 in caterpillar school. Each engineers its shelter according to a blueprint contained within its genes.

The small, stinging caterpillar Texans call the "asp," the larva of the southern flannel moth, makes a tough, compact cocoon with a trapdoor at one end. Fitting perfectly to exclude predators and the wind and rain of winter, that hinged portal can nevertheless be pushed open from inside to allow egress of the emerging moth. Never, even with opposable thumbs and supposedly superior intelligence, could we even begin to weave so perfect a refuge. The caterpillar, of course, has no more control over the type of structure it spins than over its own color or general appearance. It does not make a conscious choice. The behavior is simply driven by instinct along the paths that assured survival for its ancestors.

Consider, too, the instincts of the adult moths emerging from those silken cocoons. Their sole purpose in the complex cycle of insect metamorphosis is to mate and lay eggs, thereby producing another generation of caterpillars. Some caterpillars seem remarkably cosmopolitan in their choice of foods, browsing on many different types of leaves. Others, however, will consume only plants of a particular genus or family, and occasionally only those belonging to a single species. The female moth must thus select the proper plant on which to lay her eggs, or her offspring will starve to death. This she does by a combination of sight, scent, and taste, choosing properly a plant she may have never seen before. Long-tailed luna moths frequently choose sweetgum trees; tent caterpillar moths, wild

cherry. Io moths utilize a wide variety of larval hosts ranging from oaks to corn, but selected sphinx moths oviposit only on members of the grape family.

Insects of other scientific orders prove no less amazing in their instinctive behavior. A female twig-girdler beetle lays her eggs in the branch of a tree and then proceeds to cut off that branch. Around and around the twig she chews, utilizing her sharp but tiny mandibles, cutting like a miniature six-legged beaver, until her prospective nursery falls to the ground. Upon hatching, her young will then find a ready supply of the dead and decaying wood on which they feed.

The female mud-dauber wasp builds a nest of mud and provisions it with spiders to nourish her young. Nearby, a potter wasp may build another type of nursery. She brings tiny balls of mud in her jaws and molds them into a perfect vase, shaping the narrow neck and flaring lip until that vase seems worthy of an expert potter's wheel. She then provisions this work of insect art with caterpillars and lays an egg before sealing the opening and flying away, secure in the knowledge that she has fulfilled her role. Neither mud-dauber nor potter wasp draws a design, nor does either voluntarily choose its prey. There is no choice; the wasps are programmed. This, too, is instinctive behavior at its best.

A young spider starting out in life has no teacher or handy guide to web design and construction. Tentatively, perhaps, it strings a line between two supports and spins a frame of tough silken strands. Then, if it is an orb-weaving spider, it makes a circular section of sticky threads that will catch and hold its prey. Each type of spider holds an innate pattern within its genes. It "knows" the form its web should take.

Larger animals also rely heavily on instinct. Birds apparently possess more intelligence than do insects, at least in the way we think of it, but their nest-building skills are no less instinctive. Baltimore ori-

MESQUITE
TWIG-GIRDLER

oles weave a hanging pouch in which to rear their young. They do not build a platform of sticks, nor do they nest in a hollow on the ground. They are not hawks or killdeer; they "know" they are orioles and build according to the oriole blueprint they have inherited.

It proves instructive to think about the behavior of animals and the things they do so well. Given a supply of silken thread, we would be hard-pressed to spin either a spiderweb or a caterpillar's cocoon. Nor could we hang by our toes from a swaying tree limb and weave a nest to hold a clutch of the oriole's speckled eggs. Those instincts have been strongly ingrained in the creatures that possess them. It is nature's way of providing for their continued survival.

Insect Architects: 1975

How would you like to be presented with a brand-new home, rent free and completely stocked with food for your growing family? No, there is no new government subsidy, and none of us will be able to take advantage of the plan. However, tiny creatures collectively called "gall insects" qualify for just such assistance programs, many of them right in our own backyards.

Numerous wild creatures—ranging from wasps to humming-birds to beavers—build their own homes, displaying remarkable architectural and engineering aptitude in the process. Gall insects need no such building skills, however. Their homes are made for them by plants as soon as they choose a location and begin to raise a family.

Insect galls take many forms. A walk in the woods or a tour of your yard will almost certainly reveal strange growths on the leaves or twigs of bushes and trees. They may take the form of round balls, hard little lumps, or even soft, woolly masses. All of these curious deformities to the normal growth pattern of the plants have one thing in common. They were produced by the plants themselves in response to insect stimulation.

How do these growths form? Not even the scientists who study

them have all the answers. These growths are of interest to the entomologist because they are inhabited by insects and to the botanist or horticulturist because they involve abnormal plant growth. Even cancer researchers once investigated these anomalies because they represented cell growth gone awry.

Just how insects induce the plants to begin their building projects remains something of a mystery. The female insect pierces the plant tissue with her ovipositor, or egg-laying organ, and lays one or more eggs in the cavity. The wound initiates formation of gall tissue by the plant, and the growth continues as the insect larvae hatch and begin to feed, flooding the tissue with their own secretions. Safely sheltered from predators and inclement weather, the young insects eat away at the walls of their home, eventually pupating inside and then emerging as adults through tiny holes to mate and start the cycle once again.

The mystery of the galls is that they are characteristic of the particular insect parasite. The same kind of insect can cause similar growths on different species of plants, whereas a single plant infected by more than one type of insect may produce galls that are very different in appearance. Although the structure is produced entirely by the plant, the insect controls the form it will take. In human terms, the insect is the architect, and the host plant plays the role of builder.

Literally thousands of kinds of gall insects in several families work their magic in this manner, and their ranks know no taxonomic bounds. Tiny wasps, flies, moths, aphids, sawflies, and mites all live in made-to-order shelters provided by their hosts. Conversely, almost no form of plant life escapes unscathed, from towering trees to ferns, fungi, and even algae. While some insects instinctively lay their eggs only in a specific plant

OAK-APPLE GALL WASP

species, others utilize many hosts. Thus, the combinations seem almost limitless. More than three hundred kinds of galls have been identified on oak trees alone.

The familiar round goldenrod gall harbors a tiny fly larva, and the spindle-shaped gall on the stem of the same plant contains the caterpillar of a miniature moth. Both small boys looking for fish-bait "worms" and downy woodpeckers in search of a tasty morsel have learned to open the shelters to reach the larvae deep inside. A fly also causes willows to produce the strange and aptly named "pine-cone galls," while ovipositing wasps produce large oak-apple galls and the fuzzy growths on oak leaves and twigs.

Most galls prove relatively harmless to the plants, although they may temporarily detract from their appearance. Leaves shrivel on trees, and grotesque growths appear on roses and chrysanthemums. Periodic spraying may help keep ornamentals free from gall insects, but those insecticides also kill beneficial insects and should be used wisely and in moderation, if at all.

Only in special cases do insect galls cause large-scale damage. The wheat jointworm weakens stems of its host plants and sometimes causes stands of grain to blow down during storms. Gall-forming insects also destroyed thousands of acres of grape vineyards, seriously threatening the French wine industry, before resistant rootstock from America was imported as a base for successful grafting.

Indigenous people and early settlers to America once used galls for a number of different purposes. Oak galls rich in tannic acid produced compounds useful for dyeing fabrics, tanning leather, and making ink. Synthetic chemicals have now replaced their natural precursors, and galls have little practical value—except as fascinating bits of nature lore and as well-provisioned homes for the insects that "design" them.

3

Monarchs of the Forest

Few living things have as much visual impact as do the trees, whether they be towering, straight-trunked pines in a crowded woodlot or a single gnarled, majestic oak standing alone and exposed on a hilltop amid prairie grasses. Old-growth evergreen forests with their massive trees are treasures beyond compare, but so, too, are mangrove thickets along our subtropical coasts and aspen groves perched high on our western mountain slopes. Trees draw our eyes and our minds to the world around us, yet all too infrequently do we stop to appreciate their wondrous variety and intricacies. Trees are not just timber destined for human use; they are the framework on which nature hangs some of its most miraculous artwork, art that proves rewarding in any season of the year.

Miracles of Packaging: 1980, 1990

Spring is a magical time of year, a time when everything begins to grow anew. It is almost as if the trees have been waiting for just this moment to release pent-up energy held in check throughout long winter months. And that, in fact, is just what happens, for the new leaves and shoots have lain dormant in their buds, waiting almost unseen for the proper combination of temperature and increasing daylight hours to break free and unfurl their promise of continued life and vigor.

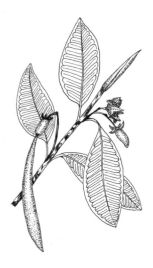

RED MANGROVE

Without these buds, no leaves would grace the branches nor flowers bloom. Yet the embryonic growths, which seem so insignificant, are seldom noticed on giant trees. They are, however, the active centers in the crucial lifeline of the plant. At the tip of each twig is a terminal bud; other lateral, or axillary, buds form in each leaf axil.

The process starts the previous year, when that season's leaves are opening. At the same time, plant cells begin to form other tiny structures that will become future foliage and flowers. Because most of the tree's energy is needed for its present growth, however, the new units remain almost microscopic in size, tucked away along the twigs at the base of each leaf. Then in summer, when the functional leaves are fully grown, flowers have bloomed and set fruit, and there is energy to spare, the tree shifts some of its growth to insurance for the future. The new structures grow into tiny leaves and flowers that are folded tightly and packed together inside the buds. When the mature leaves fall in autumn, these buds persist beside the leaf scars, promising new growth again the following spring.

Most burgeoning buds develop into leafy twigs, the terminal buds continuing the growth of the original twig, while the lateral ones provide branching in other directions. Some, however, are exclusively flower buds, and a few tree species produce mixed buds that contain the rudiments of both leaves and embryonic flowers. Still other accessory buds, sometimes deep seated beneath the bark, may lie dormant for years until they are forced into growth by pruning or damage to more active buds.

Overlapping bud scales cover the embryonic tissues and protect them from injury. So characteristic are the buds of each tree and shrub that it is often possible to identify them to species by their

shape, color, and texture. Flowering dogwood, for example, has broad, bulb-shaped buds; those of the magnolia are covered with large, silky scales; and those of the beech are slender and bronze. Some buds are fuzzy; others are sticky with viscous waxes and resins.

It might be supposed that the bud scales serve to protect delicate inner tissues from the cold, but there is no good evidence to suggest they help retain heat. The temperature of the bud is essentially that of the surrounding air, and ice crystals often form inside. Rather, the envelope protects the embryo from dehydration by the desiccating winds of winter. Then, with the lengthening days, growth begins anew. These growth processes generate heat, and the temperature within the swelling buds begins to rise.

Neatly packaged within the buds, the new leaves are folded in such a way that they do not break the veins, for these not only transport food and water but give strength to the mature leaves. Some leaves are simply rolled lengthwise, while others may be folded on either side of the midrib. Leaves of sycamore and sweetgum, with several major veins, are folded fanlike between those veins and magically unfurl without damage.

Some species of trees open their buds quickly at the first hint of spring; others are more reticent to accept the promise of continuing warm weather. The former, instead of gaining an advantage, may lose their first leaves to an unexpected freeze, for new growth is extremely tender. The latter, genetically programmed to play it safe, may actually have made the better, although involuntary, choice.

Among our favorites are the mulberries planted along our back fence to attract the birds. Their buds are large and stout, each covered by a series of overlapping scales. When they burst open, an amazing cluster of developing leaves and flowers pours out. Within hours there seems far too much growth

MULBERRY BUDS

to have been accommodated within so small and vulnerable a package. We eagerly await the opening of these buds each spring, for in them rest the promises of yet another year.

Flowers for All Seasons: 1987, 1988

There is a wonderful rhythm and harmony to the world of nature. Each element, as with each instrument of an orchestra, has its own part to play in concert with the others. The underlying rhythms are dictated by the seasons, and in the spring the music seems to swell anew, building to a crescendo as trees unfurl their leaves and burst into bloom. The melody plays on, however, for not all flowers bloom at the same time. Each species has its own short solo set in the score of a yearlong symphony.

Walking an East Texas trail in early spring, we delight to redbuds in full flower, purple tracings along each branch, outlining a framework soon to be hidden beneath broad, heart-shaped leaves. Wild Mexican plums glow white in the dark, damp woodlands, early harbingers of a season still advancing uncertainly against the residual winter chill.

MEXICAN BUCKEYE

Before long there will be the much-heralded wild azaleas and flowering dogwoods throughout the region, a pageant equaled only when bluebonnets reach their peak along our Texas roadways. It draws throngs of people along forest paths, an experience made all the more welcome by warming days and a greening world.

Like the herbaceous wildflowers, tree blossoms occur in myriad sizes, shapes, and hues.

Among the largest are the saucer-size, waxy blooms of the southern magnolia and the more delicate flowers of the sweetbay. One of our favorites has always been the orchidlike trumpets of the catalpa, which give way in summer to a profusion of long seedpods. We look forward to the fragrant cascades of black locusts along swampy woodlands and to the ethereal white flowers of fringe-trees that grace Big Thicket paths.

Moving westward across our state as we are wont to do each spring, we delight, too, in the huisache, blackbrush acacia, and mesquite that perfume the limestone hills. We seek out the beautiful Mexican buckeye and Texas mountain-laurel, *Sophora*, with its grape-colored clusters of fragrant flowers.

These are some of the species most people consider "flowering trees," the ones with blooms large and showy enough to be ornamental in their season. They are not the only ones, however, for all trees must perpetuate their species. Even those that bloom unnoticed are interesting and worthy of a closer look.

In our backyard, the harbingers of spring are the willow oaks with their slender, pendent catkins of staminate flowers that hang fringelike from the slender twigs. They burst forth with the first tiny leaves, lime green, developing almost hour by hour to spread spring's primary color in waves across the yard. Each of the oaks blooms in its own time. While the willow oaks are in full flower, nearby post oaks stand bare and stark against the sky. They will acknowledge spring much later, their larger catkins more sensitive to lingering cold.

Spring in more northern latitudes is often heralded by pussy willows, wonderfully fluffy catkins that burst their buds when most others are still held hostage by winter winds. As children growing up in Minnesota, we picked branches of them to bring indoors, scarcely thinking of them as "flowers," without petals or bright colors, without the obvious floral parts we would eventually study in introductory biology. Their true identity was most obvious, perhaps, in the swarming bees and butterflies attracted to the first nectar and pollen of the season.

The willows of our more southern swamps are also early bloomers.

SWEETGUM FLOWERS

Their catkins are larger and yellow flowered, perhaps less attractive than the appropriately named pussy willows but no less indicators of winter's end. Even earlier are the tiny blooms of red maples, red-anthered flowers that combine with new red leaves and developing samara-winged seeds to give a rosy blush to lowland swamps. Indeed, we often neglect to search for them until it is too late, forgetting their penchant for setting the tone for an early spring.

One of our favorites, although not brightly colored, is the star-leaved sweetgum, whose flowers stand up like greenish candles on the twigs. Each tiny, petal-less bloom masses with others into round globes that make up the racemes, stamens and pistils in separate flower heads. As the female flowers begin to ripen, they droop downward from the spike, eventually giving rise to the spiny fruits we know as "sweetgum balls."

Not until autumn does the shrubby baccharis begin to bloom along our roadsides and across the prairies, its massed composite blooms attracting hordes of butterflies. It is then, too, that our cedar elms put on tiny flowers, rosy purple anthers laden with yellow pollen. Small and inconspicuous, they are scarcely visible among the leaves, and we might fail to notice them except for the swarming honey bees that visit faithfully.

Through the years we have delighted to blooming madrones and guayacans, Allegheny chinquapin, and many species of viburnums. We have sought out and photographed buttonbush and cyrilla, or titi, in East Texas swamps as well as anaqua and retama in the Rio Grande Valley. All are fascinating in their own right; all have parts to play in nature's floral symphony.

The Fruits of Their Labor: 1989

It is a cool, still morning as we wander through an East Texas woodland. Sun filters through leaves turning autumn red and gold, and dew glistens on the bronzing seed heads of the grasses and from gossamer spiderwebs strung across our path.

It is a near-perfect day, and we thrill to the fall color of the trees. Today, however, we are intent on finding and photographing the various fruits produced by those same trees. They, too, are bright and colorful, intricately formed gems that add their own special appeal to the autumn scene.

Dogwood leaves form a crazy-quilt pattern of green and red, the color developing in isolated, squared patches on each leaf. Among them are clusters of bright red fruits so popular with wild birds. Each oval fruit, topped by a tiny crown that is the persistent calyx of the flower, was formed by a separate tiny yellow green blossom. Collectively, they offer proof that each structure we tend to think of as a dogwood "flower" is really a cluster of small blossoms subtended by four large white bracts.

Compact clusters of purple berries cover the arching branches of American beauty-berry. This abundant understory shrub is widely known as French-mulberry or Spanish-mulberry, although it is neither French nor Spanish. "American beauty-berry" is a literal translation of its scientific name, *Callicarpa americana*. It remains one of our personal favorites, but we know that we will be dissatisfied with our photos, for no film seems capable of reproducing the exact color that we see. We find this hue nowhere else in nature, one that deserves a special name, and we vow to carry a com-

FLOWERING DOGWOOD FRUITS

prehensive color chart sometime to determine which sample most closely matches.

The various members of the holly family add their own special shades of red and orange to the landscape. American holly, with its spiny evergreen leaves and pale bark, has a relatively large fruit that is just beginning to blush with the promise of the first frost. Yaupons grow throughout the forest, the female plants laden with red orange berries. In a little clearing along a fencerow, a possum-haw holly, or deciduous holly, has already lost most of its leaves. The branches, however, hang heavy with bright red fruits. All of these holly species are dioecious. Each tree has flowers of a single sex, and only the females bear fruit.

There are other little gems at which we stop to look more closely. Red bay, with its waxy green leaves, has scattered ovoid fruits that are a rich, deep blue black. The Carolina buckthorn, often called "Indian-cherry," has berrylike drupes in various stages of ripeness and colors ranging from red to black. We find a large persimmon tree hanging heavy with its autumn bounty, but the greenish orange fruit is still far too astringent for our taste. We will come this way later in the year to see if the opossums and raccoons have left some for us to share.

This is a time of high activity for all the creatures of the forest. Both birds and mammals are making the most of the berry and nut crops, eating their fill and storing away a portion against a time of less abundance. Fallen pecans, hickory nuts, and acorns of several different oaks have all been chewed open by squirrels and mice to get at the tasty meats inside. Empty shells litter the forest floor.

We search through the copper-colored fallen leaves beneath a beech until we find a few nuts the rodents have neglected. The intricate burlike husks are open in four valves, like miniature lanterns, the outside of that husk covered with curved, prickly spines. Inside each we find two triangular nuts, sweet and tender, leaving no doubt as to why beechnuts are a favorite wildlife food.

We wander on into the warming day, discovering new gems at every turn. Some are bright and colorful; others, wonders of intricate

and delicate design. The flowers of spring have long since faded and fallen, but the fruits of their labor add greatly to this new autumn season.

Autumn Leaves: 1976, 1984

Admittedly, the trees of the Texas coastal region in which we reside cannot match New England's flaming autumn display, nor are they as dazzling as the burnished gold foliage that cloaks the light-barked aspens on western mountaintops. Our fall colors are widely scattered and more subtle. They must be sought after and appreciated at closer range. But they do exist, and they are well worth stopping to admire.

These seasonal changes are triggered by the decreasing length of the photoperiod, the shortening of the days. Within each leaf a layer of corky cells forms at the base of the petiole, or leaf stalk. Circulation to the leaf is cut off. The plant's miniature food factories shut down.

Delightful childhood stories to the contrary, Jack Frost does not paint each leaf with a magic brush. Indeed, too severe a frost may instantly kill the leaf and turn it brown, with scarcely a hint of its potential fire. The seemingly magical process is one of simple chemistry within the cells of the leaf itself.

Yellow colors are due to carotenoids, compounds that produce most of the golden hues in nature. They are the pigments in a canary's feathers, a dandelion's flowers, and the skin of a lemon. Carotenoids are present within the leaf throughout the summer, but they are masked by the bright green chlorophyll nearer the surface. When circulation in the plant slows, chlorophyll production ceases, and the yellow color shines triumphantly through.

Reds and purples are due to anthocyanins, other compounds contained in the plant's sap. Sugars trapped in the leaf undergo chemical reactions in sunlight to produce those anthocyanins.

The more sugar present, the more vivid the resulting color. Thus the brilliance of the northern sugar maple and the more southerly sweetgum.

Cool fall temperatures help slow the removal of sugar from the leaf and facilitate the process, but sunlight is also required to provide energy for the chemical reactions. Hence, a combination of cool, crisp nights and bright, sunny days produces the most colorful display.

Each tree species has its own characteristic colors. Sweetgums turn a rich purplish red, sometimes veined with yellow and orange, while flame-leaf sumac more than lives up to the promise of its name. The broad, oval leaves of flowering dogwood are colorful mosaics of scarlet, green, and gold. Beeches and hornbeams adopt more subtle shades of copper and bronze, seeming almost to glow in the filtered light of the surrounding woodlands. Many are cloaked in Virginia creeper, poison ivy, or blackberry vines, each adding their bright colors to the autumn palette.

One of the more colorful trees in Southeast Texas, unfortunately, is also a pernicious alien. Introduced into the United States as an ornamental, Chinese tallow has now spread throughout the southeastern states, from the Carolinas to Florida and westward to Oklahoma and Texas. A prolific species, it readily sprouts from seed and grows wherever it can put down roots. Open fields quickly become thickets of seedling tallows, threatening to crowd out many of our less vigorous native plants. Once praised for its rapid growth and bright autumn colors, it is now on environmental lists as one of our most serious problem species.

As with many other trees, however, not all Chinese tallows acquire brilliant red and yellow fall foliage. Some seem merely to fade to pale green

CHINESE TALLOW

before the leaves wither and drop. Rather than a result of climatic conditions, this is likely a genetic trait passed down through successive generations.

Most regions of the country claim at least a few tree species—whether they be sweetgums and dogwoods in East Texas, riparian cottonwoods in the Great Plains, aspens in the western mountains, or sugar maples in the Northeast—that add color and beauty to the woods and fields in autumn as they shed their traditional green garb for vibrant crimson and gold. It is as if Nature is throwing one last flamboyant party before yielding to the more somber moods of winter.

The Trees of Winter: 1979, 1989

At first glance, winter may seem a dreary season. The weather is often bleak and cold; there are few wildflowers to brighten the surrounding fields; and the oaks and elms stand naked against banks of ominous dark clouds, the grayness of the forest broken only by the evergreen pines, magnolias, and hollies.

Yet the fact that the trees are leafless serves to make their characteristic shapes more evident. Gracefully arching branches or twisted, gnarled limbs can more readily be seen as artful tracings against the sky. Shapes and patterns lost in the green canopy of summer are now on display, like an exhibit of minimalist art newly hung in an outdoor gallery.

One of the most beautifully shaped of all our trees thus revealed is the American elm. From its tapering trunk, the large branches arch upward to impart a vaselike symmetry that seems somehow the epitome of natural grace in wood. Seeing these trees now, scattered through our woodlands, brings back memories of elm-lined streets in midwestern towns, streets now left unshaded by the ravages of imported Dutch elm disease.

Less graceful, but with a massive grandeur all their own, are the oaks so common throughout our forests. Of several species,

AMERICAN ELM

they follow no rigid blueprint but grow as if by whim into wildly branching shapes, each individual following its own inclination as to how an oak should look. Broad-crowned sweetgums and sycamores branch more evenly, their silhouettes further adorned with hanging fruits. Like Christmas ornaments, the balls of seeds sway in the chill wind, offering tasty morsels to resident chickadees and titmice and to vagrant winter finches.

Although each tree is genetically programmed to attain a characteristic shape, environment often overwhelms heredity. Crowded saplings stretch or bend to catch the life-giving rays of the sun and to avoid competition with their neighbors. Like people, perhaps, each attains its full potential only when given room to grow. The leafless winter trees provide character studies both for lovers of natural beauty and for philosophical minds.

Interesting, too, is the variation in bark on the trunks of the winter trees. The protective skin may be smooth or rough and

deeply furrowed, drably gray or brightly colored. Some trunks are decorated with lichens in orange, blue, and green or with fungi of myriad shapes; others bear delicate patterns inscribed by mosses, algae, and liverworts. Each tree trunk offers a living garden of other plant forms.

A personal favorite is the sycamore. Flaking off in smooth, flat sheets, the older bark falls away to reveal new whitish or pale green skin beneath. The effect is that of a patchwork quilt or a paint-by-number picture in which blotches of color ornament the trunk. Unlike the bark of the sycamore, that of the oaks forms a rough, thick sheath of corky cells. Not as attractive, perhaps, it is nonetheless utilitarian. Such bark provides an effective barrier against injury and disease. The smooth trunk of the beech and the shaggy bark of the hickory are both distinctive, as is the smooth outer bark of the hackberry that is spotted with corky, wartlike growths.

American hornbeam, too, has an easily recognizable bark, smooth but rippled, as if underlain by bulging muscles. The hardness of the wood gives the hornbeam its common name of "ironwood," but the muscular appearance lends credence to that name. Nearby, springing up along a fencerow, are several sapling Hercules-clubs, or yellow prickly-ashes. Those names derive from the sharp spines arising from broad, corky bases on the trunks and branches. The more common name, "toothache-tree," results from the mouth-deadening effect imparted by chewing on the bark.

To many people, perhaps, trees seem most beautiful when wreathed in spring flowers, the green of summer, or the fiery shades of autumn. In winter, however, their unique patterns and varied textures stand fully exposed, providing interesting subjects for study along any of our nature trails.

Trembling Leaves: 1983

Perhaps the most widely distributed tree in North America is the well-known aspen, a species famous for its golden autumn foliage.

Even as it stands bare limbed in winter, however, it is immediately recognizable for its smooth, white bark tinged with green. Generally called the quaking aspen, it also goes by the names of trembling aspen, golden aspen, poplar, and popple in various portions of its range.

Botanists place the quaking aspen in the same family as the willows, cottonwoods, and other poplars, a total of approximately 350 different species. Although its members are nearly worldwide in distribution, the family occurs most abundantly in the northern temperate and subarctic regions. All of our cottonwoods and poplars belong to the genus *Populus*.

Like its common name, the scientific name of the quaking aspen, *Populus tremuloides*, refers to the manner in which the leaves quiver and shake in the slightest breeze. The movement occurs because the long, slender leaf stalk, the petiole, is flattened at right angles to the leaf blade, thereby allowing it to twist easily in the wind. The leaves themselves are relatively small and round, with abruptly pointed tips. Bright shiny green above and paler green below, they contrast beautifully with the darker, more somber foliage of the spruces and firs with which the aspens usually associate.

Indeed, in the western mountains, aspens may be the only deciduous trees amid huge stands of Douglas-fir, blue and Englemann spruce, and white and subalpine fir. In spring their pale lime green leaves burst from thickly scaled buds to herald the coming season; in fall they light up the hillsides with tapestries of gold. They grow in exhilarating places, these white-barked trees, in mountain meadows carpeted with wildflowers and beside bubbling streams and beaver ponds teeming with trout.

QUAKING ASPEN

Although quaking aspens achieve their most spectacular autumn color in clear mountain air, they cover a large portion of the continent, from

Alaska to Newfoundland and southward to Virginia in the East and to southern Arizona and New Mexico in the West. They even range into mountainous areas of Mexico. From near sea level in northern latitudes, they reach elevations of ten thousand feet farther south. In Texas, aspens are confined to the higher slopes of the rugged Trans-Pecos. Here, in rocky canyons and spring-fed draws, they inhabit isolated islands of more northern flora and fauna that rise up from the surrounding desert floor.

Fast-growing "pioneer" trees, quaking aspens also spring up in abandoned fields and in clearings caused by fire and lumbering. Most reach no more than twenty to forty feet in height, with trunk diameters of fifteen to twenty inches, although a few giant aspens may grow to three feet in diameter and one hundred feet high. They are relatively short-lived and begin to decline at an age of about fifty years, perhaps living fifty more before giving way to natural succession. Frequently they are replaced by conifers that have sprouted in their shade.

Where aspen groves collect heavy snow cover, the trunks become twisted and bent, for the supple young trees are easily deformed by pressure from the drifting snow. The wood is soft and light, unsuitable for structural use but popular for making boxes, matches, clothespins, furniture parts, and particleboard. Wood pulp constitutes an important market, for aspen is cheap to cut and peel, and its white fibers bleach easily in the papermaking process.

The bark at the base of larger aspens becomes dark and furrowed with age, contrasting strongly with the greenish white of newer growth. Although extremely bitter to the human palate, the bark, twigs, and foliage are eaten readily by deer and elk as well as by rabbits and numerous small rodents. Grouse and quails feed heavily on the winter buds, and the inner bark is a favorite food of beavers, whose life often revolves around streamside aspen groves.

Because of the light bark, the aspen is frequently confused with the white birch, or paper birch. The latter, however, has bark that peals off in thin papery sheets, whereas the bark of the aspen adheres tightly to the trunk and does not peel. The two species are not closely related.

Standing leafless through the long winter months, quaking aspens unfurl their leaves and begin to bloom as the sun warms the meadows or mountain slopes in spring. Male and female catkins grow on separate trees, and the fluffy seed-bearing fruits drift on the wind. Through the summer the quivering, trembling leaves will manufacture food against yet another winter, and then the aspen grove will flame once more in autumn brilliance.

The Hardy Mesquite: 1984

"Spring comes to the mesquite first as a sudden rush of green to the twigs whose arthritic fingers seem to grow limber now; at this time the twigs are palatable browse to deer and cattle. Then the leaf buds burst and the foliage, at first an ethereal green, spreads over the thorny crown like a halo; swiftly each *bosque* catches the green fire, as the twice-compound leaves expand their ferny, frondose grace." Thus did nature writer Donald Culross Peattie describe the advent of spring in the desert Southwest. It is a lovely, welcome greening of the arid, winter-browned landscape, a spectacle that takes place across much of southern and western Texas.

Botanically speaking, mesquite is a legume, a member of the abundant and widespread pea and bean family. Its common name is a Spanish adaptation of the Aztec *mizquitl. Prosopis juliflora,* as it is known scientifically, grows primarily as a tropical species, with its distribution centered in Mexico and Central America. At least three varieties occur northward into Texas: velvet mesquite, Torrey mesquite, and honey mesquite. It is the latter, variety *glandulosa,* that ranges across much of the state; the others thrive primarily in the far West. *(The honey mesquite has recently been accorded full species status as* Prosopis glandulosa *by most botanists.)*

Honey mesquite grows as a thorny shrub or small tree that may reach a height of thirty feet and often forms dense thickets in dry terrain. If it were to occur in a rich, moist forest of larger trees, it would scarcely be noticed. Judged with its peers, however, it seems

more impressive, for it towers over most of the spiny, drought-stricken desert shrubs, putting on lush green leaves when most seem to struggle for their very existence in the blazing summer heat.

HONEY MESQUITE

The key to the mesquite's success lies in an enormous root system, with a taproot that is often larger than the trunk itself. The taproot may extend downward forty feet or more until it reaches an adequate water source, sending out radiating roots in all directions to compete for precious moisture. In the driest regions, it is confined to creek beds and washes; in less hostile environments, it grows up across the surrounding hills. Because of their size, the roots of the mesquite were frequently dug up by early travelers and settlers to serve as fuel. Texas' Big Bend, in fact, has been described as a place where "you have to climb [to hillside springs] for water and dig for wood."

Mesquite trunks normally divide into crooked, drooping branches a short distance above the ground and are usually less than a foot in diameter, although much larger specimens do occur. The bark is dark and rough and frequently stained black by resinous sap. The heavy, reddish brown wood is hard and durable and would certainly serve as a premier cabinetmaking wood if the trees grew larger and the trunks were taller and straighter. It is, however, used in making southwestern furniture and specialty items, and its durability in the ground makes it extremely useful for fence posts. More important to backyard cooks, mesquite-smoked barbecue proves second to none.

The leaves of honey mesquite are bipinnately compound, divided into two (occasionally four) parts and then divided again into ten to twenty pairs of small leaflets. Stout, straight spines arise

from the bases of the leaves that sprout from zigzag twigs. Small, five-petaled, greenish yellow flowers occur in pendent racemes that readily attract bees and produce excellent honey. Along with the related acacias, mesquites prove popular with beekeepers through the desert Southwest.

Mesquite fruits, or "beans," are long, straight or slightly curved pods filled with shiny brown seeds. They lack natural suture lines and do not open; instead, the pods release the seeds upon decomposition of the spongy tissue. Cattle readily browse these pods, which serve as a valuable wildlife food for deer, rabbits, coyotes, skunks, ground squirrels, quails, and doves.

Containing up to 30 percent sugar, mesquite beans also served in the past as a staple in the diet of almost all Native Americans in the Southwest. Ground into meal, the beans made a tasty bread; fermented, they produced an intoxicating beverage. In places where there were no other trees, mesquites proved vital to Native Americans and pioneers alike, providing food, fuel, and welcome shade. Their roots help control erosion in a region where soil loss continues to be a major problem, but at the same time, they are major "range weeds" that shade out native grasses and deprive them of precious water.

Frequently an indicator of overgrazing, mesquite has spread northward from Texas into Kansas, Oklahoma, and Arkansas. The seeds pass through the digestive tracts of cattle and are sown anew across the range. Scattered trees were a blessing in the arid grasslands; mesquite thickets have become a curse. Peattie phrased it very well: "So mesquite is something more than a tree; it is almost an elemental force, comparable to fire—too valuable to extinguish completely and too dangerous to trust unwatched."

4

The Staff of Life

We live surrounded by green and growing plants, from towering trees and lovely wildflowers to the myriad grasses, ferns, mosses, and algae that occupy virtually every habitable niche on earth. Without green plants, life as we know it would be drab indeed. More to the point, it would cease to exist, because plants are the only organisms that can manufacture their own food using water, nutrients from the soil or air, and the energy of the sun. All animal life-forms feed on those plants or on other animals that do. The plant world provides the basis for an amazingly intricate web of life.

Simple biomass, individual monocultures of plant species, is not enough. Most insects, for example, feed only on a few select species in a plant genus or family. They, in turn, fuel other specialists. The pyramid builds, each group of green plants providing for its own wildlife community. Diversity is the key to a balanced environment, one that nourishes humans as well as insects, birds, and other mammals. Diversity, moreover, makes the world more beautiful to our eyes.

An estimated 250,000 flowering plants bloom around the world, tracing their evolutionary origins back through the fossil record to the Early Cretaceous, 130 million years ago. We take great delight in the many wildflower species blooming beside our roadways and across the fields. We also find essential nourishment and utility in the wide range of plants that serve us so well.

Flower Power: 1983

We leave the streets of Houston behind on a Sunday morning and head westward across Texas, driving into an early spring that is slowly advancing across the state. Interstate 10 winds on ahead, a virtual ribbon of wildflowers, a wide but colorful pathway that stretches through one of the most magnificent floral displays found anywhere in the country.

Near Katy we find masses of scarlet paintbrush accented with bright yellow splashes of ragworts and false-dandelions. Large patches of evening-primroses blend pink and white from different genetic strains, each reproducing in kind in response to its chromosomal content. Slightly farther west, the yellow orange of huisache trees highlights the fencerows, the fragrance perceptible through the open windows even at freeway speeds.

The bluebonnets, however, steal the show, for they are at the very height of their season. Spikes of blue, white tipped with unopened buds, rise above the rich green foliage, massed tightly together until it seems there is no room for yet another bloom. We do not ever remember seeing them more lush and lovely.

RESURRECTION FERN

We are not alone in our admiration of the roadside flower garden on this sunlit morning; cars have stopped along the way, and people are out with their cameras, recording the spectacle as best they can. We notice sophisticated equipment and expensive lenses alongside the simplest of basic cameras. The makes and models do not matter; the reward lies in enjoying this floral treasure trove

on the most intimate of terms. Certainly no one could drive along this route today and not notice and revel in the wildflowers. It is a place where everyone who chances by must automatically feel excited by the unrivaled beauty of the land.

TEXAS BLUEBONNET

We find it interesting to speculate on the various ways in which this beauty can be enjoyed. To us, these flowers are old friends. We have seen them many times, have photographed them again and again, and know them by name. We notice an albinistic bluebonnet beside its deep blue kin; we watch for cream-colored paintbrush that blooms amid the customary scarlet form. Yet in spite of our familiarity with the flowers of the season, we are as thrilled as if we were seeing them for the very first time.

Others may not know their names, with the probable exception of the famous bluebonnet. Nor do they understand their intricate structures or familial relationships. That does not matter in the least, for today there is joy in simply being among them, in reveling in their massed beauty. The power of the flowers seems absolute; no one is immune. We are passed by a huge black stretch limousine, its occupants pointing and smiling. We meet sports cars, pickup trucks, motorcycles—all moving more slowly past the sea of blue. Drivers nod and smile at each other, an odd phenomenon on a busy freeway. They appear to share a precious secret, as indeed they do.

During a gasoline stop at a service station near San Antonio, we overhear other customers talking about the flowers, chatting amiably as they wait to continue their respective journeys. They seem relaxed and happy. Flower power has affected the mood of everyone. We subsequently pass a roadside embankment lush with bluebonnets, and there are eight cars and a motorcycle stopped beneath it. Their drivers and passengers, quite literally, have taken time to smell the

flowers. A young child runs through the knee-high blooms, while two lovers sit quietly at the top of the hill, arms around each other. A backpacker is stretched out beside the floral carpet, head propped on his pack, eyes half closed against the glare of the sun.

How wonderful it is, we think, to have a state flower that brings joy to so many people from such varied walks of life. There would be merit, perhaps, in selecting a rare species endemic to the state, but today our familiar bluebonnet ranks as an inspiration to everyone.

As we drive on, we cannot help thinking with Robert Browning, "God's in his heaven—All's right with the world." For this day at least, the power of the flowers is absolute, and they have transformed the lives of many people with experiences they will not soon forget. This nature trail may be four lanes wide, but today it qualifies as one of our all-time favorites.

In the column above we referred to "the bluebonnet" as the state flower; however, the story is not that simple. The species most frequently seen along roadways in East and Central Texas is Lupinus texensis, *the Texas bluebonnet, yet it was not the first to be designated the state flower, nor does it currently hold that honor alone.*

In 1901, the Texas legislature voted the bluebonnet the floral symbol of the state, but the resolution specified that flower to be "Lupinus subcarnosus, generally known as buffalo clover or blue bonnet." It seems unlikely, as we noted in our book Wildflowers of Houston and Southeast Texas, *that the legislators knew there were other bluebonnet species, or that the one they chose was less widely distributed than the one already designated scientifically as the Texas lupine. Thus, a controversy existed over the choice for seventy years, until 1971, when another resolution declared as state flowers all known bluebonnets and "any other variety of bluebonnet not heretofore recorded." Six species are presently known, and all six qualify as official state flowers.*

A Flower by Any Other Name: 1987

A wonderful procession of wildflowers unfolds along our roadways and across our fields and forests throughout the year. Most observers will be content to merely enjoy the colorful spectacle, while others seek to learn the names of each floral gem they find. Both approaches can be rewarding, but it also proves interesting to investigate the origins of those names. Several dictionaries of plant names and numerous volumes on the histories of wild and cultivated flowers are readily available.

For example, the name of one of our best-known flowers, the dandelion, is an Anglicization of the French *dent de lion,* the "tooth of the lion," because of its toothlike, jagged leaves. Meanwhile, "geranium" owes its origins to the Greek *geranion,* from *geranos,* or "crane," because the seedpods are long and pointed like the beaks of cranes. We, too, often use the common name "cranesbill."

Many of the names are descriptive and easily attributable to physical characteristics of the plants. The myriad penstemons (more than two hundred varieties) so common in the West were given the Greek name meaning "five stamens" by Linnaeus when he first established our system of scientific nomenclature. The fifth stamen is frequently bearded with long hairs; hence the common name "beard-tongue." "Trillium" was also coined by Linnaeus from the Latin *tri,* "three," because the leaves, petals, sepals, stamens, and other flower parts all grow in sets of three.

The first wisterias reached England from the Orient in the early 1700s, sent by the East India Company in Canton, according to Mary Durant in *Who Named the Daisy? Who Named the Rose?* The English called it the "kidney-bean tree." Early American naturalist Thomas Nuttall, however, found a similar species on this continent in 1818 and named it in honor of Caspar Wistar, the Philadelphia physician and naturalist. It is by that name that most people know the wisteria today.

The magnolia, wrote Linnaeus, is a "tree with very handsome

ERECT DAYFLOWER

leaves and flowers, recalling the splendid botanist Pierre Magnol, Professor of Botany and Director of the Montpellier Botanic Garden."

Not all derivations prove that complimentary. The various dayflower species belong to the genus *Commelina,* which was named by Linnaeus for the three Commelin (also spelled Commelijn) brothers, who were Dutch botanists. Two of the brothers, Jan and Kaspar, published widely in their field; the third published little and died without becoming well known. Linnaeus reportedly thought the three unequal petals of the dayflower—two large blue petals and one small, colorless, insignificant petal—nicely represented the talents of the three brothers.

Other names resulted from errors or improper reasoning. *(That opinion may also have been shared by the third Commelin had he known of his dubious honor.)* Lupines, of which Texas bluebonnets rank as our state's best examples, frequently grow in poor soil. Reversing the cause and effect, early botanists believed lupines destroyed fertility, wolfing nourishment from the earth. Hence the genus *Lupinus,* from the Latin *lupus,* "wolf." Likewise, pickerel-weed owes its name to an ancient belief in spontaneous generation in which the tall water plants with arrowhead leaves and blue flower spikes spontaneously bred fishes such as pike and pickerel.

Botanical roots reach deep into the mythology of many countries. Iris was the Greek goddess of the rainbow and a member of Juno's court. So impressed was Juno with Iris's virtue that she decided to commemorate her with a flower that bloomed in rainbow colors. "Mint," according to Durant, comes from Mentha, the mistress of Pluto, ruler of Hades. "She was trampled underfoot by Pluto's jealous queen, Proserpine, and transformed into a lowly plant that would be walked upon forever. Mentha's fate, however, was softened by Pluto, who willed that the more mint plants were trodden upon, the sweeter the smell that would arise."

"Pokeweed," a southern favorite, comes from the Virginian Indian *pokan*, applied to any plant with red juice used as a dye. "Sorrel" traces its origins to the High German *sur*, "sour"; its scientific name, *Oxalis*, also means "sour" and stems from the Greek *oxys*.

The profusion of vetches, most of them pernicious vines, are named from the Latin *vicia*, "to bend or twist." Passionflowers were named by the Spaniards, who found within the complex blossoms of the New World all the symbols of Christ's death on the cross, including the nails and the crown of thorns.

For some flowers, there are no recognized translations. "Lily" was *lilium* in Latin and *leirion* in Greek, both terms referring to the flowers without any obvious derivations. "Violet" comes from the early Latin *viola*, but it, too, is without a known precursor.

As Gertrude Stein so appropriately noted, "Rose is a rose is a rose is a rose"—in English, French, German, Norwegian, and Danish. Similar words—*rosa, ros, roos, rozsa, rhodon*—go back through history in Italian, Spanish, Portuguese, Russian, Swedish, Dutch, Hungarian, Greek, and Latin. These old favorites were named for nothing that we now recognize; instead, the universally known colors are named for the flowers.

Floral Teamwork: 1976, 1984

Among the bewildering array of Texas wildflowers, more than 20 percent belong to a single family, the daisy or aster family, botanically known as the Compositae. *(Most taxonomists now call this large group the Asteraceae.)* Approximately six hundred different species occur within the boundaries of our state, and about twenty thousand range around the world. In temperate zones, the composites easily rank as the largest family of flowering plants, yielding the worldwide title only to the predominantly tropical orchids.

Familiar roadside species such as sunflowers, daisies, gaillardias, cone-flowers, and asters qualify as members of the family. So, too, do chrysanthemums, dahlias, zinnias, cosmos, marigolds, and other

garden favorites. Thistles are composites, as are the goldenrods, dandelions, cockleburs, and even lettuce. Not all are large or colorful, and not all prove popular, for ragweed pollen so despised by hay-fever sufferers also comes from a composite.

To the beginner, this undoubtedly seems a bewildering array. The key to the familial relationship, however, lies in the structure of the flowers. The obvious "blossom" of a sunflower, daisy, or aster is not a single flower at all. Rather, that showy structure is composed of a cluster of tiny flowers, all arranged in a precise manner and packed together in a compact flower head called an inflorescence. One might think of them as too insignificant by themselves to attract an insect pollinator, so they unite to form a larger and more attractive aggregate. It is floral teamwork at its best.

Actually, two distinct types of flowers make up the inflorescence of most composites. Those around the outer edge, usually thought of as petals, technically qualify as complete flowers called ray flowers. Others, the disk flowers, each composed of five petals fused into a tube, make up a central disk. Each of the tiny units contains its own reproductive parts and is a complete and separate flower, although the ray flowers of some species may be sterile.

Most composites contain both types of flower units, but some species utilize only one. Thistles, for example, lack petal-like rays and consist only of disk flowers. Dandelions, on the other hand, have only ray flowers and lack the central disk.

With its own reproductive parts, each tiny flower produces its own fruit, an achene, containing a seed. Thus, a sunflower head bears a spirally arranged complement of individual "seeds," and a ripening dandelion or thistle produces numerous parachuted fruits. If the large inflorescence

ASTER FLOWER HEAD

were a single flower, it would produce a single seed or a group of seeds clustered inside a single ripened ovary.

Because this widespread family contains so many similar and confusing species, members are frequently known to amateurs and experienced botanists alike as DYCs, "damn yellow composites." Positive identification of each "yellow daisy," or even each of the numerous purple asters, can prove frustrating indeed. Without putting specific names on them, however, we can still enjoy the composites as true masterpieces of design.

Spiny Beauty: 1980

The cacti are members of one of the strangest of all plant families. Normally devoid of leaves and armored with spines, struggling against the elements in the most inhospitable of environments, cacti nevertheless blaze with colorful blossoms of stunning beauty. These showy flowers, along with the hardiness and bizarre forms found among the Cactaceae, make family members popular throughout the world. Such was not always the case, however, for cacti are plants native to the New World alone. Except for two or three nontypical species found in the forests of Madagascar and Ceylon *(now Sri Lanka)*, all grow naturally only in the Western Hemisphere.

The early explorers to the Americas had no botanical training, but the strange armored plants could scarcely have escaped their attention. Accounts spread rapidly, and the adventurers returned to Europe with numerous specimens notable for their uniqueness and their ability to survive the long voyage without ill effects. An herbal published as early as 1579 made reference to several species, calling them by such names as "hedgehogge thistle," "thornie euphorbium," and "thornie reede." Because this was a family previously unknown in Old World science, there were no names for it in Latin or Greek. Botanists, in fact, thought the cacti to be members of the thistle family. Hence, the name was taken from the Greek word *kaktos,* meaning "thistle."

By the year 1800, a "cactus craze" had swept most of Europe, and extensive collections were displayed in large greenhouses across the continent. French, Belgian, and German importers dispatched professional collectors to secure new species. Some of the cacti imported into other hot, arid locations quickly naturalized and spread across the countryside. This was particularly true of members of the genus *Opuntia,* the familiar chollas and prickly-pears. They spread throughout the Mediterranean region and colonized vast areas of Australia, to the point of becoming pernicious pests that required rigorous control.

Today large cacti are familiar sights in many countries, and few observers remember that they originally came from the other side of the globe, thus casting them in incongruous situations. Several biblical movies filmed in the Middle East for purposes of authenticity show the now-abundant cacti that were completely unknown at the time depicted in those stories.

The spiny plants occur normally from Canada to the tip of South America, with the largest number of species in broad bands along the Tropic of Cancer in Mexico and the Tropic of Capricorn in South America. Arid or semiarid desert scrub provides the typical habitat for many, but others can be found in rain forests, on the seashore, on mountaintops, and among the grasses of the Great Plains. The Cactaceae indeed comprise a broad and diverse family.

Botanists disagree on how many species there really are, for some prove difficult to distinguish from their close relatives, and new ones are discovered constantly. Del Weniger, in his authoritative book *Cacti of the Southwest,* recognizes more than three thousand species, some of them with extremely restrictive ranges. He also notes that "Texas alone presents more species of cacti than all of the rest of the United States combined." He lists 102 different species and 142 additional forms.

Evolutionary origins of the family remain a mystery; no fossil cacti have been found. The Cactaceae probably represent a relatively young group, arising some twenty thousand years ago in response to localized conditions. Most are superbly adapted for living where water is scarce.

During infrequent rains, cacti absorb water rapidly through their finely branching roots and store it in the fleshy stems that can expand to become bulging reservoirs. The leaves have been greatly reduced or eliminated entirely to control water loss to the atmosphere, and the green stems have taken over the functions of leaves and are protected from desiccation by their thick, waxy skin. The thorny exterior serves not only as a deterrent to browsing animals that seek the life-giving moisture inside but as a shady latticework to help shield tender growing tips from the broiling sun.

TEXAS PRICKLY-PEAR

Not all fleshy, spiny plants claim membership in Cactaceae, of course. The yuccas, agaves, and ocotillo so common in the Southwest reside in totally different families. The thorny, succulent euphorbias, many of which inhabit Africa, look much like cacti, but they, too, bear no botanical relationship. All have vastly different physical structures and reproductive parts, but all have adapted similar methods of self-preservation in response to similarly arid environments.

The rate of life processes, including growth, is proportional to the rate of movement of water and nutrients throughout the plant. Because they receive little moisture and retain it tenaciously, cacti grow very slowly. The enormous saguaros may take twenty-five years to reach a foot in height, and barrel cacti survive for decades in the desert. In their own patient way, the members of Cactaceae cope with adversity extremely well.

The All-Important Grasses: 1976, 1987

Grasses rank among our most abundant and important plants. Although we tend to think of grasses merely as coverings for lawns and golf greens, or as weeds in carefully tended gardens, many of the thousands of different species play essential roles in our way of life. Directly or indirectly, they provide much of the food consumed by wildlife and humans alike.

It is in late fall that we become particularly conscious of our diverse native grasses. Most of the flowers are gone, and many of the herbaceous plants have died back in preparation for the chill of winter. Now the golden grasses share the landscape with the autumn leaves, their seed heads ripening to disperse the nuclei for next year's crop.

The seeds of various grasses make up a large portion of the world's food supply. Wheat, oats, rice, barley, rye, and corn all qualify as members of the grass family. So, too, do sorghum, millet, and other feed grains. Sugarcane is a giant grass, as are the many kinds of bamboo used for so many utilitarian purposes around the globe. When Neolithic people discovered some ten thousand years ago that the seeds of certain grasses could be harvested and planted again for crops the following season, the pattern of human existence began to change. Agriculture was born, and with it the means to feed a burgeoning population. Without the descendants of wild grasses, the world's people would surely starve.

Most of our food crops, of course, result from specialized hybrids, the products of decades or even centuries of genetic manipulation. Many are scarcely recognizable as the wild species from which they derived. Without the original stock, however, there would be none of the hybrids we enjoy today, which explains why the extinction of species presents such a serious problem. We do not know the potential value of all the world's threatened plants; many have not even been identified or characterized. Somewhere in the deserts of Australia or Africa, or on the mountain slopes of the Andes, there

may grow a strain of wild wheat or corn with particularly useful properties. Its genes might impart fungal resistance to a hybrid food crop, or increase its yield, or make it freeze or drought resistant. With the loss of each species, we lose that potential.

SIDEOATS GRAMA

In addition to using the seeds of the grasses for our own food supply and that of our livestock, we use the foliage of the plants. Wildlife and domestic animals graze on pasture and prairie grasses. The latter also depend heavily on grasses cut and dried as hay.

The growing point of a grass stem lies at its base so that the stem continually pushes up from the bottom, quite unlike the growth pattern of trees or most herbaceous plants. For this reason, grazing or mowing does not kill or injure grass; it keeps on growing and producing despite being topped.

We seldom pause to notice the flowers that precede the all-important seeds, but under magnification they may appear as intricate and lovely as any rose or orchid. Because grass pollen is dispersed haphazardly by the wind, the plants have no need for showy petals or fragrant scents that attract pollinators to most flowering plants. The tiny blooms have been reduced to the bare essentials of pollen-producing stamens and receptive pistils.

Some grasses live as annuals that complete their growth and reproductive cycle in a single year and then die in response to cold or drought. Their offspring rise from sprouting seeds when conditions again prove right for growth. Others are perennials that survive from season to season, perhaps dying back to the ground only to sprout anew from the previous crown or from creeping stems.

Perennial grasses take two general forms, bunchgrasses and sod-forming grasses. Many bunchgrasses have adapted to dry soils and serve as important forage plants of deserts and arid rangelands.

Individual plants may live for many years, normally dying out in the center of the clump and spreading outward in a ring.

Sod-forming grasses, on the other hand, spread rapidly by means of prostrate stems called stolons or by underground rhizomes. Some form an extremely dense mat and are long-lived and tenacious. Indeed, some may live almost indefinitely by continual vegetative reproduction and could be considered among the world's oldest living things.

Approximately ten thousand species of grasses range around the globe and provide food and shelter, absorb carbon dioxide from the air and generate life-giving oxygen in return, anchor precious soil and prevent erosion, and perform a host of other vital tasks. Although we may consider many of them "weeds," they play a vital role for us and for the balance of nature. The ancient Greek philosopher Heraclitus could not have expressed it more succinctly when he wrote, "All flesh is grass."

Spanish-Moss: 1976

Early French settlers in North America called it "Spanish beard"; the Spaniards, in return, named it "French wig." Native American names for it translate as "long hair." Now we call it Spanish-moss, and it is undeniably one of the most characteristic plants of the Deep South. Even the latter name, however, was poorly chosen, for Spanish-moss is neither Spanish nor a moss. It is, in fact, a bromeliad, a true flowering plant in the pineapple family.

Although the primitive mosses have no flowers or seeds and reproduce by spores, Spanish-moss bears tiny, fragrant green blossoms that open in April and May. Hidden among the pendulous streamers, they normally bloom unseen but nevertheless produce capsules of small, parachuted seeds that spread widely to perpetuate the species.

Even the scientific name of this strange plant, *Tillandsia usneoides,* resulted from a mistake. Because Spanish-moss hangs suspend-

ed from the trees, Linnaeus, the eighteenth-century Swedish naturalist who created the binomial system of scientific nomenclature, thought it abhorred moisture. Thus, he named the genus after one of his students, Elias Tillands, who had such an aversion to water that he once walked a thousand miles around the Gulf of Bothnia to join a field trip rather than risk a short crossing by boat. The specific epithet suggests a similarity to the interlaced strands of threadlike lichens in the genus *Usnea*.

SPANISH-MOSS

In reality, Spanish-moss thrives on moisture, which it collects in an unusual manner. A coating of tiny gray scales traps water as it runs down the stem and leaves and allows it to be absorbed by the plant. Dust and minerals carried along are also absorbed, and these provide the nourishment required for growth.

Contrary to popular belief, this misunderstood plant is not a parasite. It does not send roots into the host on which it grows, nor does it derive nourishment from that host as do mistletoe and other parasitic plants. It produces food with the aid of chlorophyll in the green stems and leaves, and Spanish-moss can live on telephone wires or fences as well as on its favorite trees.

Neither does it kill the branches on which it grows, although the added weight may cause them to break in violent storms. Spanish-moss, however, seems to prefer branches already diseased, perhaps because decaying wood provides a toehold for a sprouting seed or a tiny fragment of a windblown plant. It has therefore developed an unsavory reputation it does not necessarily deserve, guilt by association rather than in actual fact.

At first glance, a clump of "moss" seems a strange and confusing tangle. Only on careful examination can one see it as a cluster of many plants, some with twisting stems as much as twelve feet long. At the

core of this stem lies a dark, tough fiber surrounded by a soft layer of green tissue and covered, in turn, by the gray scales. The leaves are thin and pointed. From the growing tips hang the quarter-inch flowers, three petaled and pretty in delicate yellow green.

Spanish-moss grows as an epiphyte, or air plant, depending on other plants or structures for support. Ball-moss replaces its close relative in the drier regions of the South and shares the genus *Tillandsia,* as do some four hundred other species throughout tropical America. The cultivated pineapple seems an unlikely member of the family, Bromeliaceae, until the foliage is compared with that of familiar ornamental bromeliads.

A distinctive signature of the South, Spanish-moss ranges from Virginia to Texas along the coastal plain. It clings to many kinds of trees but seems to prefer live oaks and cypresses. The hanging strands envelop the trees and shroud the swamps and bayous, tossing and swinging in the wind, gray and ethereal when dry, sodden and funereal in the rain. Ever popular with artists and photographers, the effect proves difficult to capture on canvas or film.

When cured and dried for several months, the outer sheaths of the "moss" fall away to leave hard, black fibers once twisted into crude cordage or used to stuff furniture and mattresses. Louisiana alone once had more than fifty factories that ginned moss for the upholstery trade. That industry is gone, replaced by modern techniques and synthetic products. Spanish-moss now provides a bed only for nesting parula warblers, unseen forest insects, and trilling treefrogs. However, it still lends beauty, dignity, and mystique to southern forests. As noted biologist Archie Carr so graphically wrote, "A big old live oak tree without its moss looks like a bishop in his underwear."

Tragically, Spanish-moss is disappearing or has thinned dramatically throughout major portions of its range. It seems particularly susceptible to air pollution and also suffers from timber cutting, water-use changes, and other encroachments on its southern swampland and woodland habitats.

5

Gems on the Wing

Our love affair with natural history began in early childhood with butterflies and moths, a passion that has continued throughout our lives. For decades, we found few others who shared our enthusiasm, but in recent years the popularity of lepidoptera has increased dramatically. Ardent birders and other naturalists have taken up the pursuit in earnest, and nature festivals in Texas and around the country feature seminars and field trips to study these winged gems. Butterflies now rank among the most popular of all our myriad forms of wildlife.

Butterfly Trails: 1996

The following column describes a butterfly-watching trip through the Rio Grande Valley of South Texas. It does not treat all of the species that crossed our path, nor was it meant to enlighten readers on the finer points of butterfly identification or biology. Instead, it serves to indicate the delight these parchment-winged gems can bring to any family vacation, a focal point on which to base one's travels.

Butterflies swirl like multicolored confetti around our van as we drive through the ranchland of South Texas. Hordes of small American snout butterflies drift with a northerly breeze across the highway,

while huge pipevine swallowtails hover at autumn flowers that dot the roadsides. Occasional monarchs wing southward toward their winter refuge in the mountains of Mexico, but their numbers pale now in comparison to those of the equally large and colorful queens. Essentially nonmigratory, the queens, too, stream across in front of us, taking the path of least resistance with the wind.

Literally thousands of butterflies envelop us, perhaps more than we have ever seen before. Indeed, we find ourselves wondering how best to minimize collisions with these lovely and fragile insects. Butterflies splash our windshield and stick beneath the wiper blades; others coat the grill until it becomes a rich tapestry of rainbow hues.

At a picnic table south of Hebbronville, we stop and walk along the roadside, examining casualties that lie windrowed on the shoulders. We count two dozen species in one small stretch, including seven kinds of yellow and orange sulphurs. New to us is the summer form of the tailed orange, its brilliant orange wings marked by black-etched veins.

Along the Rio Grande in the little town of San Ygnacio, a coral-vine shrouding an old stone wall attracts an estimated five hundred American snouts that flutter around the blooms in amazing profusion. Equally large numbers of an emperor butterfly called Empress Leilia bask in the morning sunshine below Falcon Dam, where their caterpillars have grown to maturity on granjeno, or spiny hackberry.

The common snout butterflies have swarmed through the

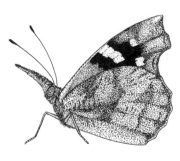

AMERICAN SNOUT

Texas Hill Country and across the southern regions of the state for more than a month, attracting a great deal of attention from travelers and media alike. Late summer rains brought forth concentrations of adults that had waited patiently in their chrysalides through the long, severe drought. They, in turn, laid eggs that quickly hatched, and the

voracious caterpillars found ample new, tender growth on which to feed.

It also seems likely that the number of parasitic wasps and flies had decreased dramatically with the drought. These insects serve as major controls of caterpillar populations, and without them, the well-fed larvae developed in unprecedented numbers, providing even more adults in the subsequent generation. Massive dispersal flights of snout butterflies are not uncommon when their numbers rise. Several such events have been recorded through the years across Texas and the Southwest, some containing millions of butterflies. Now, however, other species also have reached astonishing numbers, and clouds of butterflies are on the wing. It is truly an amazing and invigorating sight.

Hundreds of large orange sulphurs float lazily through our campsite in Falcon State Park. Emerging from pupae on Texas ebony trees, they sip nectar at Mexican olive, ebony, and a host of other flowers, congregating in late afternoon to hang beneath sheltering leaves through the night. One ebony, in full, late-season bloom, feeds scores of these and other butterflies as well. At sunset we witness a changing of the guard. As butterflies go to roost, moths take their places at the flowers, until we estimate there are a thousand individuals of perhaps one hundred species flitting around us. Most are relatively small, yet their spangled wings bear rich and intricate designs.

Orange-and-black theona checkerspots also fly in great profusion around our camp, while the pale gray green leaves of the cenizo, or purple sage, harbor huge broods of their amply spined caterpillars. Lovely little ivory chrysalides ornamented with black hang from the shrubbery and beneath our picnic table, eclosing fresh checkerspots throughout the day.

Along the Rio Grande at Salineno, we watch enormous aggregations of large orange, cloudless, and lyside sulphurs sipping water from mud puddles at the river's edge—water that contains vital dissolved salts and amino acids. Here, too, we find our first red-bordered metalmarks, a southern species we have not seen before.

When we stop for lunch in Roma, we discover, to our great con-

LYSIDE SULPHUR

sternation, two lepidopteran "lifers" on the grill of our van. *(A species we have never seen before is called a "lifer" in the parlance of nature listers.)* A Mexican fritillary and a dark buckeye are the first we have ever seen in Texas. Later, we find more of these striking subtropical residents at flowers in Santa Ana National Wildlife Refuge. At Santa Ana we walk the woodland trails, stopping to marvel at black-and-yellow zebra heliconians sailing slowly beneath draperies of Spanish-moss. Iridescent Mexican bluewings flit nervously from tree to tree. Striking in flight, the latter become almost invisible as they land and fold their camouflaged underwings against the matching bark.

Clumps of *Eupatorium,* or blue mistflower, attract macaira skippers *(now called Turk's-cap white-skippers)* and white peacocks. More familiar bordered patches, phaon and Texan crescents, amymones *(common mestras),* and tawny emperors attract less attention, especially when flying with spectacular orange-barred sulphurs. Pipevine and giant swallowtails and many more queens soar past on slowly beating wings.

Continuing eastward to the coast, we visit Laguna Atascosa National Wildlife Refuge, where great southern whites dot the salt marsh and seek nectar from the yellow flowers of sawtooth daisies. Another patch of *Eupatorium* hosts a pair of Florida whites, the male with immaculate white wings, his mate with pale yellow-tinged wings tipped with black. Both are tattered and torn, but as rare vagrants from tropical America, they thrill us nonetheless.

As the road winds through a patch of thorn-scrub brushland, we stop and walk, brushing aside clouds of mosquitoes that prove even more numerous than the butterflies. In only a few feet we count more than sixty red-bordered metalmarks and several rounded

metalmarks clustered on a variety of wildflowers. Throughout South Texas we find similar sights. Drought conditions that so stressed the land in summer have been broken by life-giving rains, and the moisture has produced a spectacular eruption of butterflies. We quickly alter our plans and enjoy it to the fullest, for the fall of 1996 will remain in our memories as the year of the butterfly.

Lifestyles of Butterflies: 1988

We continue to delight in finding butterflies in great profusion, and an encounter with a "lifer" proves particularly satisfying. Studying the unique habits of a single species, however, also brings us satisfaction, for each has its own lifestyle and its own methods for surviving in the ecological niche it occupies. The following column describes in some detail our experiences with one of our favorites.

Several species of butterflies overwinter in sheltered nooks or crannies and appear on warm, sunny days in winter or early spring, even in the northern tier of states. However, one of the pierids, the falcate orangetip, *Anthocharis midea,* ranks as one of the premier harbingers of spring. A perfect example of biological adaptation, it has evolved to fit a particular set of conditions and circumstances, and its entire lifestyle is dictated by the pressures that imposes.

We spotted the first falcate orangetips flying through the still-budded woodlands on February 25 this year. Several butterfly books suggest this species is on the wing for only a two-week period in any locality, and most of them list the flight time as April or May. That can certainly be true

FALCATE ORANGETIPS

in the colder portions of its range, for the orangetip occurs north-ward through the eastern states to Wisconsin and Massachusetts. It emerges as an adult much earlier, however, along the Texas Gulf Coast.

On March 1, we watched at least seventy-five or eighty orange-tips in the open, deciduous woodlands of San Jacinto County in Southeast Texas. All that we could approach proved to be males with bright orange patches near the tips of their hooked forewings, the features from which the name derives. Females lack the orange and have only sparse black checkering along the wing margins and a black discal spot in the center of the forewing. Complex greenish tracings on the underside of the hind wing in both sexes reveal a close relationship to others of the family that we call "marbles."

Male butterflies of many species fly slightly earlier in the sea-son than do the females, waiting patiently for prospective mates to emerge. Assuming such was the case, we returned to the same woods on March 10, and by then both sexes were on the wing, feeding on nectar from the blue violets nestled beneath the trees and from a foot-high, white-flowered mustard called bitter-cress, or spring-cress, *Cardamine bulbosa (now classified as* Cardamine rhomboidea*).*

Knowing the cress to be a foodplant of the orangetip larvae—pos-sibly the only one in the area, although they utilize other mustards in portions of their range—we had searched the leaves for eggs or caterpillars in previous years without success. We had thus been unable to photograph the early stages of the butterfly's life history. Now, convinced there must already be eggs or larvae, we lay down on the ground among the scattered plants to examine them more thoroughly. Finally, after several minutes of searching, we found on one of the slender, toothpick seedpods a minute green caterpillar no more than two millimeters long. Now knowing where to search, we subsequently located many more, all chewing away with tiny mandibles on the seedpods or on flower buds. We also found eggs scarcely larger than the period at the end of this sentence. Bright orange and spindle shaped, they proved to be delicately ribbed and

very lovely when viewed under a magnifying glass. Many such insect eggs rank as masterpieces of nature's artistry.

Most of the maturing plants contained small larvae or eggs on the fruits and flowers, but never more than two or three. Laying only a few eggs on each plant decreases predation and competition among the feeding caterpillars. If more occupied each host, they could conceivably destroy all the seeds and terminate the reproductive cycle of the plant, thereby destroying both the host and its hungry guests. Because few other insects are abroad so early in the year, and because we watched adult orangetips nectaring profusely at the spring-cress flowers, we assume the butterflies serve as major pollinators of the plants. In return, the larvae receive a portion of the harvest. It is a delicately balanced mutualism indicative of the parallel development between the diverse worlds of flowering plants and flying insects.

The orangetip larvae grew quickly and reached an inch in length in just a few days. Bluish green in color, they were ornamented with yellow orange stripes down their backs and white "racing stripes" along the sides. Short, spinelike setae arose from little tubercles in an intricate dorsal pattern. Unlike most other caterpillars, the orangetip larvae did not feed on leaves, the reason we had not noticed them before. Indeed, when captive caterpillars were offered foliage of the cress, they refused to eat. Apparently the nutrient-rich buds and seedpods provide a more complete diet that enables the larvae to develop much more rapidly than most.

In little more than a week, the full-grown caterpillars left their foodplants, which would soon wither away, and crawled to more sturdy, woody twigs nearby. There they clung to the bark and hung head downward for a day, purging their bodies of accumulated wastes and spinning tough anchoring pads of silk. Reversing their positions, they next spun girdles of silk much like the safety belts of telephone-line workers, leaning back and twisting their heads to pass the lines around their bodies. After another day in a quiescent state, each suddenly began to twitch, and the larval skin split and sloughed downward to reveal a newly formed pupa beneath. An

inch long and sharply pointed, these chrysalides looked for all the world like brown thorns arrayed along the twigs.

Here the falcate orangetips remained for nearly a year, through summer heat and winter chill. *(Indeed, some individuals live for two years as pupae, and Nick Grishin reported to us that he reared falcate orangetips that emerged an astonishing four years after pupation.)* Finally, when conditions were right, the pupal shells split open and new adult orangetips slipped out, expanded their wings, and flew off through the woodlands to mate and hurry through the process once again. Their entire life cycle, except for the interminable pupal stage, occurs rapidly; however, there is but a single generation each year. Its emergence corresponds to the flowering of the spring-cress, and the falcate orangetip has only a few short days in the warm spring sun.

Butterfly Gardening: 1991

Butterfly watching and listing have become extremely popular in recent years, paralleling an earlier interest in birding. In addition, more and more people have begun to design their gardens around butterfly-attracting plants, providing both nectar plants for the adults and host plants for the caterpillars. Many parks and wildlife refuges have established butterfly gardens, but even a few well-chosen plants in an urban backyard can attract a large complement of the colorful insects.

We are not by nature dedicated gardeners, for a heavy travel schedule, especially during the hot Texas summer, can only lead to a yard filled with desiccated and wilted plants. This summer, however, our efforts have met with remarkable success. Our shrubs and flowers are famous throughout the neighborhood, and the parade of visitors has been a steady one. Most choose to stay for lunch as well, much to our delight.

We measure these successes differently than most, we must admit. There has been no homegrown produce on the table; freshly cut

flowers seldom decorate the house. Our prized visitors are butterflies that swirl around the flower beds and patio. Their caterpillars chew contentedly on the surrounding foliage.

The major horticultural triumph has been a seedling hackberry tree that appeared by accident in the lawn where a bird, perhaps, dropped a seed. We rescued the foundling from the mower and, having only oaks and cedar elms,

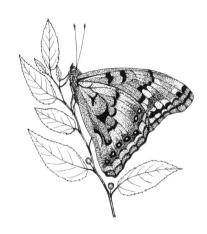

TAWNY EMPEROR

moved it to a secluded corner of the yard. A little fertilizer and water have worked wonders. The sapling has become an insect banquet table. Tawny emperor butterflies swirl around the hackberry branches every day, perching on leaves to spread their orange brown wings to the warming sun.

Two weeks ago we found their eggs beneath a leaf, a hundred tiny greenish spheres ornamented with radiating ridges. Packed methodically together and stacked in terraced layers, they resembled a truncated Mayan pyramid. Within a few days minute caterpillars had hatched from the eggs. Two molts later, they are now a half-inch long, green with yellow stripes and branching spines atop their heads. They are still gregarious and stay close together in the foliage, marching single file from twig to twig as they consume the tender leaves. They will grow through two more molts and then disperse to transform into angular green chrysalides. Within another week or so, another brood of adult butterflies will emerge to flit around our yard.

Occasionally, a different emperor joins the swirling throng. Its wings are a cooler, grayish brown that mark it as a hackberry emperor. Its life cycle is much like that of the tawny emperor, but we have yet to find its eggs or larvae on our tree.

Flying with the emperors is a still larger butterfly with short tail-like projections on the hind wings. The upper surface of the wings

is orange, marked with black and delicately rimmed with lavender. Sitting with folded wings, it disappears against the bark of the trees on which it perches, bedecked in camouflage brown except for two small silver marks that give this species its name, the question mark. Its larvae, too, thrive on hackberry. Blackish bodies spangled with orange and white and ornamented with branching orange spines, they seem as handsome as the adults.

Only in the last few days have American snout butterflies visited the tree. True to their name, they display long, projecting "snouts," unique among our butterflies. Like the emperors and question mark, snout larvae consume hackberry leaves, and adult females will lay their eggs on nothing else. It is debatable whether or not the leaves of our hackberry will last the summer, for the tree is still a small one. But this is why we rescued it, and the reception has been overwhelming.

Nearby, swallowtail butterflies of four different species visit scattered flowers in our yard. Gulf fritillary caterpillars munch on our passion-vine and will soon give rise to long-winged orange butterflies adorned with shimmering silver spots below. Little clouded skippers swirl across the patio, rising from a clump of weedy paspalum grass we spared when we discovered it is what their larvae eat.

Hairstreaks, sulphurs, crescents, red admirals, buckeyes—the list goes on and on. Each day brings us new delights on jeweled wings. Our yard will never win a prize from one of the local garden clubs, but our new boarders consider it tops.

Through Insect Eyes: 1992

A butterfly flutters gracefully through our backyard and stops to sip nectar from several flowers. How, we wonder, does it choose the blossoms that it visits? What do they look like through its eyes? Entomologists who study insects are sadly at a disadvantage, because they view the world with limited senses. Humans see in what we provincially call the "visible" portion of the spectrum; insects,

however, are visually sensitive to ultraviolet (UV) light as well.

Johann Ritter first demonstrated the existence of UV radiation in 1801, when he showed it could trigger chemical reactions. John Lubbock, working with ants that normally shield their larvae and pupae from light, proved in 1876 that insects also respond to that shorter-wavelength portion of the spectrum. Lubbock dispersed the light with a prism and found that ants carried their young away

BUTTERFLY HEAD

from the violet and blue portions of the spectrum and deposited them in the red. First, however, they removed those that were in the "dark" region beyond the violet. When he blocked the ultraviolet rays with an absorbent solution, the ants no longer responded to those wavelengths.

Pigments in human and most other vertebrate eyes shield the sensitive retina from UV radiation. Those wavelengths are strongest at high altitudes and in the tropics and are responsible for a greater tendency to sunburn. Variation in UV intensity during the day parallels that of the visible portion of the light, but we do not see it with our eyes. Scattered sunlight in the blue sky proves particularly rich in UV radiation, and it lights shadows so they do not appear as dark to UV-sensitive eyes as they do to ours.

Flowers reflect varying amounts of ultraviolet light, and they might appear quite different in that portion of the spectrum. Many, for example, display large, nonreflecting spots at the center or have dark lines pointing inward. These serve as "targets" or "nectar guides" to insects, directing them to rich nectaries at the center of each blossom.

Some flowers, too, turn color with age, reflecting varying amounts of UV light. This also happens in the visible portion of the spectrum, but to a lesser degree. Hungry insects thus can pick the

freshest flowers to visit, ensuring a better supply of nectar for their efforts. The insects benefit from a richer reward; the plants benefit by receiving pollination of fresh flowers. The flowers and insects, in effect, "communicate" in the ultraviolet with a system of signals we cannot see.

Each species of flower has its own pattern of UV reflectance, and some that look remarkably alike in normal light prove quite distinctive in the UV. Many of the yellow composites, the yellow daisies, for example, appear entirely yellow to human eyes. But in the ultraviolet, they bear surprisingly distinctive patterns that we cannot see. The insects also look quite different under UV light, with striking patterns on what first appears to be an unmarked surface. They use these patterns in courtship and species recognition as well as in the intricate relationships involving camouflage and mimicry.

Among our sulphur butterflies are two species that look much alike to humans. One has yellow wings bordered with black; the other varies with the season, ranging from yellow to orange, again with black borders. The male of the latter, the orange sulphur, *Colias eurytheme,* however, reflects a strong pattern in the ultraviolet, but the yellow male clouded sulphur, *Colias philodice,* does not. Both females appear dark at those wavelengths. Males attempt to mate with females of both species, perhaps less aware of the difference. But females normally reject males of the other species, for they see them in quite a different light.

As biologists explore the world in other portions of the spectrum, they continually discover new and fascinating relationships. As humans, we have thus far viewed the world from a very limited perspective.

Butterfly or Moth?: 1998

Perhaps the question most frequently asked by the beginning student of butterflies is, "What is the difference between a butterfly and a moth?" Although that seems at first a simple and straightforward

question, there is no simple answer. The line between the two proves difficult to draw. Butterflies and moths combine to form the scientific order Lepidoptera, a name coined from the Greek *lepis,* meaning "scale," and *ptera,* "wing." Their thin, transparent, parchmentlike wings are covered with tiny overlapping scales both above and below, making possible different colors and patterns on opposite sides of each wing.

In most modern taxonomies, the sequence in which the various families of these scaly-winged insects are placed, the butterflies fall in the middle, with some moths regarded as more primitive and some more advanced. Many entomologists no longer make a distinction between the two familiar categories.

Our common butterflies, in turn, can be divided into two distinct groups usually accorded "superfamily" status: the "true butterflies," or Papilionoidea, and the "skippers," the Hesperioidea. Skippers tend to be small, heavy-bodied butterflies whose darting flight gives them their name. Most are drably colored, but there are many notable exceptions, especially in the tropics.

In general, butterflies are active almost exclusively by day; moths tend to be nocturnal. There are, however, many day-flying moths, while butterflies occasionally turn up under lights at night.

We tend to think of butterflies as brightly colored, while moths are relegated to the "dull and uninteresting" category. Yet few would ignore the lovely, pale green luna moth with its flowing tails or the slender-winged, streamlined sphinx moths that hover like hummingbirds to feed at flowers. Some of the moths are extremely colorful, particularly those that fly by day, and they range in size from the large silk moths with a wingspan larger than a human hand to tiny "micro moths" spanning no more than an eighth of an inch. At the same time, most of the brown butterflies in the family Satyridae *(now usually relegated to subfamily status, the Satyrinae, among the Nymphalidae)* and many of the skippers are relatively drab.

Moths often have proportionately larger, "hairy" bodies covered with long scales, but there are also fuzzy butterflies, particularly those confined to high altitudes or subarctic regions. The skippers, too, often have stout bodies swathed in hairlike scales.

BILOBED LOOPER MOTH

Butterflies frequently rest with their wings spread widely, soaking up the warming rays of the sun in a pose referred to as dorsal basking. When they close their wings, they normally hold them together above their bodies, a habit that is rare for moths. Most of the latter fold their wings down tentlike over their bodies, but there are many, including the abundant inchworm moths, the Geometridae, that keep their wings spread widely while at rest.

Unique to moths is the frenulum, a coupling device consisting of a stiff bristle at the base of each hind wing and a corresponding hook or loop on the underside of the forewing. These allow the moth to hook together its hind wing and forewing so the two work together as a single unit in flight. All North American butterflies lack this characteristic frenulum, thereby distinguishing them from the moths. The diagnostic structure, however, is visible only through a hand lens and cannot be seen on live insects in the field, thus rendering it useless as an identification tool.

Far easier to observe on living butterflies are the antennae, which end in pronounced clubs or swellings. Moths, at least those occurring in the United States, lack these clubbed tips; they are instead equipped with threadlike or feathery antennae.

For almost every rule, there are exceptions. Recently a group of lepidoptera in tropical America long regarded as geometrid moths were found to possess most structures typical of butterflies. Clearly, they are most closely related to the latter, but they lack the clubbed antennae and fly primarily at night.

Thus, there is no simple answer to the question about the difference between butterflies and moths. What is clear, however, is that the latter far outnumber the former. For every butterfly species, there are at least a dozen moth species, and they range in size from minute little insects to huge Atlas moths that measure nearly a foot across.

The checklist of the North American Butterfly Association lists 717 butterfly species that have been found north of Mexico, and some authors place that total as high as 765. The number varies with the source. Regional forms are considered to be subspecies by some authorities, full species by others, and a few new immigrants wander across our borders almost every year.

NABOKOV'S SATYR, A BUTTERFLY

Moths, on the other hand, number well into the thousands. Charles Covell, in *A Field Guide to Moths of Eastern North America*, suggests a total of 10,500 species for the continent north of Mexico, but he acknowledges that number is undoubtedly low. Worldwide estimates place the number of butterfly species at about 15,000; the number of moth species at 150,000. Without a doubt, however, thousands of moths remain to be discovered and described.

Lepidoptera play important roles in the ecology of our planet. Whether they are butterflies or moths, all can contribute greatly to our enjoyment of the natural world around us.

Caterpillar Defenses: 1976

Larval stages of butterflies and moths assume a vast array of colors, shapes, and forms, making them fascinating subjects for study and close-up photography. The number and variety of caterpillars are astounding. Tiny green leaf-rollers dangle from spring foliage on slender threads of silk, ascending or descending with the skill of circus aerialists. Columns of forest tent caterpillars march resolutely up the trunks of oaks, intent on a breakfast of tender green leaves, while inchworms loop their way along the branches, pausing now and then to demonstrate their imitations of dead twigs.

Caterpillars play an essential role in nature, for they provide the key link in many of the food chains sustaining other animals. They consume green plants that manufacture their own food and are, in turn, eaten by countless other creatures. Birds, mammals, reptiles and amphibians, spiders, and even other insects all enjoy a tasty caterpillar.

It is fortunate, of course, that there are so many predators to keep them under control, for caterpillars can quickly strip a succulent tomato plant, your favorite rosebush, or even an entire forest. A delicate balance normally allows a sufficient insect population to provide food for others without swelling to epidemic proportions. Because they have so many enemies, caterpillars must also employ some means of defense in order to survive. These defense mechanisms vary greatly with the species, and almost every imaginable form of protection is employed.

Camouflage serves as a basic defense against predation throughout the animal kingdom. Most insects adopt shades of green or brown to blend with the plants on which they feed. Some, however, carry the art of camouflage much farther. The mottled brown larvae of the underwing moths in the genus *Catocala* are flattened below so that they press closely against the trunk or branches of a tree, casting no shadow as they blend with the bark. The spanworms, the inchworm larvae of geometrid moths, grasp a branch and hang rigidly out in space, becoming perfect twigs when threatened.

Other lepidoptera larvae mimic similarly inedible materials. The pine sphinx caterpillar has lengthwise stripes in shades of green to resemble the pine needles among which it lives, while the bluish markings on the back of the forest tent caterpillar render it invisible on a lichen-covered tree trunk. Some even appear to be inedible bird droppings.

Although most caterpillars prove difficult to see, a few bear vivid markings of bright, contrasting colors. The yellow, black, and white bands of the monarch butterfly larva advertise its presence, and with good reason, for the juices of the milkweeds on which it feeds make it toxic to vertebrate predators like birds and lizards. (We must admit, however, that this information has been taken straight

from other references; we have not deigned to eat them ourselves.) Throughout the insect world, species that acquire toxins or foul-tasting compounds from their foodplants display warning colors of black and yellow, orange, or red.

Larvae of most of our swallowtail butterflies discourage predators and parasitoids with a strong, disagreeable odor. Their scent glands, called osmeteria, take the form of fleshy, hornlike projections behind the head that can be extruded to discharge the pungent musk.

A bristling coat of stiff hairs called setae protects many otherwise tasty caterpillars. The great leopard moth larva, for example, rolls into a ball when touched, its formidable spines sticking out in all directions, while the familiar woolly bear and related members of the tiger moth family prove too fuzzy for easy consumption. Most birds seem unable to swallow them, although the cuckoo delights in feasting on the furriest of the lot.

In some cases, the hairs or spines are tipped with venom, an effective defense indeed. Most familiar to Texans and other residents of the southern states is the caterpillar of the southern flannel moth, locally called the "asp" or "puss-moth caterpillar," *Megalopyge opercularis*, whose sting can be extremely painful. A few other temperate-zone larvae employ similar mechanisms, but they normally cause less serious injury to humans. In tropical regions, venomous or urticating caterpillars become more common.

If you are not dangerous, the best defense may be to at least look as if you are, and several larvae have mastered the art of appearing ferocious. Spicebush and palamedes swallowtail caterpillars have two large eyespots that resemble mammalian or reptilian eyes. When approached, these caterpillars pull in their heads and arch their bodies to display the false eyes threateningly, perhaps mimicking a snake poised to strike.

When all else fails, you can always run and hide, and caterpillars have many ways of vanishing from sight. Some roll up in

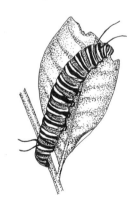

MONARCH CATERPILLAR

a leaf, while others spin silken tents around the branches on which they live. Many larvae burrow into the ground, decaying wood, or the stems of plants. Bagworms even spin cocoons camouflaged with twigs and bits of leaf and carry them around with them while they feed, living as residents of the original mobile homes.

Weaving a Masterpiece: 1984

Even the simplest and most routine of insect behaviors can prove exciting to an observant naturalist. The following column describes in some detail the weaving of a cocoon by a large silkmoth cater-pillar, a process we watched throughout a long autumn night. It was one small experience in our lives, but a major one in the life of that moth larva, a process conducted with considerable dexterity and instinctive expertise.

It is 2:00 A.M. as we sit perched on stools at the kitchen counter, watching an amazing exhibition of animal artistry. A caterpillar is slowly spinning its cocoon, carefully building up silken threads into the graceful pendent pouch characteristic of its species. It began the process during our supper hour and will continue on late into the coming day, unhurried but persistent as its instincts drive it on.

We have, to be sure, watched similar performances before, but this is a particularly impressive insect, and we want to photograph it through the stages of its life. Our subject is the larva of a calleta silkmoth, *Eupackardia calleta,* a very large moth found in South Texas and other portions of the arid Southwest. The caterpillar is fully as large as our middle fingers, pea green in color, with spots of black and fiery red. Protruding tubercles of azure blue dot its dorsal surface. Few people, we suspect, would consider a caterpillar beautiful, but this one, at the very least, is incredibly colorful.

For several weeks, since we obtained the larva from our friend Roger Peace, who shares our interest in observing and photograph-ing such things, it has munched methodically away at an ample

supply of Chinese privet leaves. At first it was yellow with black spines, then pale yellowish green with white and orange spots. Several molts made its growth possible, each shedding of its skin revealing a new and even more brilliant color pattern beneath.

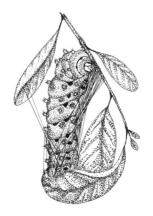

CALLETA SILKMOTH
CATERPILLAR

In its normal environment in South Texas, the calleta larva feeds on the gray green foliage of cenizo, *Leucophyllum,* and a few other native trees and shrubs. Lacking those, however, it adapts well to eating privet that we cut fresh each day. Finally it has reached maturity, and now the chemical and physical changes within its body drive it on to prepare for the next stage in its metamorphosis.

Twice tonight it has begun to spin on the branch of privet we provided, laying down silvery threads around the slender twig. Twice it then wandered off in apparent dissatisfaction with the location, responding to some unknown stimulus to search further for the perfect site. Now it has settled on a place far out on the branch, and it has been spinning slowly but steadily for several hours.

The process is surprisingly deliberate and strangely hypnotic. Extruding the fine silken threads from modified salivary glands near its mouth, the caterpillar moves its head back and forth, back and forth, leaving behind strands that harden on exposure to the air. It works carefully around the twig, attaching the developing cocoon with layer after layer of silk so that it cannot fall, however inclement the coming winter weather or strong the wind.

For a time it winds the threads around its body, building a netlike web that sets the shape of the hanging pouch, incorporating into the cocoon a leaf that hangs in a convenient spot to reinforce the bottom. Then it crawls out of the structure and stretches out along the twig to work on the point of attachment, extruding still more silk to make it stronger.

This phase of the process seems somehow more calculating and

deliberate. It is one thing for an insect to merely cloak itself in silken threads; it is another for it to move about in order to give particular attention to each stage of the construction. For here is an insect that surely must possess little of what we know as "intelligence" and has taken no lessons on the process. Yet the hibernaculum it builds is unique to its own species. It does not look like that of the cecropia or the promethea or the luna, all members of the same family. It is built like that of every other calleta silkmoth, in the fashion of its ancestors, according to an instinctive blueprint encoded in its genetic makeup.

The caterpillar works on through the night as we watch, and the cocoon continues to take shape as the busy larva fills in the initial webbing. The artisan becomes less visible behind a thickening shroud of shimmering silk. The pouch is soft, and it buckles and bulges as its occupant moves about inside. When it is complete, the caterpillar will secrete a milky fluid that hardens it into a stiff parchment shell.

By daylight the cocoon appears almost complete, and the caterpillar sticks its head out through a single small opening in the top to work on the reinforced rim. The portal is sheltered beneath the twig and closed by a number of parallel threads. Through this "escape hatch" the adult moth will emerge from its silken prison in the spring.

6

The Six-Legged Horde

Insects play an essential role in the environment, converting green plant material into food for the remainder of the animal kingdom. There are carnivores and herbivores, predators and prey. Some are large and colorful, beautiful to even casual eyes. Others lurk in the shadows and seldom appear to any but the most dedicated entomologist. All, however, fill important niches in their chosen habitats, and all prove interesting in their own right.

An Image Problem: 1994

A morning walk across our yard reveals an amazing assortment of wildlife. Bees sip nectar from the flowers, while beetles crawl through the grasses or rest camouflaged against the bark of trees. Butterflies swirl about a sunlit patch of flowers, and myriad tiny wasps and flies dart back and forth. On close examination we find that the wall beneath our porch light has accumulated an array of small moths, crane flies, and other creatures of the night, some of them now providing breakfast for jumping spiders on the prowl. Unseen beneath our feet, earthworms are hard at work with a host of other organisms, aerating and improving the soil for the plants we choose to grow.

Biologists estimate that insects, spiders, worms, and their invertebrate relatives account for 90 to 95 percent of all the animal

WHEEL BUG

species on earth. They also constitute an equally large percentage of the total animal mass, their enormous numbers more than making up for their small size. Clearly, invertebrates rule the world; however, they suffer from a monumental image problem. We humans like to think we occupy the top of the evolutionary scale, but remove us from the face of the earth and the system would remain intact. The forests, deserts, and seas, we might suggest, would even profit from our absence. Remove the invertebrates, however, and the entire ecosystem would collapse. We and our vertebrate relatives would last only a short time without insects and their kin.

Stephen Kellert, professor of social ecology at Yale University, notes in an article in the journal *Conservation Biology* that people have long been repelled by creepy, crawly bugs and worms. Because of this lack of understanding, we pay little heed to the conservation of invertebrates. Yet in the midst of a mass extinction of species by human activities, those invertebrates are undoubtedly suffering the most. In many cases, we have not yet classified what we are losing, and conservationists have thus shifted their emphasis to the protection of entire ecosystems. It is not enough to rescue bald eagles and whooping cranes from extinction; we must save their support systems as well.

Invertebrates provide food for higher animals, including the human population. We consume shrimp, crabs, and oysters; people of other cultures dine on ants, grasshoppers, and grubs. When not eaten by us directly, these small creatures furnish food for birds, fishes, and other edible vertebrates. Insects are the chief converters of plant energy to animal food; the entire world ultimately runs on insect power. Not only do invertebrates feed the world but they are the foundation of every ecosystem. They consume decaying matter and recycle nutrients, thus maintaining soil fertility. They pollinate

crops, disperse seeds, control harmful organisms, and eliminate wastes from other animals.

BUMBLE BEE

Kellert, in his paper, offers speculation as to the reasons for human aversion to insects. Admittedly, some do cause harm by stinging or transmitting disease, but those certainly remain in the minority. Others seem especially bizarre in their appearance, and we may be intimidated by their rapid reproduction and ability to invade our space so easily. "For most people," Kellert writes, "invertebrates remain largely alien and unfathomable." Other scientists even suggest that humans have a genetic fear forged out of the evolutionary battle for survival, although that would prove difficult to verify.

There are exceptions to this fear. Kellert's survey found more positive attitudes toward beautiful butterflies and toward bees and other insects whose utility we recognize. Most invertebrates, however, seem destined to endure unloved and unappreciated. It is an attitude that should be addressed, for these creeping, crawling creatures are vital to our way of life. We may not fully understand bugs and slugs, but we could not live without them.

Amazing Feats: 1983

In the previous column we recognize the importance of insects and the remainder of the invertebrate world in providing food and maintaining a viable ecosystem for other life-forms. The individual attributes of insects and their amazing physical feats also prove interesting, a subject addressed in the following material.

Nearly a million different insect species have been named and described, and thousands more are discovered each year. Entomolo-

gists do not agree on what the world's total of known species may eventually prove to be, but it could well increase severalfold.

Some insects are tiny, almost microscopic creatures; others span a foot or more. Many are considered harmful to human interests; others prove essential to our well-being. Some have developed highly organized societies with caste systems and specialized tasks for each caste member. We regard some insects as beautiful; many others, as bizarre. As amazing as their diversity is the degree to which insects have adapted to their environment. They cope with an incredible range of stresses and conditions and survive in almost every corner of the globe, from blazing desert sands to the frigid Arctic ice and snow. They crawl, hop, fly, and swim with considerable dexterity, speed, and strength for creatures so small.

Insects have no bones. Instead, they wear their skeletons on the outside, like little suits of armor, legs enclosed in tubular sections of that armor with muscles and nerves protected within. The engineering design makes them enormously strong for their size, although they must periodically shed their exoskeletons in order to grow. In one experiment, an entomologist piled weights on a scarab beetle until it was crawling under a load 850 times its own weight, a feat comparable to that of a 150-pound human hoisting 127,500 pounds.

From a rudimentary heart along the insect's back, blood is pumped through the entire body rather than confined to a system of arteries and veins, and tiny auxiliary hearts come into play wherever the blood must be forced into long extremities. These tiny "booster pumps," for example, supply the long, sensitive antennae or ensure perfect circulation in the spindly legs of a water insect.

Insects lack true lungs, and they do not breathe through their mouths or nostrils. Rather, air is admitted to the body through rows of spiracles, openings along the sides. The air tubes branch throughout the body, continuously ventilating every part. At rest, an insect requires very little oxygen, but during the stress of flight, it must be able to call on fifty times the normal amount. As the wing muscles contract, they force out air in the respiratory system; as they relax, fresh air rushes back in. Thus, the very act of flying causes an almost complete exchange with every wing beat.

Although the gossamer wings of most insects are thinner than a sheet of paper, they prove to be extremely durable. They allow a dragonfly to reach speeds of forty miles an hour and a mosquito to lift off with a load of blood twice its own weight. That mosquito beats its fragile wings at least three hundred times a second; a buzzing midge, more than three times that fast. On such sturdy wings do the familiar monarchs make their flights from the northern border of the United States southward into Mexico, and some North American butterflies have made their way to North Africa and Europe across storm-lashed seas.

Unleashing an incredible burst of energy, a common flea can leap one hundred times its own length. With equivalent powers, human high jumpers would clear the Washington Monument with ease. Grasshoppers and crickets perform equally impressive feats.

Lacking all but the most rudimentary of brains, insects govern their lives with sensory powers we can scarcely imagine. Hearing, sight, taste, and smell are all exceptionally well developed in many species. The world rings with mating calls, challenges, and messages that we cannot even hear, for insects make and hear sounds well beyond our auditory range. Few humans hear sounds above twenty thousand vibrations per second, whereas katydids hear those of more than twice that frequency. Delicate hairs on the bodies of many insects also prove sensitive to sound waves.

The world as seen through the compound eye of a dragonfly consists of up to twenty-five thousand tiny facets fitted together in mosaic fashion. Other insects have light-sensitive spots, or ocelli, that can detect light and shadows even when the true eyes are completely covered.

The feet of butterflies and moths function as organs of taste, detecting the presence of sugar in a solution containing only one part in three hundred thousand, more than

KATYDID

a thousand times the sensitivity of human taste buds. A male moth, too, can detect the faint "come hither perfume" of a female as much as nine miles away downwind. Thus, when we begin to feel cocky about our own abilities, comparing those powers with the amazing feats of insects can prove informative.

A Fondness for Beetles: 1985

British scientist J. B. S. Haldane, when asked what could be learned about the Creator by examining the natural world, is said to have replied that the Creator had "an inordinate fondness for beetles." That quote may be apocryphal, but it certainly rings true. The Coleoptera, the scientific order containing the beetles, ranks as the most successful order of animals on earth.

Of all the plants and animals that have been identified around the globe, every fifth species is a beetle. About 350,000 have thus far been described, and many others undoubtedly remain to be discovered and named. *(Biologists cannot agree on how many beetle species may eventually be found. Some estimates now run as high as eight million.)* Nearly 30,000 occur in North America, a staggering total with countless look-alike species, many so small that they must be examined under a microscope. Positive identification to species seems virtually impossible for anyone but a specialist, except in the case of the larger and more common ones. *(With the increasing popularity of insects, more identification manuals appear every year. Several guides now make it possible for the amateur to identify many of the beetles commonly encountered.)*

Our own efforts at learning about beetles have been limited to photographing them and identifying them to family under the tutelage of our son, Michael, now a graduate student in entomology at Texas A&M University. *(Mike presently teaches biology at Pima College in Tucson, Arizona, and continues to advise us on insect matters.)* Even with our limited knowledge, however, we have examined and photographed dozens of attractive beetles in recent weeks, most

of them drawn to our porch light at night.

Highly adaptable, beetles live in a wide variety of habitats ranging from ponds and rivers to the driest of deserts and the frozen tops of towering mountains. Every plant is a potential host; every rotting log is filled with beetles large and small. Many feed on cultivated plants, sometimes becoming serious pests. The cotton boll weevil, for example, causes

COTTONWOOD BORER

millions of dollars in damage each year, while indiscriminate pesticide spraying in attempts to control the weevils and other beetles causes disastrous chemical pollution and the loss of beneficial insects. Wood-boring beetles damage both living trees and those felled as timber, and we are all too familiar with the ravages of the pine-bark beetles that have decimated pine stands in our own area of Southeast Texas.

Not all beetles prove incompatible with human interests. The popular and storied lady beetles, sometimes called "ladybugs" or "ladybird beetles," rank prominently among our beneficial insects. Both larvae and adults feed on aphids injurious to plants, and the beetles are often raised in captivity or collected in their winter masses for sale to gardeners. Lady beetles also provide an excellent example of diversity in our insect fauna, for the family contains forty-six genera and at least four hundred species, many of them

BEAUTIFUL TIGER BEETLE

CONVERGENT LADY BEETLE

widely distributed across the continent. Most are patterned in orange, red, or black.

Our recent beetle visitors have included huge brown prionids as large as our thumbs and large click beetles that flip into the air with an audible sound when handled. The larvae of the former bore into dead trees in the woods nearby, while those of the latter live underground. We have identified pretty little checkered beetles bristling with stiff hairs and brightly colored, iridescent scarabs in hues of green and orange. Predaceous ground beetles prowl our patio; brightly colored leaf beetles populate our plants.

We cannot identify all our insect visitors, nor do we ever hope to do so. Nonetheless, we enjoy their presence, and we find that although we had nothing to do with their abundance, we, too, have developed an inordinate fondness for beetles.

Insect Fireworks: 1987

A large number of different creatures are capable of producing light. These bioluminescent organisms include such wildly diverse life-forms as bacteria, fungi, fishes, jellyfish, and insects. Best known and most easily observed are the fireflies. Known by a variety of different names—fireflies, lightning bugs, glowworms—they occupy none of the taxonomic groups those names imply. They are not actually flies, bugs, or worms. Rather, fireflies are soft-bodied beetles in the family Lampyridae, a name derived from an ancient Greek word that also gives rise to *lamp*. Other insects, including a large Texas click beetle, may glow in the dark; however, they produce

a continuous glow when energized. Fireflies possess the ability to flash their lights on and off at will.

The pyrotechnic beetles have been a source of wonder and delight since the beginning of recorded time. Ancient writings from the Far East contain accounts of them as far back as 1500 to 1000 B.C. The Japanese believed decaying grasses transformed into fireflies, and they staged elaborate firefly festivals. Aristotle knew and wrote of them, and Pliny thought they controlled their pulsing flashes by opening and closing their wings. That belief continued on through the Middle Ages for want of closer observation. Francis Bacon, in the seventeenth century, discovered that the light was produced without heat; famed scientists Michael Faraday and Louis Pasteur both studied the luminescent properties of insects.

Research into bioluminescence continues to the present day. We now know the light is produced when the complex organic molecule luciferin reacts with oxygen in the presence of the enzyme luciferase. That oxidation produces an unstable molecule that then decays to a lower and more stable energy level with the emission of a photon of visible light. The process proves to be extremely efficient, and no heat is given off. Complex organs in the last two or three abdominal segments of the firefly serve as mixing chambers for the chemicals and produce the light, while several layers of cells serve as efficient reflectors. The nervous control of the flashing sequence is centered in the brain and regulated by the flow of oxygen to the reaction site.

Actually, many species of fireflies, or lightning bugs, share the ability to produce light; some two thousand species have been identified around the world. Most of the North American species are brown or black, frequently with yellow or orange patterns. They share a flat, shieldlike pronotum that hides the head from view.

Different species of the beetles

PHOTURIS FIREFLY

produce different wavelengths within the visible spectrum. Most glow with a yellow light, but some have a more greenish, bluish, or orangish hue. The yellow light seems to belong to fireflies most active early in the evening. Greener lights become more obvious late at night. And some fireflies produce no light at all.

The nocturnal signals provide a distinctive insect code that identifies the sender by species and gender. Variables include the color of the light, the time of day, the number of flashes in each sequence, the duration and intensity of each flash, and the interval between pulses. One entomologist who studied the codes of fireflies recognized eighteen different species in the Potomac Valley alone. Ten of those had not previously been described. His efforts probably did not please museum curators, however, for their dead and mounted fireflies proved indistinguishable one from another and could not be correlated with the new taxonomy derived from the living organisms.

In general, the flashing codes are designed to bring the sexes of a single species together for mating. Males fly about advertising their passion and intent, while females signal back their receptiveness from perches amid the foliage. If the responses to their signals are correct, the males land and mate. The resulting eggs and flightless larvae may also bioluminesce, although the reasons for that adaptation remain unclear.

As with any system, things sometimes go awry. Predatory female fireflies occasionally lie in wait and mimic the calls from amorous males of other species. Should the male respond to the visual bait, he quickly falls prey to the imposter, a fate more permanent than a fleeting nocturnal liaison.

A great deal remains to be learned about bioluminescence and the life of fireflies. However, it is not necessary to grasp all the details to delight in nature's own insect pyrotechnics.

Bugs in Love: 1987

One of the most conspicuous insects along the Gulf Coast in certain seasons of the year is the little black-and-orange lovebug. *(This is another example of an inappropriate common name, as detailed previously. The lovebug is not a true bug at all.)* These small flies swarm in amazing numbers in both spring and fall, most frequently as mating pairs. These traits also give rise to the colloquial names "March flies" and "honeymoon flies." Subtropical relatives of the flies and mosquitoes, lovebugs range up the eastern coast of Mexico to Texas, Louisiana, and Florida. Although they do not bite and prove harmless to humans, their numbers make them highly unpopular at the peak of their seasonal flights.

L. A. Hetrick, an entomologist at the University of Florida, once wrote of the swarms in that state: "Adult flies are a nuisance when they spatter on automobile windshields at usual highway speeds. Driver vision is impaired and filling station attendants *[presumably before the advent of self-service gasoline stations]* expend considerable time and effort removing the spattered eggs and fly remnants from the glass of windshields and headlights and the fronts of vehicles. Large numbers of flies drawn into the cooling systems of liquid-cooled engines may cause overheating of motors, resulting in extensive damage. . . . The flies drift into freshly painted surfaces, and exterior painting of buildings is often suspended."

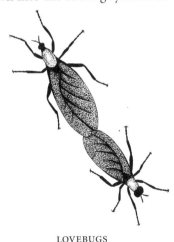

LOVEBUGS

Lovebugs develop from gray, wormlike larvae in damp, decaying vegetation, according to Howard Ensign Evans in his delightful *Pleasures of Entomology.* The larvae feed on rotting plants, grass clippings, fallen Spanish-

moss, or cattle dung and help reduce these materials to soil. They then pupate in the ground, the adults emerging a few days later.

Male lovebugs begin swarming over the breeding sites immediately after emerging, hovering near the ground and waiting for the females to appear and fly through the swarm. Males compete vigorously for the favors of each new female, according to Randy Thornhill, who studied the phenomenon in Florida. As many as ten males may grab a single female and attempt to mate with her, resulting in a "wrestling match" in which the heaviest male usually dislodges his lighter opponents.

A single act of mating may continue for as long as three days, which constitutes most of the adult lives of the participants. In flight, the slightly larger female leads, pulling the male along behind her. The male also beats his wings, however, and the Florida researchers found that coupled lovebugs could fly significantly faster than single individuals.

The females feed on the nectar of flowers, males still dangling behind them and perhaps not even able to reach the source of the sweet food. The incentive for the lengthy coupling is presumably to keep other males from subsequently mating with the same female. Experiments have shown that when female insects mate more than once, the last encounter usually fertilizes all the eggs.

During collection of lovebugs in the Florida studies, researchers learned that not only are the largest males most successful in mating but the paired females also average larger in size than unpaired ones. These are the individuals most likely to survive the long mating flights and lay viable eggs. Although larger size is advantageous, asserts Evans, it is not a result of genetic factors. Some larvae simply obtain more nourishment than others and produce larger adults. "If it were genetic," Evans writes in his inimitable style, "perhaps natural selection would produce flies of gradually increasing size. Lovebugs the size of turkey vultures would likely prove an embarrassment to the tourist industry."

The swarms of lovebugs would seem attractive fare for insect-eating birds, but predators scarcely touch them. "People who have tasted lovebugs report them to be terribly bitter," says Evans. This unpalatability

probably explains the bright orange thorax, unusual ornamentation for a fly. Orange often constitutes a "warning color" in insects, informing would-be predators that they are not good to eat.

Why lovebugs gather along asphalt highways and at fresh paint has long been the subject of study. They are not particularly attracted to exhaust fumes or to lights, but when the two were combined, the flies rushed toward them. The conclusion has been that the ultraviolet wavelengths in sunlight act on hydrocarbon vapors to produce a biochemical smog. The products of that reaction mimic the odors produced by decaying organic material in nature, the sites in which the flies prefer to lay their eggs.

It seems particularly surprising that an insect now so abundant was not even known to science until 1940. It remains unclear why lovebugs have increased so dramatically in numbers, but one biologist asserts that the change results from the draining of marshes and an increase in mowed meadows and pastures rich in cattle droppings and other organic wastes that have provided new breeding sites. Whatever the reason, we are now deluged with little black-and-orange flies that, throughout their lives, seem to be obsessed with sex.

Monstrous "Mosquitoes": 1987

Only a few insects prove familiar to most of the casual wanderers along our nature trails. Most people know the monarch and a few other showy butterflies, and everyone curses and swats at mosquitoes, house flies, and fire ants. Dedicated gardeners spray for chinch bugs, scale, or thrips, sometimes without really knowing the opponents against which they wage their wars. The remainder of the insect world, however, the most populous of the earth's many creatures, seems destined to live lives of relative obscurity, unrecognized and sometimes even unnamed. These insects seem of little concern to us because of their small size, unless their habits bring them into direct conflict with our own vested interests.

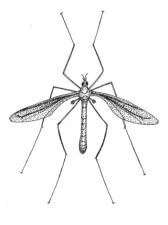

CRANE FLY

One such little-known insect is the crane fly, one of the first to take wing in late winter or early spring. Even as temperatures hover a few degrees above freezing, the first harbingers of the coming season seem to be attracted to our lights. As the weather warms, they swarm through the yard and cling to the sides of the house, sometimes finding their way indoors to fly on diaphanous wings from room to room. In spite of the crane flies' abundance, most people do not know what they are. Some are frightened, perhaps, by the crane flies' close resemblance to giant mosquitoes.

Biologists classify crane flies as members of the family Tipulidae in the larger scientific order Diptera, an order that also contains the flies, mosquitoes, midges, and gnats. Some eighty-six thousand species of Diptera occur worldwide, with about sixteen thousand in North America. Thousands of tropical species almost certainly remain to be identified. Of these diverse insects, the crane flies compose the largest family, with more than fourteen hundred found in the United States. Many could be considered very common.

With bodies an inch or more in length, and with extremely long legs from which they take their name, crane flies do, indeed, resemble overgrown mosquitoes. They differ in one major respect, however: crane flies do not bite people. They reside chiefly in moist areas with abundant vegetation, and the larvae live in water or damp soil. Most of those larvae consume decaying plant material, while a few feed on living plants or are predators on other small invertebrates. They then pupate and metamorphose into the clear-winged, flying adults. Little is known about the feeding habits of adult crane flies, although some have a long proboscis and have been seen to feed on flower nectar.

Like their dipteran relatives in 150 different North American

families, crane flies have only a single pair of wings rather than the two pairs utilized by wasps, bees, and other insects that might easily be confused with flies. The word *diptera,* in fact, means just that: "two wings." The hind wings present in the vast majority of insect orders have been reduced in the flies to small knobbed structures called halteres.

These unique stalked organs function as equilibrium devices in what one entomologist cites as the only known use of the properties of a gyroscope in the animal world. According to Talbon Waterman of Yale University, the halteres "may be considered as analogous to the turn indicator of an airplane in which the precession of a gyroscope is used to signal the direction and rate of turn."

Early observers suggested that flies used their halteres much as a tightrope walker uses a pole weighted at each end, and they called them "balancers." More recent studies show that halteres do not function in that manner, for they weigh too little to be effective. If only one haltere is removed from a crane fly or another of its relatives, the fly can move about normally, although it may be slightly out of balance. If both are removed, however, the insect goes into a spin and eventually falls to the ground.

Crane flies are only some of the thousands of obscure members of the order Diptera that use these remarkable insect gyroscopes, but their large size and early emergence in the spring make them more likely than most to attract attention. Like all inhabitants of our fascinating world, they merit closer examination.

The Grasshopper Clan: 1982

Grasshoppers live abundantly throughout the fields and along the roadsides across the country, and the group is familiar to almost everyone. Relatively large, colorful, and frequently noisy, they rank among the most visible of all our insects. They also have, of course, enormous economic importance because of their fondness for forage and food crops of many kinds.

Grasshoppers and crickets belong to the scientific order Orthoptera, a large worldwide group numbering more than twenty-three thousand. A thousand different species occur in North America. Many older insect books also include in that order the mantids, walkingsticks, and cockroaches; however, most authorities now place the latter creatures in separate orders of their own. The word *orthoptera* means "straight wing" and refers to the long, narrow, leathery forewings, which do not assist in flight. Beneath those forewings, or tegmina, are broad, membranous hind wings with radiating veins that permit them to be folded fanlike so they remain covered while the insect is at rest.

A large head with huge compound eyes and chewing mouthparts is also characteristic of the order, as are powerfully muscled hind legs for jumping and a prominent saddle-shaped plate, the pronotum, that covers the thorax. The conformation of the pronotum proves useful in the identification of many species.

Grasshoppers may be divided into two large groups, the "long-horned grasshoppers," whose antennae are as long as or longer than their bodies, and the "short-horned grasshoppers" with antennae less than half the body length. The former include the familiar katydids and usually wear shades of green or brown. The latter are the insects we usually call "grasshoppers." They differ widely in appearance and often bear brilliant colors.

Many of the species produce loud, sometimes musical "songs" by rubbing one body part against another. Katydids and other long-horns rub a sharp edge of one front wing over a filelike ridge on the underside of the other front wing, producing the characteristic calls for which they are named. Some of the shorthorns strike the leathery forewings with their hind legs. The tempo or pulse of the songs is dependent on temperature.

Still other short-horned grasshoppers snap their hind wings in flight, producing a loud crackling sound. The noise undoubtedly has some value in startling would-be predators as the grasshoppers flush from the grass in front of them.

Generally, the males alone do the singing, the sounds presumably used to serve as warnings, to proclaim territories, and

to initiate courtship. It might be expected then that these insects have developed a keen sense of hearing, and that is indeed the case. Short-horned grasshoppers detect sounds through

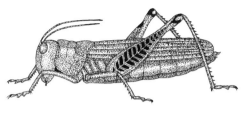

DIFFERENTIAL GRASSHOPPER

round tympana, or "eardrums," on each side of the first abdominal segment. Katydids and their closer relatives, on the other hand, have their tympana on the tibia of their front legs.

Grasshoppers undergo incomplete metamorphosis, maturing without benefit of a pupal stage in which many other insects change from larval forms to adults. Instead, the tiny nymphs look much like their parents, lacking only wings and reproductive organs. After hatching from eggs deposited in the ground, they pass through five or six nymphal stages, growing progressively larger each time they shed their skins, until they reach adulthood in the last transformation.

Some of the shorthorns are commonly called "locusts," a name derived from the Latin word for "grasshopper." These are the locusts that have historically decimated crops and other vegetation, not the periodical cicadas that frequently, and incorrectly, share that name.

From time to time, grasshopper populations build to enormous numbers and launch mass migrations over long distances to seek food, completely destroying foliage along the way. Such locust swarms can be especially prevalent in the drier regions of Africa and the Near East. One such flight in East Africa was estimated to be more than one hundred feet deep across a mile-wide front and took nine hours to pass at a speed of six miles an hour. Each of the billions of insects consumed its own weight of plant material every day. Amazingly, these same grasshoppers normally occur as solitary forms that do little damage to the environment. Only when they are overcrowded do they become gregarious.

Experiments have shown that when females are raised in close

proximity to males, the hormonal stimulus causes them to grow more rapidly and their eggs to hatch more quickly. The sequence of a favorable season for reproduction followed by drought and the resulting poor conditions for finding food leads to overcrowding. The insects band together in search of something to eat, and the increased stimulation produces a population explosion. Only then do the infamous, and devastating, locust outbreaks occur.

Moonlight Serenade: 1987

Away from the noises of the busy city, the night fills with music. Occasionally we hear the calls of various owls or coyotes. Toads trill, and frogs croak and chirp. But more than any other of the nocturnal musicians, the crickets and katydids dominate the moonlight serenade.

Crickets have long been popular in many of the world's cultures. In the East, they live in ornate cages as singing pets. John Milton and Charles Dickens wrote of crickets on the hearth; John Keats dedicated one of his sonnets to the little insects. One, of course, Jiminy Cricket, even became a movie star. Our word *cricket* is onomatopoetic, from the same origin as *creak*. It takes much the same form in many languages, reflecting our fascination with the repetitive, strangely pleasing calls.

Only the male crickets sing. A large vein on the insect's membranous wing bears from eighty to three hundred tiny ridges along its length. This "file" moves across a "scraper," a hardened portion of the wing margin, causing the membrane to vibrate, thus producing the song. Both wings of the common field and house crickets have a file and scraper, so they can theoretically be ambidextrous.

However, according to Howard Ensign Evans in *Life on a Little-known Planet*, they almost always sing with the file on the right wing overlying and rubbing the left scraper. Only about 5 percent are "left-winged," and because the file on that wing is somewhat weaker, the song proves less musical. Selective breeding may well

serve to suppress the tendency. Katydids, on the other hand, are left-winged, according to Evans. The right file is very poorly developed, and "right-winged" individuals are unable to sing. Because they are then unsuccessful in attracting mates, they do not perpetuate the trait.

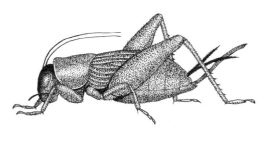

FIELD CRICKET

Actually, crickets have several different songs in their repertoire and use them for different purposes. We normally hear the loud "calling song" of males ready to mate and inviting receptive females that are within auditory range. Even though we can detect the song over a distance of 150 yards, experiments indicate female crickets are attracted from little more than 10 yards away.

Scientists realized in the nineteenth century that the rate of sound production in cold-blooded insects may be influenced by temperature. A. E. Dolbear, professor of physics at Tufts College, wrote an article entitled "The Cricket as a Thermometer" in 1897. There he presented his original formula, now known as Dolbear's Law: "The number of chirps per minute minus 40, divided by 4, and that quantity added to 50, gives the temperature in degrees Fahrenheit."

Dolbear, unfortunately, was a physicist, and he regarded "the cricket" as a single entity. In fact, there are many species, each with its own characteristic tempo. It appears likely that Dolbear was working with the snowy tree cricket, a species with clear, liquid notes and an appearance quite unlike that of the dark field cricket. Evans suggests that the latter proves to be less dependable, and the rate may vary with age, previous mating success, and other factors.

Dolbear also noted that when many crickets begin singing, all members of one species may chirp in unison, as if being led by a single conductor. More recent experiments confirm that there is, indeed, a leader. If the conductor is silenced, the rest of the chorus stops, but if some of the followers fall silent, the leader sings on. In

spite of these complicating factors, the basic rhythms and tempos of cricket song are inherited and characteristic of each species. Adult males sing their own song, and females respond to it, even if neither sex has heard the song before.

Under normal conditions, females respond only to songs of their own species, but they can be fooled. A female kept at seventy degrees is attracted to males of her species kept at the same temperature, but she may also react to other species if they are kept at different temperatures to produce the proper tempo. She evaluates the song she hears based on the temperature of her own body.

There are many variations on the theme and much about nature's musicians we do not as yet understand. It is not necessary to have memorized the score, however, in order to enjoy the insect symphony on a warm, moonlit summer night.

The Noisiest of Insects: 1977

Z-z-z-zeeeeeeee. The shrill, ascending metallic noise begins each morning as the sun warms the treetops and continues through the long, hot Texas summer, as if dozens of tiny buzz saws were at work in the trees. The sound is the song of what must surely qualify as some of the loudest musicians in the insect world, the cicadas (pronounced si-KAY-duhz). Many call these large and formidable-looking creatures "seventeen-year locusts," an unfortunate misnomer. The legendary plagues of locusts that devour crops and lay waste to the land are really composed of migrating grasshoppers.

Cicadas do not migrate, nor do they have chewing mouthparts

DOG-DAY CICADA

with which to devour crops. Instead, they possess piercing beaks to suck plant juices from trees and shrubs. Only when they occur in very large numbers are they likely to do severe damage, primarily to orchards and nursery stock. Cicadas occupy a very different and diverse order of insects from that of the migratory locusts. Cicadas belong to the Homoptera *(now often merged with the Hemiptera, the order containing the true bugs)* with relatives that include the treehoppers, leafhoppers, aphids, and scale insects.

Actually, of the more than seventy-five species of cicadas known from North America, only six qualify as "periodical cicadas." Three have a seventeen-year life cycle, and three follow a thirteen-year cycle. Much more numerous in many regions are the "dog-day cicadas." The species and broods of the latter overlap so that some emerge every year.

The precise life cycles of most of the dog-day cicadas remain poorly known. One author states that they range from two to five years in length, and another notes that the shortest known cycle is four years. In general, however, these spans are much shorter and less predictable than those of the more famous periodical species.

Cicadas range in size from less than an inch long to more than two inches. The dog-day species normally reach larger size and are often blackish with green markings. Their wings are clear and exquisitely veined. In contrast, the smaller periodical cicadas have reddish wing veins and huge, red compound eyes. The latter occupy a limited range in the eastern states.

Female cicadas lay their eggs in slits in the twigs of various woody plants. This may cause the terminal portion of the twig to die, but seldom does it result in serious damage. The eggs hatch in four to six weeks, and the little nymphs drop to the ground and burrow into the soil. There they remain, sucking juices from the roots, until they are ready to molt for the final time. In the case of the periodical cicadas, this underground life lasts for thirteen or seventeen years. Then the nymph digs its way out of the ground and climbs up on a tree or other nearby support where it can anchor its sharp claws. The skin splits down the back, and the adult cicada emerges, at first pale and soft bodied with shriveled wings but slowly hardening

and darkening upon exposure to the air. The cast-off larval skin is left behind as mute testimony to the cicada's long subterranean imprisonment.

At least thirteen different broods of seventeen-year cicadas and five broods of the thirteen-year species have been documented, the various broods emerging in different years. The seventeen-year species are generally the most northern, but both types and several broods overlap within their respective ranges. Each brood has been given a number, and some have been recognized and followed since early colonial times, appearing regularly every thirteen or seventeen years as predicted.

Emergence of a periodical cicada brood results in huge concentrations of the noisy insects. Sometimes forty to fifty per square foot dig their way out of the ground to freedom, and as many as nine thousand have been seen around the base of a single tree. The dog-day cicadas, on the other hand, emerge every year in less spectacular numbers.

Whatever the species or brood, the cicada's song makes it a prominent part of the summer landscape. This is not a vocal sound, however, but rather a noise produced by a pair of tymbals, specialized devices on the underside of the abdomen. Strong muscles cause a plate and series of riblike bands to bend and vibrate, and a large tracheal air sac functions as a resonance chamber and amplifies the sound.

Only male cicadas sing; and after mating, they die. Adult females, too, perish quickly after laying their eggs. Few adults live more than a month, a very short time in the summer sun as a reward for up to seventeen years of solitary confinement in subterranean darkness.

Consummate Survivors: 1987

Few creatures are more thoroughly despised than the cockroach. Yet at the same time, there seems to be a strange fascination with this well-known insect. Contests for the largest specimen attract thousands of proud entries and generate countless paragraphs

of media prose. Celebrity broadcaster Marvin Zindler continues to document their presence in Houston restaurants in his weekly "rat and roach report." *(Zindler passed away in 2007, ending several decades of his popular consumer reports.)*

Texas and other southern states are blessed with more than their share of the nation's roach population, thanks in part to a mild climate. One report asserts that we spend some two hundred million dollars a year in trying hopelessly to control the household pest. The ubiquitous cockroach, however, is not intimidated by authority or heavy weapons. The Pentagon must devote sixty thousand dollars of its yearly budget just to "keep roaches at a manageable level" in that august facility. *(In view of military spending practices, those costs have undoubtedly increased since this column first appeared.)*

Whatever else we feel for the cockroach, we must give it its due. It certainly qualifies as the consummate survivor. The earliest fossil roaches, dating back some 350 million years, look much like the species that repulse homeowners today. They rank as the dinosaurs of the insect world, and they show no signs of letting go of their record for longevity. One biologist called their reign "Darwinism at its best."

Extremely resistant to radiation, an enviable trait, roaches have also developed a high tolerance for many poisons. Within a few generations, a matter of only months, they adapt to a particular insecticide and learn to avoid it and any telltale dead compatriots. It does not lie within the scope of this short essay to offer a critique of cockroach control. Rather, we offer a grudging salute to one of evolution's great success stories.

Our word *cockroach* stems from the Spanish *cucaracha*. Some people try to soften the social stigma attached to harboring the creatures by giving them such euphemistic names as "oak beetles" or "water bugs."

Actually, roaches are neither beetles nor true bugs. They are members of the insect order Orthoptera, along with the grasshoppers, walkingsticks, and mantids. *(Many taxonomists have now removed them from that order and placed them in the Dictyoptera, along with the mantids.)* Generally oval and flattened in shape, they have long, hair-

like antennae and a wide pronotum that conceals the head. Some have well-developed wings, but others bear none at all. In many species, females have much shorter wings than their male counterparts.

Biologists have identified some thirty-five hundred species of roaches around the world, although most of them reside in tropical regions. About fifty to fifty-five, in five different families, now occur in the continental United States *(and more will undoubtedly appear, as is the case with so many alien species of flora and fauna)*.

We count four species—the German, American, Oriental, and brown-banded cockroaches—among our major pests. According to entomologist Howard Ensign Evans, however, the names of these roaches resulted largely by chance. All seem to have originated in Africa.

In his classic *Life on a Little-known Planet,* Evans noted that "when Swedish naturalist Linnaeus received a roach from America, he called it 'americana,' while a roach from Asia he called 'orientalis.' Even by that time (1758) most domestic cockroaches had been spread over much of the globe, and modern transportation has finished the job."

"The late James A. G. Rehn, of the Academy of Natural Sciences of Philadelphia, was, among other things, something of a Sherlock Holmes of man's cockroach camp followers," wrote Evans. Rehn's

studies revealed that the American roach and the closely related Australian roach belong to a group found mainly in tropical Africa. He felt that they, along with the Madeira roach and several others, came from Africa to America on early slave ships. The Oriental roach also claims wild relatives in Africa, but evidence suggests that it arrived in Europe much earlier, perhaps on Phoenician vessels. Later it was apparently carried to South America on Spanish galleons and to North America aboard English ships.

AMERICAN COCKROACH

Similarly, the German roach probably originated in North Africa, but at a later date than the Oriental one. During its spread across Europe, according to Evans, it was called the "Prussian roach" by the Russians and the "Russian roach" by the Prussians. Neither country proved successful in curbing its rapid spread.

North America does have native cockroach species, but few of those have moved into our homes. Some inhabit sandy soils, while others hide beneath fallen leaves or in decaying wood. Most cause no damage, and they live their lives in quiet, unobtrusive obscurity. A giant Cuban roach more than two inches long has invaded Florida and will likely continue its spread. Although most roaches are brown in color, we now have a pale green one from Cuba as well. A particularly colorful species bears the scientific name *Aglaopteryx gemma*, "the little gem," although few who encounter it will share that sentiment.

Garden Dinosaurs: 1981, 1993

Slowly and carefully the predator stalks its prey, relying on stealth and camouflage to approach the unsuspecting victim. It moves deliberately on long, slender legs, its progress scarcely discernible among the leaves. Large unblinking eyes remain fixed upon the target. There are many successful predators in nature, where every creature plays the role of hunter or hunted in the game of life. Few prove better at this deadly game, however, than an insect that famed nature writer Edwin Way Teale once called "the garden dinosaur." We know it better as the praying mantis.

Indeed, the mantis does look vaguely prehistoric. The eyes are fixed at the upper corners of a triangular face, and the head revolves to allow a backward glance, something no other insect can achieve. Large, bladelike forelegs are armed with sharp spines and held extended in the prayerful attitude that gives the mantis its common name. The objective is not piety, however, but rather predation, for those legs snap shut like steel-jawed traps.

Like the other members of its order, the cockroaches, mantids have the full insect complement of two pairs of wings. The membranous hind wings are folded fanlike beneath the narrow, thickened forewings while at rest. Flight, however, is a last resort when confronted by an even larger predator. The mantis prefers to stalk its own prey on foot. The careful approach ends with a lightning-quick lunge as the mantis grasps its quarry in its forelegs. Its sharp mandibles begin at once to dissect the hapless victim.

Cosmopolitan in its tastes, a praying mantis consumes a variety of insects, including moths and butterflies, bees, grasshoppers, crickets, and beetles. It also takes spiders and occasional small lizards and frogs. There are even rare reports and photographs of successful attempts to capture hummingbirds.

We watched one day as a mantis stalked and captured a large dragonfly. Both insects can be formidable predators, and the outcome of the battle seemed at first in doubt. The mantis soon caught both pairs of the dragonfly's wings in its powerful grasp, however, and secured victory with several bites to the thorax. Within a few minutes, only the dragonfly's parchmentlike wings remained.

Some eighteen hundred species of mantids have been described around the world, most of them in tropical regions. Some are brightly arrayed in pink, blue, or purple, mimicking flowers and lying in wait among the blossoms for careless victims to wander by.

The dozen species of North American mantids masquerade not as flowers but as foliage or tree bark, wearing shades of green, gray, or brown. In some cultures, people believe that mantids grow on trees as leaves and break loose to become insects when they mature. Most common and widespread in the United States is the Carolina mantis, which ranges from the southeastern states across Texas to California.

Two introduced species, the Chinese and European mantids, spread quickly and now occupy large portions of

CAROLINA MANTIS

the country. The former was released near Philadelphia in 1896 to prey on garden pests; the latter was discovered by a nurseryman in Rochester, New York, in 1899. It presumably arrived accidentally in the form of an egg case on nursery stock.

The female praying mantis mates and lays her eggs on warm days in autumn, and that proves a risky time for the attendant male; he often becomes a meal for the voracious female upon completion of his nuptial duties. As she lays her eggs, the female ejects a whitish, gummy material that she methodically whips into a froth with tiny appendages on her abdomen. She then forms the froth into a multichambered, herringbone-patterned case attached to a tree limb or weed stem. Like papier-mâché, the case hardens and darkens, protecting the enclosed eggs through the winter months.

With the warmth of spring, the young praying mantids emerge as tiny replicas of their parents. Camouflaged among the grasses and leaves through the summer, young mantids are seldom seen, but they rank among the most beneficial predators of harmful garden insects. By fall they have grown to full size and reappear to mate and lay their own eggs, renewing populations of an insect about which superstitions abound. "Soothsayers," "mule killers," and "devil's coach horses" are only a few of the colloquial names by which people know these relicts of an ancient age.

Talented Home Builders: 1975

A great deal of construction has been going on around our suburban neighborhood this week, with at least four homes being built in our backyard alone, each by a different builder. We suspect they would not meet city housing codes because they are made of mud or paper, but they seem extremely sturdy in spite of the cheap materials. Each was designed and constructed by master builders of the insect world, the wasps. Each wasp species builds its own characteristic structure, following a mysterious blueprint that has been employed for untold generations. The paper wasps, mud-daubers, pipe-organ

mud-daubers, and potter wasps in our yard instinctively build nests exactly like those in which they were reared.

Some are social insects that live together in highly organized communities. Most of the social wasps construct their homes of paper, a tough gray material formed by chewing wood fibers and mixing them with saliva. Most common in our area of Southeast Texas are the *Polistes* paper wasps that make open-comb nests. Yellow jackets prepare paper nests underground, and some of the hornets construct huge paper-covered jugs that hang from tree limbs or under the eaves of buildings.

A paper wasp colony starts with a single queen. She alone constructs the first cells of the nest, hanging them by a paper rope from a patch of regurgitated, sticky material placed as a foundation. The blueprint calls for six-sided cells for maximum strength and close-order packing, much like the wax cells of honey bees. No shoddy builder, *Polistes* uses a very high safety factor in her work. One nest was found to support a weight of seven pounds, although the entire colony will never weight more than a few ounces.

The queen lays an egg in each cell, and after hatching, the larvae feed on portions of insects brought by their mother. Although many mature wasps dine on nectar and pollen from flowers, their young are usually carnivorous. These first larvae develop into worker wasps that assist the queen in enlarging the nest and providing food for subsequent young. During hot weather, they may bring droplets of water to the comb and provide additional cooling by fanning vigorously with their wings.

As autumn approaches, some larvae develop into either queens or male wasps that mate with them. The old queen, her workers, and the males then die, and only the new queens survive the winter to start anew the following year.

Some solitary wasps, like the familiar mud-dauber, build ingenious homes out of moistened clay. Attractive multicolored nests may be produced by using building materials from more than one mud puddle, adding layer after layer of different hues. The female then provisions the nest with spiders she paralyzes with her sting. After laying an egg in each cell, she seals the entrance

against intruders and goes off to start another construction project. The larval wasps will hatch and grow within their secure fortress, feeding on helpless and succulent spiders.

Building on the frame of our patio door is another type of wasp, a pair of pipe-organ mud-daubers. Thus far they have built a tube about eight inches long, with strips of mud layered together in a herringbone pattern. The male guards their new home while the female ranges widely in search of spiders with which to stock the pantry. The nest will be divided by mud partitions into individual cells, each containing an egg and a supply of food. The pair may then build other tubes beside the first, giving the appearance of a pipe-organ for which the wasp is named.

POTTER WASP

Nearby, a dainty, slender-waisted potter wasp works methodically to make tiny half-inch jugs of mud, each perfectly formed with a flaring lip. Instead of hunting spiders, however, this wasp shops the backyard supermarket for caterpillars for her prospective family. She then suspends an egg on a thread above the paralyzed food supply and seals the mouth of the nursery.

Many other wasps build their nests underground. Loosening the dirt with their jaws and raking it back with their legs, they then carry the grains away to avoid a telltale mound. Caterpillars, spiders, grasshoppers, crickets, aphids, and roaches all serve as food for young hatchling wasps of various kinds. One large and formidable species specializes in tarantulas that it drags to its burrow and pulls underground.

Preparations for parenthood complete, the burrows of the digger wasps are sealed and carefully camouflaged with freshly packed soil. Some wasps have even been observed using a pebble held in their jaws to tamp down the earth around the entrance, one of the few known examples of tool use in the insect world.

7

Reptiles and Amphibians

Few creatures evoke more fear and loathing than a slithering serpent; however, it is a fear that is largely misplaced and extremely unfortunate, both for the snake itself and for the person who encounters it. Only a small number of North America's snakes are venomous, and fewer still are aggressive. All are fascinating in their own right, and all play important roles in the balance of nature. Thus it is that we seek out reptiles and amphibians and delight in learning more about them, encouraging others to do the same.

Sandsnakes and Sidewinders: 1994, 1998

The sun is sinking rapidly toward the Tortolita Mountains to the west as we leave Oro Valley on the northern edge of metropolitan Tucson, Arizona, and head out into the desert. A thunderstorm over the rugged, rocky peaks presents us with a spectacular light show as vivid bolts of lightning flash against the flaming orange-and-purple sunset sky. Midsummer rains, known locally as *chubascos,* bring out a wide variety of wildlife ranging from butterflies and moths to secretive mammals. Of special interest to us on this trip are the unique reptiles that also inhabit the southeastern corner of the state.

During the day we delighted in the desert spiny lizards that darted quickly across the sand at our approach. At higher elevations on the mountain slopes, those large reptiles were replaced by equally

EASTERN COLLARED LIZARD

handsome and imposing Clark's and Yarrow's spiny lizards. Zebra-tailed, greater earless, side-blotched, and tree lizards scampered underfoot, as did a variety of whiptails that can be identified to species only after careful study. Amazingly, many of the latter populations consist only of females. They reproduce by parthenogenesis, laying unfertilized yet viable eggs from which hatch more females.

Wandering the rocky slopes and creek beds, we saw a large black coachwhip that darted away at breakneck speed and a mountain whipsnake that sought refuge in the top of a mesquite. With its long, slender body, the latter seemed perfectly at home among the branches high above the ground.

Now, with the setting sun, there is a changing of the guard. The night creatures begin to forage across the desert. With lightning still flickering all around, black-tailed jackrabbits and desert cottontails emerge from shelter to graze on new vegetation spawned by the life-giving rains. Banner-tailed and Ord's kangaroo rats and several species of pocket mice bound across the road. Short-tailed grasshopper mice pause in the headlights of our car to allow a closer look, as does a large woodrat. The latter is often called a "packrat" because of its penchant for accumulating assorted artifacts in its midden of cactus stems and other debris. Woodrat nests dot the desert floor.

A barn owl rises from the roadside on ghostly pale wings and

sails out across the flats, and not far away we spot a great horned owl perched atop a towering saguaro. With an abundance of rodents and rabbits afoot, these nocturnal raptors will not go hungry on this warm summer night.

We drive slowly along, intent on the road winding ahead of us, searching for desert snakes that hide by day from the scorching sun. We spot the first one shortly after dark and stop to admire its graceful, sinuous movements and brown-spotted pattern. It is an Arizona glossy snake, a harmless, beneficial reptile that seldom ventures out by day. Next the headlights reveal one of the prime targets of our search, a large snake crawling slowly across a rough gravel road. We quickly jump from the car and surround a Mojave rattlesnake that stops and coils in the beams of our flashlights. Flattening its sizable body and raising its powerful head, it watches us warily through lidless eyes, flicking its tongue to test the air.

All too often, drivers deliberately run over snakes on the road, but that is ecological terrorism at its worst. Even the venomous snakes play an important role in our delicately balanced environment, and this rattlesnake poses no threat to anyone tonight. Carefully we herd it off the road and out of danger, leaving it to go on along its wandering route.

Rattlesnakes prove particularly fascinating to most who admire snakes, and few regions host more different kinds than does southeastern Arizona. We frequently encounter Mojave and western diamondback rattlesnakes in the desert, and handsome black-tailed rattlesnakes inhabit the rocky foothills of the surrounding mountain ranges. On one such trip we even encountered a rare tiger rattlesnake, a pale, banded serpent with a small head and absurdly large rattle.

Our favorite, however, continues to be the sidewinder, a relatively small rattlesnake with the peculiar sideways gait from which it takes its name. We found our first sidewinder near Tucson several years ago and never tire of seeing them here in the easternmost portion of their range. In what most people would regard as empty, barren desert, we almost never fail to find one or more of the pale pinkish tan rattlesnakes with "horns" above its eyes and the characteristic looping style of locomotion. Indeed, tonight we chance upon five

sidewinders along one stretch of road through a low, sandy tract of creosote-bush.

SIDEWINDER

Not all the snakes we encounter are venomous, of course. Most are completely harmless, and we pick up some of them for close examination before releasing them again to go on their way. We find several Sonoran gopher snakes, one of the largest species of the region, as well as colorful long-nosed, patch-nosed, and lyre snakes and checkered garter snakes. A small regal ringneck snake constitutes a special prize, as does a particularly lovely California kingsnake banded with contrasting black and white.

Some are shy, secretive creatures seldom seen without a careful nocturnal search. One with a particularly euphonious name, *Hypsiglena torquata,* more than lives up to its common name, the night snake. Saddled and spotted leaf-nosed snakes have been added to our list over the last couple of days, and tonight we encounter our first banded sandsnake *(now called the variable sandsnake),* a small burrowing snake that literally "swims" its way through loose desert sands. Only after a headlong dive and some frantic digging in its wake do we succeed in capturing this elusive prize for close examination and then let it go once again.

Invertebrates, too, vie with the reptiles for our attention. Countless tarantulas cross our path, most of them dark, long-legged males that roam in search of mates when the rains begin. Tonight, however, we also find a large, light brown female ambling slowly along. It is a rare occurrence, for females seldom venture far from their deep burrows in the sand.

Giant hairy scorpions appear along the roads, as well as strange solpugids, also called "wind-scorpions" or "sun-spiders." The former possess only a mild venom and do not deserve their fearsome reputation. Other, smaller scorpion species are far more venomous. The solpugids lack venom entirely, but their strong, sharp jaws enable them to quickly dispatch their insect prey.

We never know what to expect on these nocturnal "road-hunting" expeditions. One night, after another drenching rain, processions of enormous black millipedes march across the roads, and that same life-affirming moisture brings out red-spotted and Great Plains toads along with a few gigantic and comical Sonoran Desert, or Colorado River, toads. Spade-footed toads freshly emerged from the desert sands sing their courtship songs from ephemeral pools.

Each evening of our stay begins with an incomparable sunset over a sublimely picturesque setting; each night brings new discoveries of unique desert creatures. There are many more we do not see, of course, and they will be targets for yet another nocturnal foray.

Little-Known Lizards: 1982

Some of our lizards are large and colorful, but most North American species are small, shy, defenseless creatures that dart for cover at the first hint of danger. Some are seldom seen and even less frequently recognized. Such are the members of the scientific family Scincidae, the skinks.

One of the most abundant reptiles in the Houston area also qualifies as one of the least known. The tiny ground skink, *Scincella lateralis*, inhabits woodlands, brushy fields, city parks, and even lawns and gardens; however, few who come across it know it by its proper name. Most see it only as a small brown, ephemeral shape slithering rapidly into the underbrush or beneath fallen leaves.

More than twelve hundred species of skinks—smooth, shiny, active lizards—belonging to some eighty-seven genera occur around the globe. They occupy every continent except Antarctica and inhabit many of the oceanic islands. They reach their peak of abundance in portions of Southeast Asia and in the Indo-Australian archipelago. Only about fifteen species of skinks occur in North America.

The ground skink ranges from southern New Jersey along the Atlantic coast to the Florida Keys and throughout the southeastern

states to Kansas and Texas. In our state, it occurs westward onto the Edwards Plateau and from the Red River to the Rio Grande. Roger Conant described it as "an elfin reptile of the woodland floor, quietly but nervously searching for insects among leaves, decaying wood, and detritus, and taking refuge, when approached, beneath the nearest shelter."

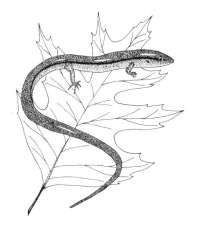

GROUND SKINK

Only an inch and three-quarters in length upon hatching from the tiny oval white egg, the ground skink grows no larger than three to five inches, including its long, slender tail. That tail has fracture planes that cause it to break off easily in the grasp of a would-be predator, a defense mechanism that allows escape while the confused predator is left clutching only the still-writhing tail. Like most other lizards, the skink can then regenerate the missing appendage, although the new growth will probably be shorter and of a different color. We sometimes find skinks and other lizards with forked tails, presumably through some "missed signal" in the regeneration process.

Sometimes called the "brown-backed skink," the ground skink ranges in color from golden brown through reddish to a dark blackish brown. Extreme variability of individuals and changing color and pattern with age seem characteristic of many skink species. The body bears dark dorsolateral stripes, and the underparts are whitish or dusky gray. Although many of the small skinks across the country look much alike, most can be separated by range as well as by their subtle markings.

Because their small, glossy scales give ground skinks a smooth-skinned appearance, they are often confused with salamanders, a mistake heightened by the skinks' fondness for moist places. They are, however, true lizards, reptiles rather than amphibians. They might also be misidentified as small snakes as they scurry under

cover, for they run with sinuous, snakelike lateral movements when in a hurry. The legs are small but fully functional.

Like most others of their family, ground skinks tend to be almost strictly terrestrial, as reflected in their common name. They are also diurnal, foraging actively during daylight hours and seeking shelter for the night beneath rocks, fallen logs, and other debris. Although they cannot tolerate the direct rays of the hot sun for long, these cold-blooded lizards need the heat of the day to function at top speed.

Transparent "windows" in the lower eyelids allow the ground skink to detect movement when its eyes are closed, thereby enabling it to forage and watch for danger while at the same time keeping dirt out of its eyes. Food items consist almost entirely of insects, spiders, and other small arthropods. Because of its small size, the ground skink is limited in its prey, but some skinks, particularly species of the Asian and Australian regions, reach enormous size and can devour young mice, baby birds, and eggs as well as the customary insects. Most species attempt to bite when handled, but the nip of the smaller ones is completely harmless. The largest of the family are capable of inflicting a painful pinch.

Ground skinks apparently mate throughout much of the year, from January until at least August, and a single female may lay as many as five clutches of eggs. Each clutch contains from one to seven leathery-skinned eggs hidden in the leaf litter or in rotting wood. Although some skinks tend their eggs during incubation, female ground skinks promptly abandon their nests after laying. The eggs will be hatched by the warmth of the sun to provide more tiny but voracious lizards to consume insect pests in our yards and gardens.

Voices in the Night: 1996

Twilight envelops our lakefront cabin in northern Minnesota, and the avian chorus that has entertained us throughout the day winds

slowly down. The cheerful songs of the robin fade with the sunset, and the bravura performance of the purple finch and the Baltimore oriole draw to a close. From deep in the shadows a veery sings its evening vespers, a series of reedy, cascading notes with harmonic overtones. Out on the lake a loon salutes the end of another day. Now, however, other music begins to rise and swell. New musicians take their turn; new voices herald the deepening darkness. A frog chorus serenades the night.

From the birches and alders along the shore comes the high-pitched, piping whistle of the spring peeper, the single clear note repeated again and again. The tiny inch-long brown frog with a dark *X* marking its back is seldom seen, but its voice can be heard throughout the eastern portions of the country. Slow, flutelike trills rise from the surrounding woodlands, joining the whistles of the peepers. This is the musical call of the gray treefrog, one of many anuran voices that permeate the night.

A longer, drawn-out, high-pitched trill joins in as American toads take up the refrain. Their pleasing voices blend with the shorter clucks and grunts of wood frogs and northern leopard frogs. Underlying the chorus is the persistent, rhythmic beat of mink frogs that call from the sedges and water-lilies along a nearby river channel. A creature of the far North, this mottled green frog ranges from Canada southward only to the northern fringes of the United States. Its call has been likened to the plucking of a loose guitar string.

As the darkness deepens and myriad stars appear, we sit enthralled and listen to this music of the night. It will continue long after we fall asleep, a soothing symphony as pleasing as the daytime melodies of the birds. This particular chorus is unique to our present location, the voices those of species that blend only in a narrow band across the continent. Some reach the northern limits of their ranges here in Minnesota; others occur no farther south.

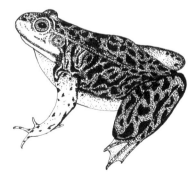

MINK FROG

Similar music, however, can be enjoyed almost anywhere from late winter or early spring through the hot summer months. From the sawgrass marshes of Florida's Everglades to the mesquite-fringed banks of a desert pond or limestone rill, frogs and toads of many species incessantly and persistently serenade the night.

Each anuran has its own characteristic voice, and learning the cast makes the concert more enjoyable. Indeed, tapes of the various frog and toad calls are readily available, just as are recordings of most avian songs. The gray treefrog was once thought to be a single species occurring across much of the eastern United States. More recently, scientists discovered there is actually a complex of two species with very different genetic makeup. One is diploid; the other tetraploid, with twice as many chromosomes. Identical in appearance, however, the two can be distinguished in the field only by the slightly different pitches of their songs.

Florida naturalist and herpetologist Archie Carr once observed that the reason frog songs are not more widely appreciated is that "they are sung in places where mosquitoes and snakes live." Certainly the mosquitoes are prominent in our Northwoods retreat, but there are no venomous snakes. Most people, nonetheless, retreat indoors at dusk, shutting out the night.

Many Americans, Carr further suggests, hear frog songs only as sound effects in motion pictures. Since the days of the first talking films, Hollywood has used recordings of the Pacific treefrog for scenes around the world, no matter how inappropriate the geographical setting. That colorful treefrog, in fact, is the only American species with the famed *ribbit* call.

David Badger and John Netherton, in their spectacular book *Frogs,* note that early visitors to the New World often marveled at the "frog music" encountered on our shores. One Englishman gushed: "The first frog concert I heard in America was so much beyond anything I could conceive of the powers of these musicians that I was truly astonished."

The first land animals with vocal cords, frogs "probably fathered all of the vertebrate music on earth," reflected nature writer Edward Hoagland. Certainly frogs and toads communicate in other ways as

well, but their vocal prowess remains one of their major attributes. Their repertoires fulfill a number of different roles.

Most common is the "advertisement call," or mating call, of mature males during the breeding season. It serves to attract a potential mate of the same species and warn rivals that the territory is already occupied. When hundreds of males congregate and sing in chorus, the overwhelming din can be heard for an amazing distance. The characteristic songs undoubtedly play an important role in isolation of the different species, allowing sexual partners to find each other. It is possible for related frogs to interbreed, but hybrids seldom survive and reproduce successfully.

Distress and alarm calls serve as warnings of impending danger, and some male treefrogs produce a rain call on the approach of showers. Quite different is the "release call" made by a male that is inadvertently clasped firmly by another male in the darkness and the passion of the moment.

Resonating vocal sacs make these sounds possible. A singing frog inhales through its nostrils and pumps the air back and forth over its vocal cords. With the mouth closed, the vocal sacs then act as resonators, projecting the vibrations and creating a variety of frequencies and intensities. In some frogs and toads, the inflated sac resembles a balloon beneath the throat; in others, the throat expands and bulges outward on both sides to produce paired vocal sacs. Tracking a song to its origin, one can watch as the thin balloons swell in forceful anuran song.

Asleep in our cabin, we wake several times during the night to listen through open windows to the nocturnal chorus until it fades with the impending dawn. Then, almost immediately, the birds begin anew, providing nature's symphonic music around the clock.

Endangered Toads: 1993

Numerous species of frogs and toads live in peril around the world; many have become extinct in recent years for various reasons. Scientists

continue to investigate and track their fate; indeed, a thorough analysis would fill several volumes. Global warming has dramatically altered the environment of many species, and disease and fungal infections have unquestionably taken their toll. As with many other forms of wildlife, from birds and mammals to tiny insects, however, loss of habitat also plays a major roll. Such is the case for the endangered Houston toad.

We walk slowly down the forest trail on a dark, heavily overcast night, a layer of threatening clouds obscuring a full moon. Flashlights in hand, four of us follow single file behind David Hernandez, a Texas Parks and Wildlife Department biologist, as he makes his rounds. We have come to Bastrop State Park east of Austin, Texas, in search of the rare Houston toad.

One of the first animals to receive protection under the federal Endangered Species Act, the Houston toad once flourished on the Texas coastal prairie; however, it declined sharply because of urban sprawl as Houston, one of the largest cities in the nation, expanded in all directions to crowd out remnant prairie tracts. It no longer occurs near the city for which it was named. Until 1989, the Bastrop site and an area near College Station, Texas, were the only remaining locations known. Subsequent surveys identified Houston toads in a total of eight counties, but Bastrop State Park remains the population stronghold.

Relatively poor burrowers in hard soil, these small toads require areas of deep, loose sand. The white sands and shallow ponds in the park's "lost pines" provide the perfect habitat, but even here the demand for multiple-use areas within the park system continues to erode vital habitat.

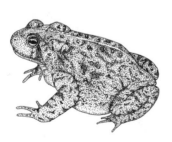

HOUSTON TOAD

Biologist Andy Price, assisted by Hernandez, is studying the basic ecology of the toad, determining its life expectancy, range, and breeding cycle. He captures singing toads during their spring breeding season and

implants electronic tags within their body cavities. Each of these tiny glass chips is encoded with a number that can be read by a hand-held scanner, thereby uniquely marking each individual toad.

On this night we follow Hernandez for half a mile to a pond created by a low earthen dam. Leopard frogs dot the banks, and we hear the songs of gray treefrogs and cricket frogs. We wait quietly while Hernandez slowly circles the pond, his headlamp illuminating the quiet water. He encounters no Houston toads, however, nor do we hear their trills above the other voices of the night. On some nights, scores of toads come here to breed; on other nights, they fail to appear at all. Cloudy weather masking the full moon is usually a good sign, but tonight seems to be the exception. Hernandez records the temperature of the air, soil, and water as well as the humidity, adding to the data bank on the behavior of the threatened toads.

Unsuccessful at the main study location, we retrace our route toward a shallow rain pool along the trail. Ahead we hear the high-pitched trill of a Houston toad, longer in duration and shriller than the songs of the treefrogs. Approaching slowly, we see the singer in the water, his throat swelling in courtship song. Another joins the chorus, and then another, the latter singing from atop a fallen log. All seem oblivious to our presence, continuing to sing as we stoop to examine them closely in the glow of our lights. Their throats puff up like toy balloons, mottled with the dark, dusky gray pigment that characterizes the male Houston toad.

Moving carefully, Hernandez catches all three and holds each one in turn beneath the scanner. There are no electronic sounds; no characteristic numbers light the screen. Too far from the principal research site, these males have not been tagged before. Weighed and measured, they are injected with new chips and quickly released, each in his own corner of the pool. One begins immediately to sing, undeterred by the brief encounter. Another of the trio hops over to sit beside the singer, acting the role of a "satellite male." Conserving the energy required for singing, he rests quietly and hopes to steal away a female as she approaches.

We, too, wait patiently in the night woods, but no female appears to accept the courtship offer. Finally, we turn and walk back along

the sandy trail, still delighted with our new adventure. We have seen one of the rarest and most endangered residents of Texas, and we feel a sense of hope for the continued preservation of the Houston toad and others that share its vanishing environment.

Secretive Salamanders: 1987

Although they are numerous and widespread across the country, salamanders remain much less familiar to most people than their amphibian relatives, the frogs and toads. Because they tend to be secretive, voiceless, and largely nocturnal, salamanders are seldom encountered by the casual wanderer along our nature trails.

Unlike frogs and toads, salamanders have long tails and slender bodies with distinct divisions. They usually possess front and hind legs of nearly equal size, adapted for crawling or swimming rather than for jumping. Frequently confused with lizards, they lack the body scales and claws of those terrestrial animals. Lizards are reptiles most commonly found in dry environments; salamanders qualify as amphibians for which moisture remains an absolute necessity.

Approximately 350 salamander species range throughout North and South America and the temperate regions of Asia, Europe, and North Africa; however, more kinds occur in the Americas than in the rest of the world combined. At least 112 species inhabit North America north of Mexico, depending on the taxonomy one chooses to follow.

All of our salamanders lay eggs, sometimes after elaborate court-ship rituals. Most deposit those eggs in water; others lay them in damp cavities or caves. The young that hatch on land are miniature replicas of their parents, while those that hatch in water begin life as larvae, breathing through external, feathery gills. The latter differ from the tadpoles of frogs and toads in growing legs at an early stage in their aquatic development. After several months, most larvae transform into adults and leave the water. Some develop lungs to replace the juvenile gills; others take in oxygen through their moist

skin. A few, termed "neotenic," retain their gills and become sexually mature in water.

Although many of the terrestrial salamanders are small, inconspicuous, and drab in color, there are also large and colorful species. Seven different families occur in North America, the strangest of which contains the aquatic giant salamanders like the hellbender, mudpuppy, waterdogs, amphiumas, and sirens. Herpetologist Roger Conant, in his field guide to reptiles and amphibians, calls these large animals "an assortment of big, bizarre salamanders that look more like bad dreams than live animals. Some are long, dark and slender and resemble eels. Some permanently retain their larval form, bearing external gills throughout their lives. Others are flattened and suggestive of weird creatures crawling forth from the antediluvian slime."

Many thrive in aquariums, and the waterdogs are frequently raised commercially as fish bait. The huge, grotesque hellbender grows up to two feet long, while the eel-like greater siren attains a length in excess of three feet. In spite of their impressive size they pale in comparison to the enormous five-foot Japanese salamander. Such giants, however, qualify as the exceptions among the Caudata, the scientific order of the salamanders. Most grow to only a few inches long, including the tail, and spend most of their time hidden beneath stones, logs, or fallen leaves.

The mole salamanders get their name because, like moles, they remain underground, only congregating in pools or ponds after early spring rains to court and lay their eggs. One of the family, the small-mouthed salamander, is commonly found beneath fallen logs and other debris in damp East Texas forests. Its black or dark brown body bears a pattern of pale snowflake markings.

Another salamander family, the newts, remains essentially aquatic, and its members are frequently sold as aquarium animals. Some transform from the larval form into an intermediate called an eft, which remains on land for one to three years and then returns to the water to become an aquatic adult.

Herpetologists have classified a varied array of lungless salamanders, in which respiration takes place through the skin and the lining

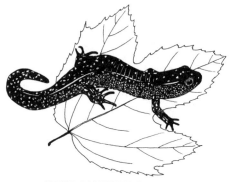

SMALL-MOUTHED SALAMANDER

of the mouth. Other salamanders are blind, having adapted to life in the perpetual darkness of caves or underground streams, where they have no need for functional eyes. Some species range widely across the continent; others are limited to a small localized area or even a single bog or cave. Each of these unique salamanders has adapted to life as an inhabitant of a specific, carefully balanced ecosystem.

Ancient Instincts: 1995

The sun is sinking toward the western horizon as the painted turtle leaves the river and crawls laboriously up the steep, grassy bank. She stops often to test the ground and continues slowly on, driven by an instinct etched in her genes, an instinct as old as her ancient lineage. Finally, she selects a spot and begins to dig in the hard-packed sand and gravel beside an asphalt road. It is not the softest ground along her meandering route, nor is it the safest, for she labors within two feet of an occasional auto that whizzes by. This female turtle has chosen a nest site based on criteria known only to her. Her sisters select other sites along the bank or wander off into the surrounding trees, stopping in weedy clearings or along forest trails, often far from the clear but sluggish stream.

These western painted turtles are responding to the instinctive call on a warm, moonlit June night in northern Minnesota. It is a call, however, that repeats in many locations and at many seasons of the year. Around the world, turtles of various species leave their homes in lakes, marshes, and the sea to lay their eggs ashore.

As we watch, the turtle begins to dig with her wide, paddle-shaped hind feet. The round, narrow entrance hole widens into a

flasklike chamber. Slowly, patiently, she stretches a foot down into the chamber and removes a bit of dirt, placing it carefully on the rim of the hole. Scoop by scoop, unable to see her progress behind and beneath her, she follows the genetic blueprint of her species.

The nest finally completed to her satisfaction, she begins to lay her white, leathery, elliptical eggs, rising slightly on her stubby legs as each egg appears. Absorbed in her labor, she pays no attention as we squat beside her and watch in fascination.

About twenty eggs are laid at fifteen- to thirty-second intervals, each dropping unerringly into the underground cavern. Then, clutch completed, the turtle begins to refill the hole. Again she uses only her rear feet, raking in a small amount of dirt at a time and packing it carefully. It is a long and tedious process, going on well into the night, but turtles seldom seem pressed for time.

Finally her efforts are over; scarcely a trace of her excavation remains. She rises up and drops back down several times, tamping the earth with her plastron, the lower portion of her shell. Only then does she turn away and trudge slowly back toward the riverbank. Many of the eggs will subsequently feed raccoons, skunks, and other predators that search them out by smell and dig them up, but a few will survive undiscovered in their underground refuge. It will be enough to spawn another generation.

Hatching will begin in late August after seventy to eighty days of development, but the young turtles may not leave the nest until the following spring. Secure underground, they survive temperatures near zero as snow blankets the land. Amazingly, laboratory experiments show that the sex of the hatchlings is determined by nest temperatures during their development. Above eighty-four degrees Fahrenheit, the eggs produce mostly females. Lower incubation temperatures result in higher numbers of male turtles.

On subsequent evenings, we also discover snapping turtles laying their eggs

WESTERN PAINTED TURTLE

along the lakeshore. Much larger than the painted turtles, these females likewise tolerate our approach as they dig their nests and lay their eggs, although they may turn and snap their powerful jaws should we venture too near. Snappers have a fearsome, prehistoric look about them, an appearance that is well deserved, for they trace their lineage far back in geologic time. With snapping turtles, too, the sex of the babies depends on incubation temperature, with eighty-two degrees producing a 50/50 mixture.

Every creature has its own unique formula for survival, and the turtles are no exception. Although losses of eggs and young are heavy, their reproductive strategies have been successful for a very long time.

8

At the Edge of the Sea

The seashore holds tremendous fascination for almost everyone. The relentless surge of the waves and the shifting sands of the beach and dunes provide an ever-changing spectacle of power and beauty. Most regard it simply as a place for recreation or perhaps as a source of tasty morsels for the dinner table. Examined more closely, however, the seashore teems with marine creatures of enormously varied habits, appearances, and adaptations, each perfectly suited for its own way of life in the deep or along the edge of its watery realm. The finely tuned system is a symphony of sun, sand, sea, and surf.

The Bounty of the Beach: 1978, 1982

We walk slowly along the sandy beach of Texas' Mustang Island, scattering small flocks of shorebirds that scamper about at the water's edge. Sanderlings and snowy plovers run ahead of us like tiny windup toys; larger willets and knots keep pace with measured strides. Meanwhile, laughing gulls and royal terns fly low overhead, screaming avian insults at these intruders to their shore.

Waves roll up on the sand, tumbling shell fragments and erasing the hieroglyphic tracks of darting sandpipers. The ebb and flow leaves a line of shimmering iridescent foam, and in its wake lie translucent jellyfish and fragile sand dollars. Hermit crabs scuttle about in their secondhand shelters.

We pick up several scallops of varying hue and a huge cockle shell ornamented with brilliant sunset shades. Long strands of whip coral lie in the wrack line, looking for all the world like sections of bright red and yellow telephone wire. On these gorgonians, or soft corals, are polished little simnia shells that match the colors of their hosts. There, too, are barnacles found on no other substrate. Each coral strand harbors a unique community of highly specialized organisms.

Most of the shells we find are bivalves, a few still in pairs as special prizes for the shell collectors. There are colorful tellins and lucinas as bright and delicate as flower petals. Arks of several species litter the beach, their thick shells easily withstanding the repeated pounding of the waves. The scouring action of water and sand has removed the periostracum, the tough, leathery brown coating, to reveal the white-ribbed shell beneath. Tiny open coquinas lie on the sand like little butterflies of many colors, purple rays streaking the valves. As the waves retreat, live coquinas lie momentarily exposed before digging rapidly out of sight.

On a nearby jetty we find other mollusks more suited to life on the rocks and in the tidal pools. Periwinkles lie scattered everywhere, and limpets cling securely to the rocks, withstanding the waves and the prying beaks of prowling birds. Wading in a shallow bay, we scoop up sand and shake it through sieves to examine animals that live beneath the surface. Small razor clams appear, and lovely little tellins, slender white sea cucumbers, and several types of marine worms.

We have not previously been connoisseurs of worms, and we suspect worm-watching ranks several steps below bird-watching on the social ladder. Mentally apologizing to the worm specialists for that thought, however, we find worms immensely fascinating. Many live in protective tubes made of tiny shell fragments; others construct their shelters of individual grains of sand. Some have jelly-like egg masses attached. One annelid worm lies in our hands and literally shoots its long pharynx out through its mouth in search of food. It is not, perhaps, a beautiful animal except to a marine biologist, but it is certainly interesting.

We have accompanied a three-day field trip from the Houston

Museum of Natural Science to this watery wonderland, and in the afternoon we sail on one of the research vessels from the University of Texas Marine Science Institute in Port Aransas. We cruise up the channel filled with smaller boats and out into the broad bay system flanked by marsh grasses and black mangroves, passing flocks of both brown and white pelicans, watching cormorants and herons fishing in the shallows. Gulls and terns follow the boat in anticipation. Occasionally a bottle-nosed dolphin rolls nearby.

Pulling a small otter trawl, we net an assortment of fishes and crustaceans for study, most of them small but interesting nonetheless. Along with the edible pink, white, and brown shrimp are little rock shrimp and mantis shrimp with their praying-mantis claws. Scuttling across the deck as we dump the catch are purple crabs, hermit crabs in cast-off snail shells, and a beautiful calico crab dotted with bright red spots.

Carefully, we sort out stingrays and sea catfish with their formidable spines and toss them gently back into the water. Remaining are strange, large-headed sea robins and stiff-bodied lizard fish. Pinfish, pigfish, silver perch, whiting, menhaden, and anchovies all blend in shimmering silver. On further examination we identify several different kinds of small flatfish, including Gulf, southern, and fringed flounders along with bay whiffs and tonguefish. How strange these creatures seem, with both eyes on one side, adapted to lying camouflaged on the ocean bottom.

We pick up spiny burrfish, or puffers, and they inflate in our hands. So, too, does a least puffer, until it looks like a tennis ball with tail and fins. A small squid, viewed under a microscope we carry with us, pulses with iridescent colors like an illuminated neon sign. We examine each in turn and then return it to the bay.

Bunking overnight at the marine

MANTIS SHRIMP

institute, we continue on down Padre Island the following day. Here, too, we discover myriad shells, including such bivalves as the Venus clam, disc dosina, channeled duck clam, quahog, and tulip and hooked mussels. The gastropods, or snail-like mollusks, have descriptive names like sundial, slipper shell, baby's ear, and tulip. We find beautiful and shiny lettered olives but, disappointingly, only fragments of the delicate Scotch bonnet. Many of the shells have small holes bored in them by the rasp-sharp proboscises of carnivorous moon snails.

Seeking out a rocky area beneath some seaside buildings that Tom Pulley, the museum director, has permission to explore, we find a totally different marine fauna by wading out to turn over rocks and examining each one carefully. Here are sea anemones and sea urchins, brittle stars and an assortment of small crabs. We catch a pistol shrimp that stuns its prey with a "thumb" it cocks and then releases with an audible pop, and we encounter large sea hares, mollusks with only small internal shells that swim by "flying" through the water on fluttering "wings," like giant aquatic butterflies.

The rocks are encrusted with small sponges and bryozoa, "moss animals" whose ancestors existed in much the same form half a billion years ago. We study vivid green algae and tunicates in a variety of colors. The latter are minute colonial animals placed in the phylum Cordata because, amazingly, their larval forms possess a semblance of a backbone.

These myriad life-forms thrive along our shores and prove immensely interesting for young and old alike. Each of us discovers creatures we have never seen before, and we learn much about the fascinating world that borders the churning sea. There is no season on discovery, virtually no limit to what the curious might find.

Flowers of the Sea: 1980

Hordes of people flock to Texas beaches at Galveston, Bolivar, Surfside, and Mustang and Padre Islands during the long sum-

mer months. Most go to swim, sun, and surf, but a few also stop to examine the shells and other marine creatures they find along the coastal strand. One of the prettiest and most unusual of these, perhaps, is also one of the least understood. Although it looks like a "flower of the sea" with rings of colorful petals, the sea anemone is, in spite of its name, an animal.

Sea anemones thrive on the jetties and rock groins along our coast where they can gain purchase on a solid base; however, they are less frequently noticed than one might expect. Exposed by low tide, they withdraw their tentacles and shrink down into shapeless blobs of rubbery jelly, revealing little of their true nature. They are best studied when covered by shallow water.

Anemones are members of the scientific phylum Cnidaria, sometimes referred to as Coelenterata. Included in that phylum are three different classes: the Hydrozoa made up of the abundant little hydroids and the familiar Portuguese man-of-war and its relatives; the Scyphozoa composed of the jellyfish; and the Anthozoa containing the corals, gorgonians, and anemones. Although those scientific names seem imposing at first, they have simple meanings of Greek derivation. Anthozoa means "flower animals," an appropriate name for the anemones and the corals. Some of the latter are responsible for building huge calcareous reefs in tropical climates.

SEA ANEMONE

The name of the phylum, Cnidaria, refers to the stinging cells employed by its members—"sea-nettles," Aristotle called them as he wrote about the anemone. "It clings to rocks. . . . It has no shell, but its entire body is fleshy. It is sensitive to touch and, if you put your hand to it, it will seize and cling to it . . . and in such a way as to make the flesh of your hand swell up."

These stinging cells, called nematocysts, are unique to the Cnidar-

ians, and all members have them. Some, however, are too weak to harm humans. None of the anemones of the Texas coast can penetrate human skin, although the cells impart a sticky sensation when touched, as Aristotle noted. Nematocysts of some of the jellyfish and the Portuguese man-of-war, on the other hand, cause painful, disabling stings that serve both for protection and for trapping food. Microscopic, egg-shaped capsules embedded in the special cells have bristlelike triggers projecting from the surface. A long tubular filament lies coiled inside. When the trigger is touched, the filament shoots out and embeds itself in the attacker or prey. Some inject venom; others function like little lassos or sticky flypaper.

Most sea anemones are cylindrical columns standing on a base, the pedal disk. The mouth, located at the other end of the column, is surrounded by one or more rings of tentacles. Most live attached to rocks, pilings, old shells, or other solid substrates, but they are able to move slowly about, gliding on the pedal disk. Because they are often securely anchored in holes or crevices, however, they are normally difficult to remove.

The majority of sea anemones are relatively small, some no more than half an inch across the spreading tentacles. The largest species ever recorded from Australia's Great Barrier Reef, however, measured more than two feet across. Some bear such colorful names as "dahlia anemone" and "snakelocks anemone," and many are extremely long-lived. Record aquarium specimens have survived for up to ninety years. Reproductive methods may be either sexual or asexual; some lay eggs, while others produce small progeny by budding. They feed on both live and dead animals, ranging from plankton to small fishes, and they are preyed on, in turn, by fishes, nudibranchs ("sea slugs"), and even larger anemones.

A species known as the common jetty anemone occurs abundantly along the Texas coast. Usually light brown in color, it has vertical rows of blue dots along the column, and the tentacles are reddish below with blue stripes across the top. Individuals vary widely in color and pattern, however, and other common species look much the same. Accurate identification can be extremely difficult, requiring study of the internal structure and the type of nematocysts.

Sea anemones are frequently covered with sand and shell fragments captured by the tentacles. This debris serves not only as camouflage but as a physical barrier against predators, abrasion by the waves, desiccation, and sunburn. Strangest of all are the close associations with other organisms. Some anemones are colored by green algae living within their tissues; others play host to the clownfish that seeks shelter among the tentacles, immune to the venom and repaying its host with scraps of food. Some even spend unusually mobile lives riding about on cast-off snail shells inhabited by hermit crabs.

Seeing Stars: 1983

Many of the various creatures living in the sea have familiar counterparts that inhabit terrestrial environments. Land snails, for example, resemble closely the marine mollusks that crawl about on the ocean floor. Oceanic crabs, lobsters, and shrimp have many relatives that prowl the earth, especially on the banks of freshwater streams and ponds. There are other denizens of the marine world, however, that bear no resemblance to any creatures we find on land. They live exclusively in the eternal ebb and flow of the sea. Among those we count the sea stars, or starfish, inhabitants of almost all coastal waters around the world.

Most of the animals with which we are familiar also display bilateral symmetry. Whether insects, fishes, birds, or mammals, they have paired appendages on either side of an axis running from end to end. Even a worm has a front and a back, although we may not always be able to discern the difference.

A sea star, on the other hand, knows no front or back, no left or right. Its body consists of a central disk from which radiate identical arms, most frequently arranged in the form of a perfect five-pointed star. There are no directions in the rhythms of this radial symmetry; the processes seem more foreign because of it. With no close relationship to the fishes, it seems more appropri-

ate to employ the name "sea star" rather than the frequently used "starfish."

Near the center of the sea star's back is a circular, sievelike structure through which water is admitted. Then, through an intricate system of canals, valves, and reservoirs, the water flows to the radial arms. Little tubes on the underside of these arms serve as the sea star's feet. Water fills the tube feet and, as each is pressed against the substrate, the animal draws out the water and creates a suction. Rhythmically the sea star fills its tube feet and empties them in turn, alternately anchoring each tiny suction cup and withdrawing it, creeping slowly along by means of its seawater plumbing.

Thus the starfish gropes its way across the seafloor. It does not see where it is going; tiny eyespots on the arms are sensitive only to the presence of light or darkness. Encountering a clam or oyster, it gradually clambers atop its prey and encircles it with the five arms; then it begins to apply its tube feet to the shell, foot after foot with laborious patience. When its suction grip is carefully established, the sea star begins to pull, maintaining a relentless pressure. For hours if need be, it tugs at the two halves of the bivalve's shell. No clam can resist such force indefinitely; eventually it yields.

Now the sea star extrudes its stomach from its mouth on the underside of its body and inserts that organ into the opened shell. The everted stomach covers the soft body of the clam or oyster and begins to pour forth strong digestive juices. The process proceeds slowly, but there is no haste in the life of a sea star. In time the prey is digested, the stomach is withdrawn, and the predator creeps resolutely on.

The most common starfish on the Texas Gulf Coast, however, lack such powerful tube feet and are thus unable to open resistant bivalves. Consequently, they often feed as scavengers on dead fishes and

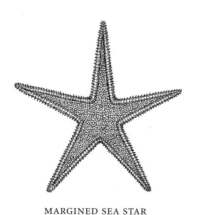

MARGINED SEA STAR

marine invertebrates, even including as prey other members of their phylum, the brittle stars and sand dollars. Food preferences vary with the species, some even grazing on living coral polyps.

Equally bizarre is the sea star's reaction to traumatic injury. Most animals die on being torn apart, but the sea star has the power to regenerate lost body parts. Each portion of that broken body settles to the ocean floor and begins to grow replacement arms, complete with new tube feet and new light-sensitive eyespots. The process, like everything else the sea star does, is extremely slow, but eventually regeneration is complete. Where once there was a single rough-skinned sea star, there will be two, each creeping slowly along on little tube feet.

Ghosts on the Beach: 1982

With the coming of autumn, we find ourselves drawn more frequently to the sandy, crescent beaches of the Texas Gulf Coast. Admittedly we are out of synch with the majority of sun worshipers and swimmers who swarm the beach in summer, but we prefer the shore in the cooler months of fall and winter. By then the crowds have thinned, and we can walk the sands in solitude, immersed in the subtle rhythms of the surf and the myriad creatures that dwell beside the sea.

One such animal is the charming little ghost crab, the pale-colored, camouflaged invertebrate that scurries about the upper reaches of the beach and among the shifting dunes. One of nearly a hundred species of crabs to be found along the Texas coast and in its offshore waters, it is the most frequently encountered.

Crabs have adopted an amazing variety of shapes, sizes, and color patterns to suit their individual habitats. The edible blue crab, the hub of a multimillion-dollar fishing industry, ranks high in commercial importance. There are also hermit crabs that appropriate empty snail shells as their own and tiny commensal crabs that thrive only in association with particular mollusk species. Texas

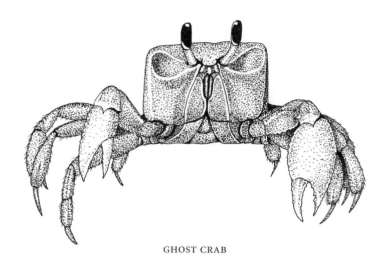

GHOST CRAB

claims stone crabs, mud crabs, purse crabs, and spider crabs. Some live only on rock jetties; others, only on floating sargassum weed. Although most crabs live beneath the water's surface in their various marine environments, the ghost crab remains essentially terrestrial. It does need to visit the surf periodically to wet its gills, but it will drown if kept submerged. Its normal home lies in the sands above the high-tide line.

The ghost crab, locally called the "sand crab," seems appropriately named, for its pale coloring makes it appear little more than a ghostly apparition as it darts across white sand beaches. The scientific name, *Ocypode quadrata,* is also well chosen, *ocypode* meaning "swift footed." It shares a family with the fiddler crabs, members of which are characterized by square carapaces, or shells, and long, jointed eyestalks.

Ghost crabs occur sparingly northward as far as Long Island, but they are not common beyond the beaches of Virginia and the Carolinas. From there they range south through the Caribbean and along the Gulf of Mexico to Brazil.

Primarily nocturnal, they forage most actively from dusk until early-morning light. They usually remain hidden during the heat of the day, although a few may wander the sands at almost any hour.

From mid-December through February in Texas they retreat beneath the dunes, plug their burrow openings with sand, and remain dormant through the winter chill.

Young crabs tend to live closer to the water than do older ones, digging shallow holes just above the intertidal zone. Larger individuals inhabit the upper beach and foredune ridge, their burrows extending down as much as four feet to reach moist sands. At night, ghost crabs rush to the surf to exchange the seawater carried in their gill chambers. Dense, hairlike setae around the openings of those chambers help keep out sand and retard water loss. The impermeable shell also prevents desiccation.

Like most crabs, *Ocypode* is a scavenger, feeding on dead fishes and other organisms washed up on the beach. Even the stinging Portuguese man-of-war may be devoured by a hungry ghost crab.

Unlike blue crabs, which mate when the female is shedding and in the "soft-shell" state, ghost crabs can apparently mate at any time throughout the year, even when their shells are hard. The female carries her eggs beneath her body and releases the developing larvae in the surf. Soon the active, inquisitive little crabs will come ashore to dig their own tunnels in the sand and help clear the beaches of debris. They serve as an attractive and useful part of the seaside fauna, these great excavators of the coastal sands.

Visitors from the Sargasso Sea: 1975

Legends of the Sargasso Sea abound in sailors' folklore. Strange, ferocious sea creatures lurk beneath the waves. Trapped in masses of floating sargassum weed and becalmed in endless doldrums, sailing ships drift helplessly as crews perish from hunger and thirst. The tales, of course, remain largely fiction, but the facts prove almost as interesting as the fables.

Stretching from the Azores to the Bahamas, the Sargasso Sea covers an area almost two thousand miles across. It is the hub of the North Atlantic wheel, a region of calm within the circling ocean

currents. Fifteen thousand feet beneath the surface lies some of the clearest and least productive water in the world's ocean system, a biological desert created by the lack of circulation.

Yet on the surface of this inhospitable sea resides a unique community of animals, all living on a floating plant called sargassum weed. The name was applied by early Portuguese sailors when the round air bladders of the plant reminded them of a small Portuguese grape called *sargaço*.

Like most other "seaweeds," sargassum is one of many forms of marine algae. Instead of being anchored to the seafloor like its relative the giant kelp, however, this brown alga floats on the surface, traveling wherever winds and currents dictate. Far from being limited to the Sargasso Sea, it occurs throughout the Caribbean as well. While flying over the Gulf of Mexico in a helicopter to visit offshore oil platforms, we saw it lying in long, yellow brown ropes across the water, as if a giant aquatic reaper had cut and raked it into windrows.

Sargassum, locally called "gulfweed," sometimes rolls up on Texas beaches in enormous quantities, where it proves highly unpopular with swimmers and sunbathers as well as with tourism departments and chambers of commerce. For the curious naturalist, however, it is a treasure trove of strange and fascinating creatures, most of which are found nowhere else. Prowling the beaches on Galveston Island with members of the Ornithology Group of the Houston Outdoor Nature Club, we recently stopped for a quiet lunch beside the water. The Gulf was covered with patches of floating sargassum, and soon it was piled high on the beach, a heavily branched plant with many leafy blades and the small grapelike bladders that keep it afloat. Wading into the surf, our son, Michael, scooped up some of the sargassum and found a strange nudibranch, or "sea slug." Birds and sandwiches were quickly forgotten as we hunted for more.

Nudibranchs are classified as mollusks like the common snails, but they lack a protective shell. Instead, they have perfected the art of camouflage. Removed from the water, the translucent mollusk becomes nothing more than an unattractive lump of creamy brown jelly; in its element, it ranks as one of the most graceful

and beautiful of marine creatures. Frilly projections along its sides and brown and greenish markings on its body matched exactly the plant on which it rested, making it virtually invisible. Pulling out a field guide, we identified it as a sargassum nudibranch, a logical but somehow satisfying conclusion. It was the same species those first Portuguese sailors might have encountered sailing the Sargasso Sea.

SARGASSUM PIPEFISH

Wading out and scooping up more armloads of floating weeds, we searched industriously for the strange little sargassum fish, but without success. This inch-long creature is found only in the floating algal forest, climbing around with the aid of handlike fins and feeding voraciously on tiny sea animals. The sargassum fish, like the nudibranch, bears numerous tassels and ribbons to match its background. It even possesses spots that resemble the air bladders of its host. Nature has perfected camouflage to an amazing degree.

Unsuccessful in our search for the sargassum fish, we nonetheless found a sargassum pipefish, a long, slender cousin of the seahorse. Acquiescing to equality of the sexes, the male pipefish carries the fertilized eggs in his pouch until they hatch, thereby freeing his mate for whatever tasks or pleasures might be found in a floating patch of brown algae.

Small crabs and shrimp, most of them less than an inch long, also fell from the sargassum as we shook it onto the sand. A crusty, coral-like lacework of bryozoans and waving threads that proved to be tiny hydroids covered the stalks and blades. Each of these animals was a species uniquely adapted to life in a world comprised solely of floating sargassum and ocean currents, an incredible world of specialization.

Sargassum weed is unpredictable, sometimes covering large areas of the ocean surface and sometimes absent even from the Sargasso

Sea. Old plants die and sink to the bottom, to be slowly replaced by new ones as they develop their unusual flotation chambers. Washed up and decaying on a coastal beach, it becomes less than attractive and more than a little odoriferous. However, we find it utterly fascinating, for it presents a new and exotic arena of exploration.

9

Pronghorns and Pocket Mice

Of all the forms of wildlife that people encounter on their travels, mammals seem to attract the most attention. Birders abound, of course, and travel widely in pursuit of new and interesting species for their lists. Others share a penchant for reptiles and amphibians or for butterflies. However, it is the moose, elk, or bison in a mountain meadow or the deer wandering through a campground that draws a crowd. Even the little chipmunks and ground squirrels that freeload at picnic tables and the cottontails placidly munching grass beside the road provide a constant source of amusement for everyone who ventures out along our nature trails.

Bewildering Diversity: 1987

Although most casual observers of nature appreciate seeing wild animals, few realize how many different mammals there really are, even in their own backyards. Most recognize a mouse or bat or rabbit, but they make no distinction among the dozens of similar species. Indeed, some of those species can be difficult to differentiate, but even the novice can accumulate a surprisingly lengthy list.

During the latter portion of the summer, we made a wide sweep across the West, driving through Texas, New Mexico, and Arizona to Nevada to lead two Colorado River raft trips for the Smithsonian Institution travel program, then back across Utah and Colorado

TEXAS ANTELOPE SQUIRREL

before heading northward to visit family in Minnesota. On that tour we kept a list of mammals we had seen, a list that would eventually total forty-four species.

We hasten to add that we did not go out of our way to seek out new animals for the tally. We demurred at driving up a mountainside in drenching rain to search for elk we knew to be there. We did not often venture out at night with lights in hope of spotting more nocturnal creatures. We simply watched those we encountered and enjoyed them immensely as their paths chanced to intersect with ours.

Most exciting for us were desert bighorn sheep seen from the raft in Grand Canyon, for among them were three gleaming white individuals. One, we believe, we have watched for three consecutive years, and finally this year he was developing the heavy horns that marked him as a ram. The others were a ewe and her little lamb, both pure white among their gray, rock-colored companions. Later, in Colorado, we spotted a larger strain of the same species, the Rocky Mountain bighorn sheep.

Throughout the western states, mule deer wandered through our campsites, some with spreading antlers still in velvet. In Minnesota, white-tailed deer replaced their large-eared cousins. Twice we came across a doe with twin spotted fawns, their backs still dappled with the camouflage of youth.

A herd of pronghorns trotted across our path on the rim of Utah's Canyonlands National Park. These unique animals are frequently called "antelope," but that name is better applied to the unrelated antelope of the Old World. Perhaps the fastest of all mammals over a distance, pronghorns rank among the most beautiful and graceful.

Although we have worked with and photographed many bats, we must admit great difficulty in identifying them on the wing. Thus,

though we were visited in almost every camp by these wonderful flying creatures, we could add only a few to the list. Western pipistrelles were easily identified by their tiny size and pale pelts in Utah's Dead Horse Point State Park, and we are reasonably certain we found both Brazilian free-tailed bats and Yuma myotis in Grand Canyon. There were undoubtedly several others we failed to recognize.

No mammalian order was as well represented as the rodents, for we found twenty-six species ranging from large beavers in the Grand Canyon and in Minnesota lakes to a tiny montane vole crossing a Utah roadway. We were able to watch a friendly little deer mouse, and a big-eared pinyon mouse was drawn to the light of our Calf Creek campfire. We made no positive identifications, however, of the numerous pocket mice and kangaroo rats that bounded across the roads, and we undoubtedly overlooked many others as well. Mouse-watching is an exacting art.

Our list contained five chipmunks from different ecological niches, as well as five ground squirrels. Among five tree squirrels were the lovely little northern flying squirrel on a white-trunked Minnesota birch, a spectacular tassel-eared squirrel in the Grand Canyon region, and the feisty red squirrel that chattered back at us from the top of a Douglas-fir. We found three species of prairie dogs, including the endangered Utah one; yellow-bellied marmots and their eastern woodchuck counterparts; muskrats; and a spiny and very belligerent porcupine.

Six members of Lagomorpha, the order that contains the rabbits, included our familiar black-tailed jackrabbit, a northern snowshoe hare, and three different cottontails, which we must confess to identifying largely from their different habitats and the appropriate park checklists. The lagomorph prize proved to be the tiny pikas above timberline on Colorado's Trail Ridge Road,

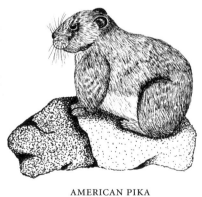

AMERICAN PIKA

busily drying grasses in miniature haystacks against the pending cold and snow that would soon sweep in.

A coyote crossed our path in New Mexico; a lovely long-tailed weasel, at Black Canyon of the Gunnison in Colorado. We spent a few slightly anxious moments with a large striped skunk beneath our camp table in Utah's Capitol Reef, and we watched in fascination as a mink chased and caught frogs along a Minnesota lakeshore.

It is not a long list by taxonomic standards, a mere fraction of the animals we might have encountered along such a route had we been concentrating on them alone. But each of those forty-four mammals provided a moment of excitement and delight; each added its own vitality and personality to our trip.

Our Only Flying Mammals: 1982, 1985

As night settles over the mountains and canyons of West Texas, the skies come alive with millions of glittering stars, a spectacle too rarely seen by those of us who live beneath the opaque umbrella of urban glow. The clear night air also fills with the faint rustle of parchment-like wings and with high-pitched clicks and squeaks, for this is the time when some of our most interesting animals emerge from their hiding places to go about their nighttime business. Other mammals share this nocturnal tendency, a trait inherited by many creatures of the hot, arid desert regions. The ones we seek, however, are the only true flying mammals, and the night sky belongs to the bats.

Bats occupy the scientific order Chiroptera, from the Greek meaning "hand wing," named for the elongated fingers supporting wing membranes that extend back along the sides of the body to the hind legs. The thumb of each hand is free and terminates in a claw that serves in clambering about the roost.

Bats are not blind, but they have small and relatively inefficient eyes, a deficiency they more than make up for with unusually well-developed hearing. The sensitive middle and inner ears and high-frequency vocal sounds combine to function as a kind of sonar vital

in guiding bats in flight and in capturing aerial prey. Most species emit thirty to sixty supersonic squeaks each second at a frequency of thirty thousand to one hundred thousand cycles. The sounds reflect from objects in their path and are then detected by the ears. Muscles in the ears appear to contract and relax in synchronization with the squeaks, thereby blocking out the emitted sounds and receiving only the echoes. With this sophisticated system of echolocation, bats can determine the size, shape, position, and relative motion of objects with unbelievable precision.

Nearly worldwide in their distribution, bats are most abundant in the tropics, and none occurs in either the Arctic or Antarctic. Next to the rodents, which include nearly three thousand species worldwide, bats rank as the most numerous. Of all known species of mammals, one-fifth are bats. About forty species reside in North America, three-quarters of which have been reported from Texas. Some range virtually across the continent, but others are confined to the rocky canyons of the desert Southwest.

With mammalogy professor David Schmidly and some of his graduate students from Texas A&M University, we have come to the Sierra Viejas, southwest of the Davis Mountains and bordering the Rio Grande, to capture and photograph some of these rare western bats. With permission from the rancher, a biologist by training, we camp on the rim of a remote and beautiful little canyon beneath the crest. This is also the site of an early 1900s army post built during the time of Pancho Villa, and we utilize the old barracks as our headquarters.

In the bottom of the rock-walled canyon lie quiet pools that water lush cottonwoods and willows, in stark contrast to the parched desert scrub on the surrounding slopes. Across these pools we string mist nets of fine nylon mesh, thirty feet long and eight feet high, attached to poles implanted in the banks. The nets serve to trap and hold bats that swoop down to drink or hawk insects over the trickling stream.

The bats have begun to swirl against the sky at dusk, fluttering mothlike, of obviously differing sizes but unidentifiable to our untrained eyes. Occasionally one hits a net and bounces out, but others

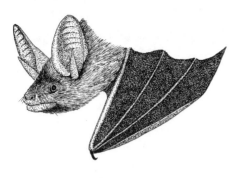

PALLID BAT

become entangled and do not escape. Carefully we remove them from the mesh and drop them into cloth bags; we will photograph them the following morning. Working in the glare of our headlamps proves tricky at first, for the thin net strands can become badly tangled. However, we have used similar nets in banding birds and soon master the technique. We are also careful in handling the little mammals so as not to be bitten by their sharp white teeth, bared in defense as the bats struggle to escape.

The threat of rabies has made many people afraid of bats, but that threat is overrated; there is no reason for the average person to come into physical contact with these tiny mammals. Because of our work with them and with other animals, however, we have had an experimental vaccine series and just received booster shots for good measure. Still, we work carefully.

The old buildings of the fort, too, prove to harbor hordes of bats. Some we capture with mist nets strung throughout the rooms; others we scoop directly from their ceiling roosts with long-handled dip nets. Most common here are pallid bats, pale in color as their name implies, and with enormous ears that curl back against the body while at rest and rise erect when the animal is disturbed. Smaller Townsend's big-eared bats roost with the pallid bats, a species we have never seen alive until now.

Altogether, we capture eight different bat species during our week-long stay in West Texas. We catch our first ashy gray western pipistrelles, no bigger than our thumbs, the smallest bat found in the state. It is our first chance to see the fringe of hairs on the flying membrane of the fringed myotis and our first look at western subspecies of several more widely distributed bats.

In photographing them, we learn the feisty personality of the big brown bat and can study again the lovely frosted fur of the hoary

bat. Our trip provides a rare chance to meet new creatures and learn their habits before releasing them again to course the night sky over far West Texas, hawking insects as they go.

Efforts by conservation groups such as Bat Conservation International and by various governmental agencies in recent years have served to dispel much of the fear of bats and make them more popular with the general public. Well-publicized urban roosts and tours to caves harboring tens of thousands of bats have also aided in this effort.

Unfortunately, rabies has been detected recently in several bats found in school buildings in the Houston, Texas, area, and at least one young man died after being bitten by a rabid bat in his home, thereby reintensifying the fear. These are extremely rare occurrences, however, and much less likely to claim lives than a fatal accident on any freeway. The key is to avoid direct contact with bats, especially those found on the ground or apparently ill.

Bats provide an essential service in consuming prodigious quantities of flying insects, many of them serious agricultural pests. Bats remain a vital part of our environment, one that we must continue to protect, both for their well-being and for our own.

The Myopic Mole: 1982

Virtually everyone has at least heard of the animal called "the mole." It has been featured in numerous children's stories and cartoons; the term has become part of our lexicon in several different contexts. Few people, however, have actually seen a flesh-and-blood mole, for this strange, myopic mammal lives out its life beneath the surface of the earth. The mole ranks, perhaps, as the most subterranean and most highly specialized of all our mammals. It is perfectly adapted to a life spent tunneling underground.

Actually, seven different mole species inhabit North America, but the eastern mole remains the most widespread and the best

known. Found throughout the eastern half of the United States, except for the northern fringes, it is also the only species that occurs in Texas. Taxonomists place moles and shrews together in the order Insectivora, mammals that do, indeed, feed heavily on insects. Shrews, however, actively hunt a variety of other prey, and moles also consume quantities of worms and a small amount of vegetable matter. Neither family is exclusively insectivorous.

Scalopus aquaticus, the eastern mole, comes by its generic name honestly—*scalopus* means "to dig" in Greek. *Aquaticus,* on the other hand, apparently results from a misconception about the little mammal's webbed feet. The eastern mole is definitely not an aquatic animal. Instead, the wide, spadelike front feet are turned outward and designed for burrowing. They arise from arm bones that are short and flat, with powerful muscles to provide enormous leverage. The breastbone extends forward and has a keel to support large pectoral muscles as well. The mole, quite simply, is a digging machine. With its conical head and short neck, it presents little resistance as it pushes through the soft earth, and its fur is virtually grainless, allowing backward as well as forward movement within the burrow. That luxuriant fur is also thick and velvety, often with a gleaming silver sheen.

Eastern moles range from four to six inches in length and weigh up to five ounces. The short, inch-long tail is naked, as is the long, pointed snout with nostrils located on the upper surface. There are no external ears, although the mole's sense of hearing is fairly well developed. The ear openings lie concealed beneath the fur to keep them free of dirt. Skin covers the pinhead-size eyes, and these organs are little more than light-sensitive spots. In the subterranean darkness, sight serves little purpose. Moles find their prey by scent and touch and by vibrations detected with their sensitive whiskers.

Moles are restricted in their range to areas with moist, friable soil, and they avoid dry sand and heavy clay. In Texas,

EASTERN MOLE

they occupy the eastern half of the state and a narrow strip along the floodplain of the Rio Grande but are absent from the rocky gravels of the West. The sandy loams of lawns, golf courses, and gardens provide perfect, if unpopular, habitats for burrowing. Actually, the burrow system proves beneficial in aerating the soil and providing drainage, but the resulting ridges and mounds make moles less-than-welcome tenants of most fastidious landowners.

The tunnels are of two distinct types: shallow surface runs marked by long ridges where the earth is simply pushed upward, and deep burrows from which the dirt is brought to the surface and piled in conical mounds. The former are associated primarily with foraging for food; the latter provide for protection and the rearing of the young. Such a system may be in continuous use for several years, and one burrow along a Texas fencerow was found to be more than four hundred yards long.

Moles remain active both day and night in all seasons of the year. They live solitary lives except in early spring, when males seek out females in their burrows. The four or five young are born after a gestation period of about six weeks and are miniature but naked copies of their parents. There is but a single litter each year. At the tender age of one month the young are independent, and they wander off to establish tunnel systems of their own.

A Charming Campground Guest: 1987

Many families on summer vacation travel extensively through the parklands of the western states, thrilling to spectacular mountain vistas and rugged canyon depths, visiting campgrounds and picnic areas along the way. Among the wild creatures they are most likely to encounter on such trips is the charming golden-mantled ground squirrel. A friendly freeloader, this little mammal inhabits virtually every park in the American West.

One of some eighteen different species of ground squirrels, most of which are western in their distribution, the golden-mantled ranks

as the most colorful and distinctive. However, it is often misidentified as a chipmunk. Indeed, both chipmunks and ground squirrels are members of the squirrel family, the Sciuridae, along with the tree squirrels, flying squirrels, woodchuck and other marmots, and the prairie dogs. Biologists classify them all in the more expansive order Rodentia, the rodents.

The pelage of the golden-mantled ground squirrel is brown above, frosted with gray or silver, and whitish below. The head and shoulders are glossed with a rich golden or coppery red, the "golden mantle" from which the animal takes its name. The intensity of the color varies with different populations. A white stripe, bordered above and below with black, runs along each side.

The presence of these stripes leads to the confusion with the similarly marked chipmunks. However, chipmunks, of which there are about twenty species, have body stripes extending onto the face. The ground squirrel lacks those facial stripes and exhibits only a broken ring around the eye. Chipmunks also tend to be slender little animals with pointed noses; the golden-mantled ground squirrel is larger and chunkier and has a broader snub-nosed face. Its head and body total six to eight inches in length; its well-furred tail, another three to five inches. An adult weighs about half a pound.

This colorful rodent occurs from southern Canada to California, Arizona, and New Mexico. Unlike many of its ground squirrel relatives that inhabit prairie grasslands and cultivated fields, the golden-mantled ground squirrel avoids open, agricultural lands. It remains an animal of the coniferous forests, ranging up the mountain slopes to altitudes above timberline. It frequents campgrounds and picnic areas in search of handouts, and its attractive appearance and ingratiating friendliness assure it of a steady food supply during peak tourist season, although it would be far better not to feed these uncommonly tame camp followers. In its natural environment it feeds primarily

GOLDEN-MANTLED GROUND SQUIRREL

on seeds, nuts, and fruits. The scientific name of the ground squirrel genus, in fact, is *Spermophilus,* meaning "seed lover." Leaves and flowers, mushrooms, and beetles and other insects supplement the diet on occasion.

Like others of its genus, the golden-mantled ground squirrel is a burrower, constructing shallow tunnel systems a foot or two deep. Some of these miniature subways have been measured at more than one hundred feet in length and serve as tributes to the industriousness of their makers. When surplus food becomes available, the ground squirrels stuff their cheek pouches with tasty tidbits and carry them back to their burrows. They then consume the stores during brief periods of winter activity or upon awakening from hibernation in the spring. Hibernation normally extends from October into May, depending on latitude and altitude. Females give birth to a single litter of four to six young in early summer.

While sitting recently on the porch of a cabin at the North Rim of the Grand Canyon, we became absorbed in the antics of a chubby little golden-mantled ground squirrel taking a dust bath nearby. Stretched full length in the dirt beside a walkway, it bulldozed its way along on its belly, pushing with its hind legs. Then it rolled over and wriggled around on its back, the billowing dust serving to remove excess oils and grime from its fur. Sitting erect, it next meticulously groomed every hair back into place, using both claws and teeth as combs.

Finally ready for the social circuit, the cunning little ground squirrel scrambled up the steps to our porch and sat at our feet, expecting to be fed. Unsuccessful in this quest, and chattering under its breath in seeming disgust, it darted around us and through the open cabin door, wandering around on alert for neglected crumbs beneath the furniture. Finally it emerged from the room and, looking disdainfully over its shoulder, darted off to find a more generous host.

Vacationing with Foxes: 1998

The persistent sound echoed from the birches and willows along the quiet shoreline of the lake, the quacking of a female mallard with her brood. Slowly we paddled closer, until the ducks were within a few feet of our canoe. They did not swim away as would more wary goldeneyes or wood ducks. Indeed, we had canoed with this mallard family for several days, always approaching them without alarm. This morning, however, something was clearly wrong. The hen kept up her loud, repeated cries even though surrounded by her half-grown young.

At first we wondered if one duckling might be missing, but we counted all eight as they milled around their frantic mother. Then, looking up to the shore, we saw the problem. There, on a low sandbank beside the water, stood an adult red fox, eyeing the ducklings hungrily. It was a beautiful animal, its fur a rich orange red with golden highlights. The lower legs were blackish; the bushy tail sported a dapper white tip. The fox, of course, had seen us immediately, but it held its ground against an innate urge to flee. For several minutes we sat looking at each other before the fox grew restless and trotted slowly off down the shore.

Amazingly, the mallard left her brood and flew along beside the would-be predator, quacking loudly all the way. We followed in our canoe, and the strange procession continued for a hundred yards or more, until the lovely canid ruefully gave up and vanished into the woods. Satisfied, the duck then returned quickly to her young. Elated with the experience, we paddled on, leaving the mallard family to regroup. Never had we been so close to a wild red fox nor seen it interact with potential prey.

This chance encounter was to be

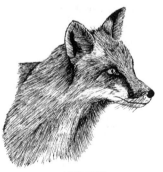

RED FOX

the first of several over the following three weeks. We would meet foxes on woodland trails and see them crossing the roads in front of our car. Our son, Michael, and his family, who shared this vacation with us in northern Minnesota, came upon one carrying a young muskrat in its jaws.

Our nephew, Chris Tveten, who works as a dock hand for owners Doug and Carol Pitt at Bailey's resort during the summer, had told us about a fox den near the harbor. *(Chris is now a commercial airline pilot, and Bailey's on Leech Lake's Kabekona Bay is currently operated by Dana and Cindy Pitt. Meanwhile, we still return year after year.)* Chris had previously seen the kits playing nearby and put out fish to supplement their natural food. It was undoubtedly this vixen that we encountered.

According to biologist Adrian Forsyth in *Mammals of the Canadian Wild,* "The red fox enjoys the largest geographic range of any living carnivore. It is found, probably as a single species, throughout the northern parts of both the Old and New Worlds, wherever the habitat is relatively undisturbed."

In North America, it ranges from the high Arctic of northern Canada and Alaska to the Deep South along the Gulf of Mexico. Scientists argue, however, whether the red fox is truly native to our continent. Some populations undoubtedly descended from European animals introduced into New England in 1750, and others were distributed around the country for recreational fox hunts until the genetic lines became hopelessly intertwined.

The diet of the red fox, notes Forsyth, is limited only by what it can catch. Small animals, including mice, ground squirrels, and cottontails, are staples of the omnivorous diet, but insects, frogs, birds, and eggs are also eaten. Foxes scavenge carcasses of larger animals, and when such fruits as wild grapes, blueberries, or cherries are in season, they may eat little else.

Red foxes exhibit a wide variation in social and breeding behavior, but they are usually monogamous, breeding once a year in burrows they dig themselves or appropriate from other mammals. Some males stay with their families and assist in rearing the pups; others wander off and ignore such parental duties.

As the pups grow older, they accompany their parents on foraging trips, where they acquire the hunting skills necessary for survival. By the end of summer they will disperse to find territories of their own. Except during the breeding season, red foxes live solitary lives and hunt alone. They mark their home ranges with scent and normally stay within those boundaries.

It was apparently another fox that we met one day along a trail through the forest. Walking slowly along, looking at butterflies and listening to the songs of the birds, we suddenly spotted it lying at the edge of the trail, partially concealed by long grass. We stopped abruptly, no more than thirty feet away, and the fox scarcely moved. Turning its head slightly, it stared at us through half-closed eyes. Raising our binoculars, we could see little more in the field of view than those piercing golden orbs. The pelage of this red fox was sprinkled with blackish hairs; its tail seemed darker than that of the animal we had encountered beside the lake. Several minutes passed before it grew restless and slowly stood up, trotting into the woods and quietly vanishing among the pines.

In this same area, we also came across two half-grown fox pups playing beside a den dug into the face of a sandbank among the trees. For fifteen to twenty minutes we stood quietly and watched through binoculars as the pups wrestled and romped, each grasping the other's muzzle in its jaws and playfully tugging and biting. As one paused at the bottom of the bank, the other launched itself from the top and bowled over its litter mate, both of them rolling down the hill in a tangle of slender limbs and bushy tails. Rising and shaking themselves off, they began again to tussle, engaging in the play-fighting that prepares most carnivores for the tough years ahead.

Only when their skirmishes and chases carried the pups into the woods and out of sight did we turn and slowly walk away, once again elated by a new experience with one of nature's most beautiful animals.

Prairie Pronghorns: 1977

The pronghorn of the western plains arguably qualifies as one of the most beautiful and graceful of all our native mammals. Often called an "antelope," it is, in fact, taxonomically far removed from the true antelopes of the Old World. Although the pronghorn bears a strong physical resemblance to the fleet animals of the African grasslands, biologists place it in a scientific family all its own.

The slightly curved horns, each with a single prong projecting forward, give the animal its name. They are true horns, consisting of bony cores covered with tough sheaths of compacted hair. Unique, however, is the fact that the sheaths are shed each year after the breeding season, leaving the cores intact. Thus, the pronghorn differs from all other hoofed mammals, which have either permanent horns or antlers that are shed in their entirety.

Pronghorns inhabit open country, from the prairies of Canada's Saskatchewan Province southward into Mexico. When early settlers arrived on the continent, an estimated forty million pronghorns roamed the plains. Together with the bison, they were hunted mercilessly, until only about twenty-six thousand remained in 1920. Now, with proper management, they have staged a comeback, and limited hunting is allowed in many states. Current estimates place the population at about one-quarter million.

Texas Parks and Wildlife biologists keep a close watch on the pronghorns that range across the western half of Texas. A recent census found about ten thousand, with 60 percent of the population in the Trans-Pecos and the remainder split between the Permian Basin and the Panhandle. *(According to David Schmidly, a 1999 census, more than twenty years after this column first appeared, found the population had risen slightly to 11,500, and the distribution in critical areas had remained about the same. That year, 603 bucks were taken in a limited hunt.)*

Pale tan in color with white underparts, throat bands, and rump patch, pronghorns stand about three feet high at the shoulder and

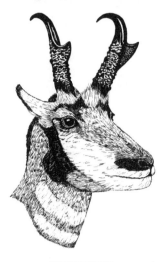

PRONGHORN

weigh up to 130 pounds. Both sexes have horns, although those of the female are shorter and seldom pronged. Males also sport contrasting black markings on their heads. There are only two toes on each foot, with no dewclaws borne by many other hoofed mammals. The large white rump patch serves as a signal to the herd, a sort of early-warning system. The stiff, hollow hairs can be erected by muscle control when the pronghorn is alarmed and fleeing from danger, and the flashing patch warns others of an impending threat.

Pronghorns rely on keen eyesight and speed for protection and are perfectly adapted for life on the open prairies and plains, where they browse on sagebrush as well as other shrubs and graze on grasses and annual forbs. The large, protruding eyes provide nearly 360-degree vision across the unbroken expanses, so intruders are quickly detected. When alarmed, the fleet animals easily outdistance any pursuer, for the pronghorn is the fastest mammal on the North American continent and probably the swiftest of all four-legged creatures over a long distance. The cheetah might catch a pronghorn in a short race, but the cheetah is a sprinter that tires quickly; the pronghorn is a marathon runner capable of sustained effort.

Authorities differ on the top speed of the pronghorn. Some accounts claim speeds up to seventy miles an hour, while others report no more than forty-five. The former seems possible in short dashes, but the more conservative estimates probably apply for a sustained run of several miles.

Strangely, the pronghorn shows great reluctance to leap over obstacles, preferring to slip through or crawl under fences rather than jump over them as do the deer. Presumably this trait has been acquired over hundreds of thousands of years of living in open country with few barriers to sheer speed. Not until humans strung

ribbons of wire did anything impede the headlong flight across the prairie.

Yet another personality quirk of the pronghorn is its intense curiosity. Although very nervous, it will often investigate any unusual sight, relying on speed should the intruder or event prove dangerous. Hunters and photographers sometimes capitalize on this trait by hiding and waving a white handkerchief to lure a curious pronghorn into range.

Pronghorns roam about in small bands, each dominant buck battling with others for his harem of does. After the fall breeding season, the outer sheaths of the horns are shed and tempers wane; the horns will grow anew the following year. The young, usually twins, are born in the spring. After a few days of being left alone except at feeding time, they can follow their mother in daily forays. Wobbly legs strengthen quickly, and soon they are able to outdistance any predator, taking their place with other members of the herd.

Lessons Learned from a Manatee: 1995

From a report by the Texas Parks and Wildlife Department: A manatee was reported in Houston on November 27, 1995, one of eleven sightings of this unique marine mammal along the Texas coast in the fall of that year. It is possible, however, that several of those encounters were of the same individual. The species is listed as endangered by the U.S. Fish and Wildlife Service, and it is estimated that fewer than one thousand remain in the United States, most of them in South Florida. Apparently this rare manatee traveled over twenty-five miles across chilly Galveston Bay and up the Houston Ship Channel before being attracted to the warm discharge from a wastewater treatment facility.

We were on the scene the following day and followed the plight of the wayward manatee until December 7, when an advancing winter cold front threatened its survival. It was then captured by a joint team from federal and state environmental agencies and moved to safety

in captivity, eventually to be flown to Florida and released back into the wild.

The following columns, written at the time, reflect the manatee's astonishing impact on an entire city. Because of intense media coverage, we limited our newspaper material to information about the manatee and the lessons learned during its visit, rather than to its day-to-day activities.

Few events in Houston created more public interest than the visit of a manatee to the Houston Ship Channel and the upper reaches of Buffalo Bayou. Crowds of people lined the bayou banks daily to watch its aquatic antics. Virtually every local media outlet covered the unfolding story.

During that time, the city's 69th Street Wastewater Treatment Facility also served as an invaluable environmental classroom. Most of the visitors had never seen a manatee; a significant number had never even heard of such an animal. Some assumed it was a type of fish, and many wondered aloud why it did not eat the smaller fishes that shared its warm-water refuge.

Actually, the manatee is an air-breathing mammal that nurses its young and has scattered hairs on its tough, leathery skin. In those respects, it resembles common terrestrial mammals except, of course, for its adaptation to a totally aquatic life. It is tempting to compare it to the more familiar whales and dolphins or to the seals and sea lions, but those marine mammals are not close kin. All have simply evolved a similar body shape in response to a common habitat.

The manatee is a member of the scientific order Sirenia, a lineage most evolutionary biologists believe diverged from the elephants during the Eocene. Fossil remains indicate a gradual adaptation to the water. Similarities in the skull reflect the link to elephants, as does the unusual tooth arrangement. Manatees have an indefinite number of molarlike teeth that erupt in sequence throughout its life. As the front teeth wear down, they fall out and are replaced by new ones moving forward.

Four living species occupy the order Sirenia. The Houston visi-

tor was a West Indian manatee, *Trichechus manatus*, an animal that once ranged along the coasts of Florida, Mexico, Central America, the West Indies, and the northern portions of South America. It has unfortunately become very rare or has vanished entirely from most of its former range. Although there have been scattered sightings along the Texas coast through the years, the journey up the Houston Ship Channel seems to have no modern precedent.

The genus *Trichechus* also includes the smaller Amazonian manatee of the Amazon drainage in South America and the West African manatee. The dugong of the Indian and southwestern Pacific Oceans differs from the manatees in having a notched tail more like that of the whales. Biologists place the dugong in a different family with the extinct Steller's sea cow. An enormous animal weighing up to three tons and adapted for life in the frigid Bering Sea, the latter was exterminated by hunters less than three decades after its discovery in 1742.

The flesh of the sirenians is said to taste much like veal, and the hide makes excellent leather. Oil from its blubber also has served a number of uses over the years. Thus, the defenseless animals have been hunted relentlessly. Commercial hunting of the West Indian manatee began in the seventeenth century in the Caribbean, where it was considered a fish by the Spanish church and could be eaten on days of abstinence. In 1950, more than thirty-eight thousand manatees were killed in Amazonas, Brazil, alone.

Now classified as an endangered species, our manatee is protected under both the Endangered Species Act and the Marine Mammal Protection Act. Occasional poaching and senseless vandalism and harassment still take a small toll, but boats and barges pose the most serious threat to the slow-moving mammals. Most bear scars from whirling propellers.

Manatees can live in both fresh and salt water and spend their lives almost completely submerged. They normally frequent large rivers and shallow coves and bays, where they hang suspended just below the surface or lie on the bottom to rest. Most sources suggest manatees can stay underwater about fifteen minutes before rising to breathe, but the intervals are usually shorter.

Totally herbivorous, manatees eat both submerged and floating vegetation. In salt water, they subsist primarily on sea grasses; in fresh water, on water-hyacinths, hydrilla, and other aquatic plants. They apparently consume fifty to one hundred pounds a day and may be instrumental in helping keep waterways free of excess vegetation.

Manatees are not social animals and congregate only in favorite environments or during courtship and mating. Unable to withstand low temperatures, they often assemble at warm springs during the winter months. Use of the water at Houston's sewage plant was not unique, for the animals are known to use the discharge from power plants or water-treatment facilities for thermal control. An amazing aerial photo from Florida some years ago showed 141 manatees around the effluent of the Riviera Beach Power Plant.

Manatees produce a series of underwater squeals, chirps, and grunts, but there is no evidence they navigate by sound as do the cetaceans. Most pronounced of these sounds are the alarm duets of a cow and her calf.

Transparent nictitating membranes and copious oily secretions protect the manatee's eyes. There are no external ears, although hearing is acute, and valvular nostrils on the upper surface of the muzzle close underwater. The upper lip is deeply divided, with the two halves functioning separately in working food into the small mouth, a process aided by stiff bristles on the muzzle.

The bones of the manatee are extremely dense, allowing the animal to sink with a full breath of air and remain submerged. Front limbs are modified into flippers that bear flat nails at their tips; there are no hind limbs. The rounded tail is horizontally flattened and functions as an efficient paddle.

Newborn manatees weigh 40 to 60 pounds and are slightly over 3

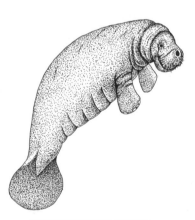

WEST INDIAN MANATEE

feet long. They reach sexual maturity at about eight or nine years of age and a length of at least 8 feet. Captive animals have lived as long as thirty years. Some references list the manatee's length at up to 15 feet and its weight at as much as 2,200 pounds. Such large specimens, however, are extremely rare. At 10.5 feet and 1,252 pounds *(determined after its capture)*, Houston's female manatee qualified as a mature adult.

In retrospect, there are several lessons to be gained from the unexpected encounter with Houston's wayward manatee, which was held for tests in San Antonio prior to her release. We all learned more about this rare and endangered marine mammal, but we also discovered much about the city's most famous bayou. And, just possibly, we learned some important lessons about ourselves.

Many other creatures shared the manatee's temporary refuge. Grass carp proved plentiful in the murky water, nibbling on water-hyacinths and romaine lettuce provided at the floating "salad bar" for supplemental feeding. Schools of mullet swirled past in close formation, while crabs paddled slowly at the surface. Wildlife officials were surprised to discover an enormous pacu and numerous plecostomus, both South American fish that presumably grew too large for someone's aquarium. Such aliens should never be released to compete with native species, but their survival indicates the bayou is now a habitable environment.

Double-crested and neotropic cormorants swam around the manatee, diving for small fishes, while flocks of ring-billed and laughing gulls circled overhead. Occasional great egrets, snowy egrets, and black-crowned night-herons stalked the shallows or waited patiently along the water's edge for careless prey. A spotted sandpiper walked quietly along the bank, and a belted kingfisher perched on an overhanging willow, plunging repeatedly to catch small minnows.

We remember a time not many years ago when such an idyllic scene would have been impossible. Buffalo Bayou ranked as one of the most polluted waterways in the world; even the hardiest urban creatures avoided its reeking waters.

Recent tests reported by the Bayou Preservation Association show that fecal coliform counts register hundreds of times lower than they did ten years ago. They still exceed standards recommended for contact recreation, of course, but the improvement has been enormous. Dissolved oxygen, an indicator of a stream's ability to support aquatic life, now measures three times the minimum standard. Thanks to the Clean Water Act and the cooperation of both public and private concerns, Buffalo Bayou can now support a wandering manatee. That, in itself, is gratifying, for the improvements must certainly benefit human life as well.

Shortly after reaching San Antonio, however, the manatee alarmed her keepers by regurgitating a plastic bag. There seemed to be no ill effects from that encounter, but ingestion of such bags often proves lethal to sea turtles and marine mammals. At dawn one morning on the bayou, we also watched her chew up and spit out a Styrofoam cup, an item that is obviously not part of a manatee's recommended diet.

Although the water quality of Buffalo Bayou is undeniably better than in years past, floating trash abounds, marring the waterway's appearance and posing a hazard to wildlife. Clean-water standards cannot help. Trash thrown carelessly in roadways or gutters washes into storm sewers and directly into the bayous; it does not go through any treatment system. Thus, in the famous words of Pogo, "We have met the enemy and he is us." We alone must solve the problem.

On a positive note, we were extremely impressed by the cooperation of everyone concerned with the well-being and eventual capture of the manatee. The city's Public Works Department proved a gracious host, welcoming people to the plant grounds throughout the week-long episode. It would have been easy for the treatment facility to bar casual public access, pleading safety concerns or interference with daily tasks. Instead, city personnel provided the entire community with an exceptional learning experience, attesting, at the same time, to the quality of the discharge water from their plant.

People from many agencies served as members of what biologist Ron Jones of the U.S. Fish and Wildlife Service called the "manatee

mud wrestling team." Federal fish and wildlife personnel from the Houston area worked closely with manatee experts from Florida. A volunteer veterinarian accompanied the Florida team to supervise medical tests. The Houston Zoo responded with water-hyacinths from their ponds to stock the manatee's bayou salad bar, and Gallery Furniture in Houston contributed a truck for transportation to San Antonio.

Employees of Texas Parks and Wildlife did yeoman service, monitoring the manatee and conditions in the bayou and eventually deploying the long capture net. The cooperation between state and federal agencies was gratifying to see. The dive team from the Houston Police Department manned a boat during the capture, guarding against potential accidents in the hazardous operation, and other officers provided traffic and crowd control. The U.S. Coast Guard added a patrol boat and closed the bayou to barge traffic.

Amazingly, even during the busiest and most hectic of times, all of these people were ready with answers to the endless stream of questions that flowed around them, from the media and spectators alike. For the countless array of cameras and reporters and for the smallest schoolchildren, officials provided candid information. They made many friends throughout the community.

So, too, did the manatee first named "Hugh Manatee" and then rechristened "Sweet Pea" when close examination proved she was a female. The entire ordeal was undoubtedly a stressful one for her, although it was difficult to tell from her phlegmatic countenance. It was, however, a giant leap for manatees in general. Who among us would now ignore the quiet charm of such an animal? At a time when opposition to the Endangered Species Act continues, few who visited Buffalo Bayou would deny the value of the protection it imparts.

We heard many comments during our week-long vigil along the bayou. One person, after asking what kind of fish it was, commented, "It sure is ugly!" Another, seeing it for the first time exclaimed, "God it's beautiful!" We would certainly agree with the latter viewpoint, as would so many others who shared this unprecedented experience with a wayward manatee.

In April 2007, the U.S. Fish and Wildlife Service recommended upgrading the manatee's status from endangered to threatened despite rigorous opposition by environmental groups. A 2007 manatee census recorded 2,812 of the large marine mammals in Florida waters, a substantial increase over the past decade but still a small number on which to base the future of so charismatic a species. The reclassification could mean changes in boating and development restrictions along the Florida coast. Despite the change in status, however, the West Indian manatee remains protected by federal laws that make it illegal to harass, poach, or kill a manatee.

10

Around Every Corner

Fascinating flora and fauna can be found throughout the country. The nature at your doorstep in the desert regions of southern Arizona might include rare butterflies and moths or a large and colorful Gila monster, while those living among the craggy peaks of the Rocky Mountains may host rosy-finches and ptarmigan. Exploring shady woodlands and bogs in northern Minnesota, we found numerous species of wild orchids, including three different coral-roots, the lovely dragon's-mouth orchid, and the rare and threatened ram's-head lady's-slipper with its sheep's-head pouch and petals curling around it like a pair of horns.

GILA MONSTER

RAM'S-HEAD LADY'S-SLIPPER

The cienegas or springs of West Texas support marsh-loving plants and animals that occur nowhere else. Diamond Y Spring in Pecos County, for example, harbors a stand of the rare puzzle sunflower, a species not known to science until 1958 and one that occurs in only a few locations in West Texas and adjacent New Mexico. The spring also provides the last remaining home for the little Leon Springs pupfish, and it is one of only a handful of sites that still host the Pecos gambusia, another rare and endangered fish. Two species of endemic snails inhabit only these waters; a third is rare elsewhere. All of these plants and animals depend on the flow of the spring for their tenuous existence, leading a precarious life in one of the most amazing of all Texas' ecological niches.

Such exciting discoveries await even the casual observer on nature trails across the land. As long as such vital habitats can be preserved, their attendant plants and animals will continue to thrill us, even at our own back door.

LEON SPRINGS PUPFISH

PUZZLE SUNFLOWER

PUBLISHER'S ACKNOWLEDGMENT

The Texas A&M University Press is privileged to add its imprint to this Wardlaw Book. The designation claims a special place in the list of Texas A&M publications.

Supported with funds inspired by the initiative of Chester Kerr, former head of Yale University Press, this book, along with its companion volumes, perpetuates the association of Frank H. Wardlaw's name with a select group of titles appropriate to his reputation as man of letters, distinguished publisher, and founder of three university presses.

Donors of these funds represent a wide cross-section of Frank Wardlaw's admirers, including colleagues from scholarly presses throughout the country as well as those from other callings who recognize and applaud the many contributions that he has made to scholarship, literature, and publishing in his four decades of active service.

The Texas A&M University Press acknowledges with profound appreciation these donors.

Mr. Herbert S. Bailey Jr.
Mr. Robert Barnes
Mr. W. Walker Cowen
Mr. Robert S. Davis
Mr. John Ervin Jr.
Mr. William D. Fitch
Mr. August Frugé
Mr. David H. Gilbert
Mr. Kenneth Johnson
Mr. Chester Kerr
Mr. Robert T. King
Mr. Carl C. Krueger Jr.
Mr. John H. Kyle

John and Sara Lindsey
Mrs. S. M. McAshan Jr.
Mr. Kenneth E. Montague
Mr. Edward J. Mosher
Mrs. Florence Rosengren
Mr. Jack Schulman
Mr. C. B. Smith
Mr. Richard A. Smith
Mr. Stanley Sommers
Dr. Frank E. Vandiver
Ms. Maud E. Wilcox
Mr. John Williams

Their bounty has assured that Wardlaw Books will be a special source of instruction and entertainment to the reading public for many years to come.

ISBN-13: 978-1-60344-036-3
ISBN-10: 1-60344-036-4